THE HAUNTED L

Cover: Ladywell, Edington – see page 31.

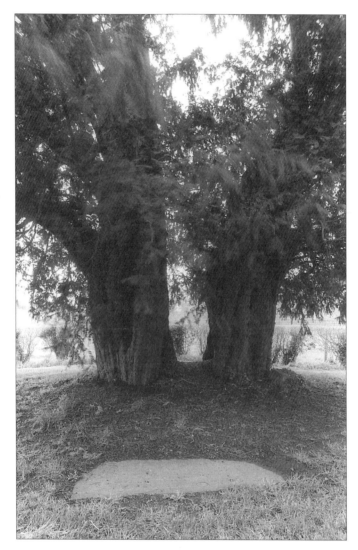

Ancient sacred yew at Alton Priors.

THE HAUNTED LANDSCAPE

*Folklore, ghosts & legends
of Wiltshire*

Katy Jordan

Photographs by
Richard Pederick

EX LIBRIS PRESS

Published in 2000 by
EX LIBRIS PRESS
1 The Shambles
Bradford on Avon
Wiltshire BA15 1JS

Printed by Cromwell Press
Trowbridge
Wiltshire

ISBN 1 903341 08 6

Contents

DEDICATION

In memory of
Frederick James Jordan
1916-1999
who would have
enjoyed reading
all these tales

Introduction

This is a book about folklore. But what exactly *is* folklore? Where does it come from? Why does it exist? My ancient edition of *Chambers Twentieth Century Dictionary* defines it as "embracing everything relating to ancient observances and customs, to the notions, beliefs, traditions, superstitions, and prejudices of the common people", but it seems to me that nowadays folklore has outgrown this rather limited definition.

The word *folklore* itself was coined relatively recently, in 1846, as a convenient term for the belief structures reckoned to underlie what was then known as antiquities, the field of study we would now call archaeology. It is made up of two old words, *folk* and *lore*. *Folk* is an old Anglo-Saxon word meaning 'the people', and *lore*, also Anglo-Saxon in origin, means something that is taught or learned. So *folklore* is simply the learning of (ordinary) people, the common belief structures current in society.

Early folklorists tended to see folklore as somehow preserving ancient pagan beliefs and practices almost unchanged from pre-Christian times, like an insect preserved in amber, and many kinds of customs and traditions were interpreted as the old pagan rites and beliefs, barely changed by the passing centuries. This view can still be found expressed today by some authors who assert that modern Paganism is part of a continuing tradition going back unbroken to the pagan Celtic period and before. There is no doubt that elements of contemporary Paganism are ancient – archaeology confirms this – but recent studies have shown that they are much more of a modern reinterpretation and recreation of ancient beliefs than a direct survival through centuries of religious change.

During the twentieth century the study of folklore came of age, and folklorists have recognised that the lore of the folk is a living, changing entity, arising from the hopes, fears, preoccupations, needs and concerns of us ordinary people as we try to make sense of the world we live in. Like people throughout the ages, we try to come to terms with the great imponderables of existence – birth, death, religion, war, the passing of the years, and the terrors which lurk outside the comforting circle of lamplight – but what we believe and the way we respond to them changes as time passes and society changes. Very few people nowadays would ever suggest,

like Anne Jefferies in the seventeenth century, that they had been stolen away by the fairies, but a significant number of people maintain that they have been abducted by aliens. In both cases people are clearly at once afraid and fascinated by the possibility that there might be a race of beings existing alongside us yet apart from us, who might show us wonders or treat us maliciously, as the whim takes them. That mixture of fear and fascination is the unchanging human response, but how we rationalise and interpret the focus of it – as fairy-folk or alien beings – is the part grounded firmly in our contemporary culture. And so folklore beliefs shift and transform themselves over the years, telling us much in the process about the nature of the society from which they spring.

Much folklore has been written down over the years, and can be found published in books and journals. In a sense this is the insect-in-amber approach. Writing down a tradition fossilises it and prevents it from changing and developing – or it would do, if people only learned their folklore from books. Fortunately most people do not read folklore, and so legends and traditions continue to develop and grow, to change and die out, as they have always done. In this book you may read tales that you have heard before, perhaps in a different version or from somewhere else entirely. There is no 'correct' version. Each is valid in its own right.

It has been my aim here to draw together some of the strange tales I have read or been told about Wiltshire. You will find the theme of religion represented by tales of saints, devils and old gods, by holy wells and holy trees, and by various traditions centred on the church building itself. People are deeply marked by the experience of battle and war, and traditions of battles from many different times have come down to us today. In the latter part of the book comes the section dealing with our fear of the unknown and uncanny, the entities that lurk on the roads, woods and fields around our homes, and worse still inside them: ghosts, witches, black dogs, alien big cats, and other more malevolent beings.

Some of what you will read has been published before, but as far as possible I have tried to avoid simply rehashing what can easily be found in previous books of Wiltshire folklore (although occasionally a tale recounted there is just too good to be omitted!). A good proportion of the book – particularly the ghost stories – is made up of new tales told me within the last 10 years by Wiltshire people who have seen or heard or felt something strange. Wherever possible I have related these tales exactly as they were told to me, for many people are born storytellers, and their own words have an immediacy and a natural rhythm that are well worth sharing.

A note on referencing sources

It has taken me a while to decide how to balance readability of the text (without too many footnotes or other references intruding) with a responsibility to record systematically the oral and written sources of my information.

For written sources I have settled for the system used in the Batsford *Folklore of the British Isles* series produced in the 1970s. At the end of each chapter are brief references to the folklore and where I found it. This refers you to the full references in the bibliography at the end of this book. So if you want to read more about Anne Jefferies who was abducted by fairies, you will see in the references section below that the source is Briggs (1977a), p.152-3. Look up the author in the bibliography at the end of the book, and you will find full details of the books and journal articles I have used. Most of these sources are available from public libraries in Wiltshire. Occasionally I refer to websites, and I give the URLs for these in the references section to each chapter.

For oral sources you will find in the references to each chapter the informant's name, followed by the phrase *pers. comm.* (i.e. 'personal communication'), plus a brief note of when and where I collected the folklore.

References
Modern paganism, survival and recreation: see Hutton (1999) and Jones (1995).
Archaeological evidence for pagan beliefs: Hutton (1993).
Anne Jefferies stolen by fairies: Briggs (1977a), p.152-3.
Main Wiltshire folklore texts: Whitlock (1976); Wiltshire (1973); Wiltshire (1975); Wiltshire (1984).

Acknowledgements

Many people have contributed to this book, as will be obvious from the number of original accounts in its pages. I am deeply indebted to all those who have allowed me to reproduce their own tales here.

Various people have contributed substantially to the creation of this book, and deserve especial mention:

John Bowen for showing me the many wells of Malmesbury, and for much information on the history and traditions of that ancient borough.

John Chandler for explaining and guiding me through the intricacies of Wiltshire Record Office, for advice on various points of Wiltshire history, and in particular for his painstaking research into the non-existent curate of Rollestone.

Roger Jones, my publisher, for having the patience to wait a whole year longer than he expected for the completion of this book.

Alan Jordan for reading chapter 3 and advising me on the military and historical details.

Michael Marshman and the staff of Trowbridge Reference Library who obligingly checked references for me, and let me rummage freely around the shelves of the Wiltshire collection.

Jean Morrison for many insights into the history and folklore of Bratton and its locality.

Rich Pederick for his support and encouragement, and of course for the photographs which so enhance the text of this book.

Helen Williams, last but emphatically not least, for reading every chapter as it was written, commenting constructively and critically, verifying facts, and generally encouraging and supporting me throughout the whole writing process.

Chapter 1

Saints & Devils

Darkness and light

The struggle between the light and the dark is a strong theme in western folklore and mythology, so it is worth taking a look at the protagonists on both sides and thinking a little about where they come from. In the folklore of the British Isles, which is steeped in the Christian tradition, we find the light represented by many different saints, and the dark by that most intriguing of folk villains, the Devil.

The Devil as we know him seems to have taken his first form under the Zoroastrian kings of Persia, where the evil spirit Ahriman stood against Ahura Mazda, the spirit of good. When the Jews were in exile in Persia they acquired and incorporated much of the character of Ahriman into Satan, the great adversary, and later still the Christians inherited him. As Christianity spread across Europe it encountered many pagan gods. Unlike the tolerant Romans, Christians would not countenance any gods other than their own One God, and so the native deities were made out to be devils. Inevitably, the Devil now took on aspects of these pagan gods: the horns and hoofs from the Roman Pan and from the Celtic horned gods; rampant sexuality (played down in latter years by embarrassed Victorians) from the various fertility gods, and so on. It is far too simplistic to say, like one folklorist, that "whenever we encounter the Devil in legend and folklore we are usually in the presence of an old god", but it is clear that the Devil in folklore has been shaped and moulded in the image of the old gods. He contains elements of many, combined and re-formed into something more than spirit of darkness, old god or Christian Devil: the anti-hero of legendary Britain.

In the place of the pagan gods, the early Roman Catholic Church set the ranks of saints, and in many ways they came to resemble the gods they replaced. Each had responsibility for helping certain professions or ranks of person, who prayed to them for help rather than directly to God the Father.

St Catherine of Alexandria, for example, with her attribute of the great wheel on which she was martyred, was the patron of all those who worked with wheels in some way – wheelwrights, millers, spinners – and they would pray to her for assistance in their work. Yet unlike the old gods, the saints were in the beginning mortal men and women, and only acquired larger-that-life status through the process of sanctification and popular belief. In folk tradition now, the saints have become heroes like other legendary or historical characters, like King Arthur, Wild Edric or Sir Francis Drake, and the tales told in folklore about them often seem little different from those told of any folk heroes.

Saints in Wiltshire

The saints associated with Wiltshire seem to fall easily into two distinct types: the major 'universal' saints who were revered all over the Christian world, like St Mary the Virgin, St Michael the Archangel, St Peter and St Catherine of Alexandria; and home-grown, national saints such as St Augustine, St Thomas of Canterbury and Wiltshire's own St Aldhelm. Perhaps what we see here is the divide between saints-as-gods and saints-as-heroes, with the more distant, 'universal' saints taking on the godly role, and the saints closer-to-home becoming the folk heroes.

St Thomas of Canterbury

Thomas Becket lived from 1118-1170 AD, and is one of the greatest English saints and martyrs. His great shrine at Canterbury Cathedral was the focus of many pilgrimages, and it is here that Chaucer's Canterbury pilgrims were heading when they told their tales. He was at first Chancellor of England to Henry II, and a great personal friend of the King. But after 1162 when he was made Archbishop of Canterbury, Becket underwent an apparent change in character, resigned as Chancellor, adopted an austere lifestyle and found himself more and more in opposition to the King's will. Henry's fatal outburst of frustrated rage, "Who will rid me of this turbulent priest?" is almost legendary in itself, and led inexorably to the martyrdom of Becket in his own cathedral by four barons anxious for the King's favour. Henry did public penance for Becket's death, and soon miracles were being reported at his tomb. He was canonised in 1173, just three years later. Clearly Thomas was as effective a saint as he had been Chancellor and Archbishop.

Dressed like a beggar

In Wiltshire folklore Thomas appears several times. He is said to have consecrated the great altar-stone in Longbridge Deverill church, and to have cut into it five consecration crosses which can still be seen, one at each corner and one in the centre of the stone. The nearby village of Crockerton also has its Becket tradition. Crockerton Revel, the great summer feast, was always held on the first Sunday after the Feast of the Translation of St Thomas of Canterbury. The tradition goes that every year the saint would come, dressed like a gentleman, to Crockerton Revel, and leave through Sowley (Southleigh) woods dressed like a beggar, because he had spent all his money at the Revel.

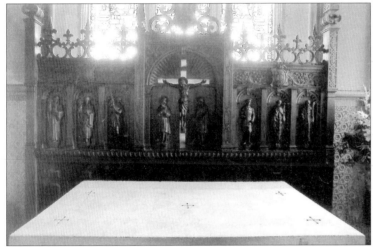

Thomas Becket's altar stone at Longbridge Deverill.

Perhaps he travelled part of the way on Thomas Becket's path, of which John Aubrey writes. This seems to have lain somewhere between Winterbourne Earls and Clarendon Palace, around the SU175325 area, and could be seen to the right of the road which is now the A30. In his usual way, Aubrey seeks a scientific explanation for the phenomenon.

> In the common field of Winterbourn ... is the celebrated path called St Thomas Becket's path. It leads from the village up to Clarendon Parke. Whether this field be sown or lies fallow, the path is visible to one that lookes on it from the hill, and it is wonderfull. But I can add yet farther the testimonies of two that I very well know (one of them my servant, and of an excellent sight) that will attest that, riding in the rode from London one morning in a great snow, they did see this path visible on the snow. St Thomas Becket, they say, was sometime a curé priest at

Winterbourn, and did use to goe along this path up to a chapell in Clarendon Parke, to say masse, and very likely 'tis true: but I have a conceit that this path is caused by a warme subterraneous steame from a long crack in the earth, which may cause snow to dissolve sooner there than elsewhere: and consequently gives the dissolving snow a darker colour, just as wee see the difference of whites in damask linnen.

Around the same time, on Sunday 5th June 1687, James Yonge also saw the same feature, and noted down the experience in his journal.

Two or three miles out of Salisbury [en route to Basingstoke via Stockbridge] on the beginning of a high down I saw plainly that which they call Thomas a Becket's walk. There was corn in the fields of the right hand, and this walk discovered itself by a darkish colour in the corn (which was then well grown) and lasted from the side of the down about a mile over the valley. It seems an exentrick line, like a path, and they say Thomas a Becket had a solitary abode on the top of these downs and used to walk over this ground to a house for his subsistence and meditate by the way. It's certain that whatever sort of corn or grass grows on that place – it's of another colour different from the rest and may be discerned some miles off.

Both accounts suggest that what Aubrey and Yonge saw was not a path, but a crop-mark showing where some archaeological feature lies beneath the soil. Here the soil for crops is shallower, with less water available, and the plants grow less well. When the weather is dry, the grass parches here sooner than elsewhere, leaving 'parch-marks' which show up well in aerial photographs. Aubrey was on the right track (so to speak) when he sought an explanation that was based on a subterranean cause for the phenomenon.

Blood of the Blessed Thomas

Ella Noyes records the most elegant piece of folklore about Thomas Becket. In her book *Salisbury Plain* she writes

A certain boy of Salisbury – which was then still situated upon the hill now called Old Sarum – set forth one day on foot to go to Marlborough. After he was gone several miles he saw suddenly before him three men of very tall stature, dressed in white garments like hermits. The middle one, who was the tallest of the three, carried a vessel full of

blood. The boy's hair stood up on his head with terror, for he supposed them to be murderers, and the place where they were was in the midst of the great Plain, far from any habitation of men. But the leader of them spoke kindly to him, and seeing how reverend he was in aspect and in speech, the boy was no longer afraid, but boldly asked him what that was which he carried. He answered, 'The blood of the Blessed Thomas of Canterbury', and bade the boy return home immediately and relate what he had seen to the Canons of Sarum, warning him not to look behind him before he had got two hundred yards away. The boy obeyed, and when he had gone the appointed distance he looked back, but there was no man to be seen in all the wide expanse around.

This tale has several elements commonly found in folk tales and legends. The number three, and multiples of three, turn up again and again: here we find three mysterious men out upon the Plain. Their height shows something of their importance: in legend folk heroes are very often of great stature, and the greatest in time become giants. The vessel full of blood recalls the Holy Grail of the Arthurian legends, which was the cup that caught the blood of Christ as he died upon the cross. Here in reverent parallel it holds the blood of a holy martyr. Finally the boy is exhorted not to look back as he leaves: we find this condition again and again in myth and legend. When Orpheus goes to Hades to find his wife Euridice, he is told that she may follow him back to the world, but that he must not look back. Less obedient than the boy in this tale, Orpheus glances back over his shoulder, only to see his wife sinking back into the underworld.

Holy wells

Holy wells and sacred springs are a passion of mine, and so you will find details of several such wells in the pages that follow. A holy well is a source of water, usually a spring, or simple dipping well, which has some reputation for holiness. Often we find the well is dedicated to a saint, or has healing qualities. We find holy wells in large numbers in the Celtic areas, in Cornwall, Wales and Ireland, but they are to be found all over England too, often sadly neglected and undervalued.

A reverence for water is found all over the world, and goes back to pre-Christian times, when rivers had river-gods and springs were inhabited by nymphs or guardian spirits. It is likely that pagans then, as now, regarded all springs as sacred places. We know that when St Augustine was directed by the Pope to convert the pagan English at the start of the 7th century AD,

he was told to convert the 'pagan temples' to Christian use. It is likely that such temples in England took the form of natural features like stones, trees and wells as well as stone and wooden shrines. Some of the wells may have been consecrated to saints at this stage – we do not really know as no written records survive – but we do know that chronologically the earliest form of well name was the simple *halig welle*, meaning 'holy well'. This casts some doubt on the popular theory that pagan sacred springs were specifically rededicated to a Christian saint, with little effect for the local populace that revered the spring other than the guardian spirit's change of name. Whatever the truth of the matter, we can say definitely that a reverence for springs and wells was and is common to Pagans and Christians alike, and at some stage in the Christian period, many wells acquired the patronage of a particular saint. I have a theory that every parish once had its holy well, but we have lost or forgotten many of them over the years. Those that remain are seldom treated with the respect they deserve.

Becket's well

A spring near the Church of St Thomas a Becket at Box was known as Becket's well. The area near the church in Box is well established as an ancient site of sacred springs: in Roman times there was a villa here and perhaps more in the way of temples based upon the many springs which rise along the escarpment. Certainly the pond in the garden of the house below the church contains fragments of tessellated pavement, and an archaeologist who assisted with excavations here in the 1960s believes that the whole area around the church was part of a significant villa complex.

The well sacred to St Thomas Becket was to be found near the church, and the Box church guide notes that on July 7th a service would be held in church followed by a procession first to the holy well of St Thomas and then via the By Brook back to the church. As recently as 1780 the churchwardens' accounts note that they paid 3s 0d 'for mending Becket's Well', but by 1953 Pafford was unable to identify the well with any certainty. It seems to me that the spring in the garden of the house called Springfield, which abuts the churchyard, is the most likely candidate of all those around for the role of Becket's Well. The spring feeds a dipping well by the church gate, and in 1996 a local inhabitant told me that it used to be the water supply for all the cottages in that part of Box. Above the dipping well, the spring flows into a large shallow pool in the garden of Springfield, and this seems to be a bathing pool similar to those at holy wells in Wales. When I saw the well in 1996 the pool was heavily disguised as a garden water feature.

Of course without proper excavation no categorical statements as to antiquity can be made, but what I saw seemed with its shallow rectangular shape and firm stone-clad margins to be very much in the nature of a bathing pool. If this is indeed Becket's Well – and it seems a very strong candidate – it is unique in Wiltshire holy wells in having a pool of this type. Bathing pools are needed where the waters of a spring have healing properties, and we can infer that Becket's Well was once a healing spring of some status.

The well is on private ground in the garden of Springfield, but a fairly good view can be had from the east side of the churchyard which adjoins the garden.

St Aldhelm

Aldhelm was a remarkable man of his time. He was a relation of the King of the West Saxons, and was educated first at Malmesbury and then at Canterbury where he became a Benedictine monk. He returned to Malmesbury and in about 675 AD became Abbot there. He was concerned to improve the standard of education in Wessex, and founded several monasteries, including the one at Bradford-on-Avon where tradition says that he also built the little Saxon church. When the diocese of Wessex was divided in two he was appointed first Bishop of the western half, and established his see at Sherborne. He was apparently an unorthodox preacher, keeping his listeners' attention with clowning and songs. He loved language and books, and wrote many songs and hymns to help the poor and illiterate people of his diocese understand the message of the gospels. He died in 709 AD while visiting Doulting in Somerset. Doulting has its own well of Saint Aldhelm, which, like Becket's well in Box, has a fine wide bathing pool. The great abbey church at Malmesbury housed his shrine.

Aldhelm's treasure

St Aldhelm is quite a significant figure in Wiltshire folklore. John Aubrey tells us "The old tradition is that St Aldelm, Abbot of Malmesbury, riding over the ground at Hazelbury, did throw down his glove, and bade them dig there, and they should find great treasure, meaning the quarre [quarry]." In other words, it was St Aldhelm who discovered the great Box Ground Stone beds, whose stone was used in the building of the Abbey at Malmesbury. Aubrey also tells us that "There was a great bell at Malmesbury Abbey, which they called St Adelm's bell, which was accounted a telesman, and to have great power, when it was rang, to drive away the thunder and lightning."

The Bishop's tree

Aldhelm is responsible for the naming of Bishopstrow, near Warminster. The name means Bishop's Tree, and the story of its naming comes from the life of St Aldhelm related by William of Malmesbury.

> There is a village in a valley to which he is said to have come to fulfil his desire of preaching. (They say) that while he was discoursing to the people he had by chance fixed in the earth the ashen staff upon which he was wont to lean; the staff in the meantime, by the power of God, grew up to a wonderful size, enlivened with sap, clothed with bark, putting forth tender leaves and beautiful boughs. The Bishop, who was intent upon the Word, being admonished by the shouts of the people, looked behind him, and having adored the miracle of God, left the staff there as a gift. From the stock of the first tree many ash trees sprang, so that, as I have said, that village is commonly called Ad Episcopi Arbores - Bishop's Tree.

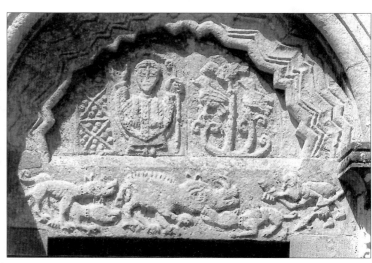

St Aldhelm preaching at Bishopstrow? Tympanum at Little Langford.

When Aldhelm left the village the Bishop's Tree remained as evidence of the great miracle, and now we have only the place-name to remind us of the power of Aldhelm's preaching.

The Maid and the Maggot

This tale may be depicted on the naive Romanesque tympanum over the door of Little Langford church. Here a figure holding a staff raises his hand in a gesture of blessing, while to the right stands a stylised leafy tree

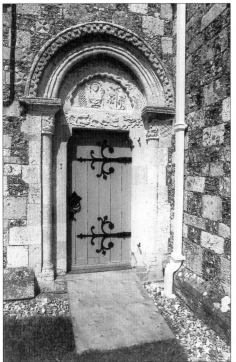

Aldhelm and staff, or maid with maggot?

with three birds in the branches. Perhaps what we see here is Aldhelm planting the staff, and then the staff grown into a tree sometime later. But it has to be said that the local interpretation of the tympanum has nothing to do with St Aldhelm, for as Noyes tells us, it is locally known as 'The maid and the maggot'. A young maid went nutting (always a dangerous occupation in folklore: you are very likely to meet the Devil out nutting[1]) in Grovely Woods, and in one nut she found a maggot that she kept and fed. The maggot grew hugely until it turned on its keeper and bit her so badly that she died. The bishop in his robes is identified as the maid, and the canopy over the bishop is supposed to be the maggot. Below the tympanum is a lively hunting scene with dogs and a boar, and this is supposed to show how a beast ate the maid and was then hunted to its death. Clearly the legend is designed to explain the stylised figures upon the tympanum, but the tale of a dragon-like creature (worm) that is found and nurtured by unsuspecting human beings is common in folklore. We find it in many locations: one of the best-known is at Bamburgh Castle in Northumbria where the Laidly Worm, a beautiful princess under enchantment, grew into a destructive dragon until she was freed from her enchantment by the Childe of Wynde, the son of the King.

St Aldhelm's Well

Like St Thomas of Canterbury, St Aldhelm had his holy well, in the ancient hilltop town of Malmesbury. Malmesbury is full of wells of all kinds. Many are shaft-wells dating from the mediaeval period or later. Almost every household has its well, and these all seem to be about 30-40 feet deep. At the bottom of the wells the fresh water is constantly active, bubbling up from the water table far below.

But much older than these mediaeval wells is the small and secret spring known as St Aldhelm's well. It lies in a small alcove set into the wall of a private house in the town, and so is not open to public view in any way. The stone-built house encloses the well on three sides, and overhead is a huge flat stone, like a sarsen stone, which perhaps has been associated with the well from long before the house was built around it. Water trickles from a pipe into a small pool, gravel-bottomed with one step down, and then runs away under the garden. Nobody is certain where the water comes from or where it goes. Around the well grows a delicate green plant that seems to be *helxine* or something very similar.

It is in this well that St Aldhelm is supposed to have "bathed in all weathers". Indeed one source describes the saint as "a veritable apostle of the cold tub". The well must have changed drastically in appearance and structure since Aldhelm's time, for there is no room to bathe more than your feet in it nowadays. But back in the 7th century AD this would have been an open spring on the hillside, ideal for bathing – or for mortifying the flesh for the good of the soul, which is the usual reason offered in folklore to explain why saints bathe in holy wells. Those who look for old gods hidden behind the saints associated with wells will suspect that these old tales of bathing in wells recall the naiad or water-spirit of pagan tradition that inhabited the sacred spring.

St Peter the Apostle

The major saints of the Christian church are also fairly well represented in Wiltshire folklore – but as we will see they are remembered rather for magical attributes than for their historical nature. We will begin with the gatekeeper of paradise, St Peter, and the one quite modern legend that I have collected about a saint.

Simon Peter, the leader of Christ's Apostles, is well known to us from the Gospels, and will need little introduction to many readers. Christ told him that as well as being the rock on which his church would be built, he would personally be given "the keys of the kingdom of heaven". So it is that Peter is typically depicted holding a key, and is generally associated with portals and gates.

St Peter at Heaven's Gate

In 1997 a Bratton resident told me a tale she had heard 30 years previously from a Brixton Deverill man: -

There is a tradition of a great treasure and golden gates being buried in a tunnel at Heaven's Gate. St Peter was supposed to have brought the golden gates, that's why it's called Heaven's Gate. People went searching up there with metal detectors once, and the detectors picked up something. And the tunnel was supposed to go from Heaven's Gate to some other old house in the area. There were mediaeval tunnels for the monks [from Longleat] to use because it was dangerous to take all their treasures – gold and jewels – from one church to the other, because of robbers. So they built these secret tunnels to take their treasure from one place to another. He [the informant] was quite convinced about this. He said the tunnels went miles and that there's one connecting Salisbury and Winchester and another one going from Winchester to Glastonbury. 'If the tunnels are all that long', I said, 'how could they make all them bricks?' They had enough trouble building Box tunnel, didn't they? Well, when you think about it it's pretty well impossible for it to be true. I suppose it's just folklore; it's part of our heritage really, isn't it?

Clearly this is a piece of folklore devised to explain why Heaven's Gate (ST824425) is so called – it must have been because St Peter, the Gatekeeper, brought the gates of heaven and hid them there. Yet another tradition associates Heaven's Gate with Bishop Ken, the Bishop of Bath and Wells who refused to take the oath of allegiance to William and Mary. He was given a home at Longleat by the Marquis of the time, and he lived there until his death in 1711. Bishop Ken is said to have composed some of his sacred songs on the beautiful hill overlooking Longleat House, and to have named it Heaven's Gate himself. So it seems fairly safe to say that this folklore has grown up since the latter half of the 17th century, but in the 20th century it has acquired a modern gloss with the element about metal detectors.

Built into this legend we have the very common motif of tunnels, which if all the legends are to be believed, criss-cross the entire country and must be undermining the foundations of many ancient buildings. There seems to have been no serious study made of tunnel-lore, but Jacqueline Simpson comments "there are great numbers of these, so many that it would be impossible to list them... The situation is confused by the occasional discovery of real short tunnels, or at any rate recesses, leading from old cellars and crypts, which may possibly have been once used as smugglers' hides. But the great majority of the legendary tunnels are quite impossibly long, and they can only be fictitious." I have heard it suggested that where old tunnels stretch over long distances, they may be indications of leys,

those long alignments of ancient (and more modern) sites which have been identified all over the country, and which are believed by some people to have been deliberately laid out by our ancestors.

St Peter's well

St Peter probably had a holy well somewhere in Wiltshire, as the place-name, *Petreswell*, dating from 1279, suggests. Unfortunately we don't know where this well was. What is certain is that it is not referring to St Peter's Pump, the large mediaeval cross-like structure on the Stourhead estate in Six Wells Bottom (ST761354). This covers one of the sources of the river Stour, and was removed from St Peter's street in Bristol in 1755. To add to the confusion, in Bristol the cross stood over the well of St Edith, not St Peter, but a pump nearby was named St Peter's Pump, and it is this name which has travelled from Bristol with the cross. Six Wells Bottom is also linked in legend with King Alfred, but this tale will be told in a later chapter.

St Catherine of Alexandria

The cult of St Catherine was very widespread indeed in England. She is rather a shadowy character historically, but is supposed to have lived in the 4th century AD. Her cult grew up in the 9th century, and her mythical legend identifies her as a noble young woman, persecuted for her Christianity. She protested at the persecution of Alexandrian Christians by the Emperor Maxentius, and as a result was martyred by first being tortured on a wheel, and then, when that broke injuring bystanders, she was beheaded. She is customarily depicted with her attribute of the Catherine wheel, and it is this that has led to some identifying her as a later incarnation of the Roman goddess Fortuna with her ever-turning wheel.

Fortune's wheel

At St. Mary's church at Marlborough, we find set into the west interior wall a carving that is a defaced Romano-British bas-relief of the goddess Fortuna with her wheel. Fortuna was a goddess particularly favoured by soldiers, who had more need than most of good fortune to preserve their lives in battle, and it is likely that she came to Marlborough from the Roman settlement of Cunetio (Mildenhall), which lay upon the major Roman road connecting Winchester to Cirencester. This Fortuna has been much defaced, so that her upper body and head can barely be discerned, but her wheel is clearly visible behind her lower body. She was probably vandalised in the 16th century by some Protestant reformer who thought she was a statue of

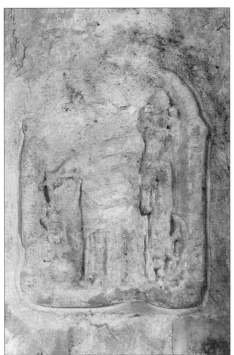

Much-abused Fortuna with her wheel.

Saint Catherine of Alexandria. But there can be no argument: this is a Romano-British sculpture, and the goddess Fortuna is placed in a most unlikely position high in the interior of a Christian church.

Katern's well

There are two Wiltshire wells that seem likely to have been sacred to St Catherine. The first is in Compton Chamberlayne. C. Penruddocke wrote to C.V. Goddard around the year 1940: "Katern's well in the Park here is an almost inexhaustible spring, rather ferruginous in character, and supplies water night and day to my large triple action force pumps". Cattern is a contraction of Catherine commonly found in folklore. Her feast day, November 25th, was known as Cattern Day, and the traditional food

Katern's well rises in the Park near Compton Chamberlayne church

on that day was Cattern Cakes. So it is almost certain that Katern's well was once the holy well of St Catherine.

Cat's Well

Cat's Well, in Bratton, (ST917522) is the second of the wells sacred to St Catherine. She is also remembered locally in the dedication of Edington Priory Church, which is sacred to Our Lady, St Katharine and All Saints. Indeed, the well lies beside the road which leads through Imber past Our Lady's Well at the Stone Cross (now Ladywell barn on Salisbury Plain), Cat's Well and Edington's Ladywell on its way to Edington Priory. The names of these three wells clearly echo the Priory Church's dedication, and it may be that this route was once a pilgrims' way across the Plain to the Priory, visiting holy wells carefully chosen for the refreshment of travellers.

This simple dipping well was lost for many years, and has been rediscovered and restored fairly recently through the efforts of a tireless local historian, Jean Morrison. It is a rectangular well constructed of stone, with two steps leading down to standing water. More water trickles from a pipe into the well, but the flow is very slight and the water is doubtless brackish and unfit to drink - unlike some of the other excellent springs in this area. A new railing has been set around the well, and a plaque on it reads *Mediaeval well of St Catherine's*. This should ensure that the well should not sink back into obscurity for the foreseeable future.

Cat's Well beneath its hazel trees

St Michael the Archangel

"I remember my honoured friend Sir W. Dugdale, told me his Remarque, viz. That most churches dedicated to St Michael, either stood on high ground, or els had a very high Tower, or Steeple, as at St Michaels church in

Cornhill…" writes John Aubrey in the 17th century, noting a phenomenon of which much has been made in recent years. In the Book of Revelation Michael is the chief of the angelic warriors in the hosts of heaven in the great battle against the Devil, and a contemporary folklorist has identified him as "the natural saint to oppose the Devil in high places". Those who are enthusiastic to identify direct translations of pagan gods to Christian saints have discerned in Michael the Roman god Mercury or the Celtic God Lugh, making of him a Christianisation of a pagan deity. It is known that his cult arose in Italy as late as the 5th century AD, and it spread to France and England only during the 7th century. He is therefore quite a late import into the ranks of popular saints in the British Isles, and there is nothing particularly Celtic about his cult. But some of the evidence for his association with Mercury and Lugh is persuasive. What is most likely is that shreds of pagan cults have been combined with the biblical character to create a new and separate figure that formed the focus of the Christian cult.

St Michael's Well

The hilltop town of Malmesbury had a chapel sacred to St Michael close to the Abbey. In 1542 the chapel was still standing south of the abbey transept, near the place where the house called St Michael's still stands. Near the chapel was the second of Malmesbury's holy wells, the well of St Michael. There is nothing to be seen of the well now, as it is buried under the road in front of St Michael's. John Bowen of Malmesbury, who comes of a family of dowsers, was able to show me the well's location, and introduced me to the interesting concept of dowsing with my feet. Soon I too could tell where the well was, because my left foot tingled significantly when I stood over it.

Michael and Mary currents

There is a whole body of current belief about Michael churches, of which probably the best-known example is the Michael line. This is asserted to be a ley-line[2], which crosses the country in a straight line from St Michael's Mount in Cornwall to the North Sea near Lowestoft in East Anglia, passing through or close to many St Michael sites on the way. The existence and validity of the very long Michael line is disputed by some ley researchers, notably Danny Sullivan who has written the most recent history of leys and ley-hunting.

In 1990 Hamish Miller and Paul Broadhurst published their account of how they dowsed the Michael line, and identified two 'dragon currents' that are twined about it. These they named the Michael and Mary currents,

because they passed through many sites dedicated to the two saints. The Michael line crosses Wiltshire, and the Michael current, crossing and re-crossing the line, passes in the process along the axis of St James' church in Trowbridge, and through St George's church in Preshute. Its twin, the Mary current, runs along the axis of St Mary's church, Bishops Cannings, and later through the Swallowhead springs near Silbury Hill. Places where the two currents cross are identified as 'nodes' and supposed to have been locations of power and significance in the distant past. They find two nodes in Wiltshire: a small neglected spring near Bowerhill, Melksham; and the round barrow by Ogbourne St Andrew church which was avoided by local children as recently as 1938, because it was reputed to be "the abode of venomous vipers". The serpent or dragon, in church iconography, is the symbol of the Devil. Pagan gods and powers were labelled devils by the early church, and it is possible that the church at Ogbourne St Andrew was positioned deliberately beside the pagan burial mound. If Miller and Broadhurst are right about their lines of dragon power – and who knows what might be possible? – then the twining serpents of dragon power which criss-cross the Michael line might have contributed to the Church's need to disempower this pagan site.

St Mary the Virgin

The last of our saints is the most popular of all, with the most church dedications across the country, and more holy wells to her name than any

Ogbourne St Andrew church, where Michael & Mary meet.

other. The unique distinction of being mother of the Son of God has made Mary subject to a particularly devout veneration, which has led some to identify her cult as a continuation of the veneration of the ancient mother-goddess. Whatever its origins, the most fervent period of the Marian cult undoubtedly took place during the fourteenth and fifteenth centuries, a time when Christianity was deep-rooted in the social and religious consciousness of the people. Indeed the number of well-shrines which appear during the High Middle Ages dedicated to Our Lady, only reflect the explosion of Mariolatry in that time.

Ladywell lost

In Wiltshire there are many churches, including the great cathedral at Salisbury, which are sacred to Mary mother of Christ, but unlike the other saints we have been considering, Mary lingers otherwise mainly in the holy wells which bear her name. Like other cathedrals in the country, Salisbury had its holy well, now lost, which was south of the cathedral near the equally lost bell-tower. The small house at 33 The Close dates from the 18th or 19th century, and is called Ladywell, recalling the well that stood nearby in the 15th century. We know that the well was still there in 1732, because of complaints made about the state of the water: "the Spring of Water, called the Ladywell arising in the churchyard near to the house there… is foul and stinking and thereby a great nuisance to all persons…" The well probably disappeared during the 19th century when much work was done on the watercourses around the cathedral: a sad and regrettable end for what must once have been a much-revered sacred fountain.

Merry Well

Sadly, this is not the only well sacred to Mary which has disappeared over the years. Merry Well, which Archdeacon Hony described in about 1860 as "a remarkably fine spring which pours forth at all times of the year abundance of pure water" now no longer lies near the Manor in Baverstock. Back in 1485 a small house was built in Baverstock for the Abbess of Wilton, Cecilia Willoughby. It was sited near St Mary's Well, later corrupted to Merry Well, because the spring was found to have healing properties. Like many healing wells, this one cured eye diseases, and pilgrims visited it to wash their sore eyes. Canon Goddard noted around 1940 that the well was still said to be good for bad eyes, and it is only quite recently that it has been lost to us. In August 1997 I received a letter from a parishioner of Baverstock, who told me "There was indeed a MARY'S WELL, and it was

reputed to have therapeutic qualities for eyes. It was mainly used for watering cattle having a windlass-chain-bucket arrangement mounted on a wooden frame. With the advent of piped water it became neglected – and during the late '70s early '80s dismantled and it was filled, as far as I am aware no-one complained... it is now covered by ... the drive [of the Manor]."

Bradford's Ladywell

Happily, not all wells sacred to Our Lady have been destroyed. In Bradford-on-Avon, beside a semi-hidden footpath, we find a charming small well, Ladywell (ST823608), which is also the name of the house which stands on Newtown above it. Canon Jackson noted in 1867 that the well was a major water supply for the town, but by the 1920s the purity of the spring had been polluted by engineering works and seepage from cesspits. Today there is a notice on the wall warning people that the water is not fit to drink.

In 1907 Jones wrote that the whole area in which the well lies is called Ladywell. This may be because the spring breaks through in more than one place – indeed the whole escarpment on that side of the town is full of intermittent springs. On Newtown above Ladywell there is a drinking trough set into the wall, and although this is now dry, at times of heavy rain the spring breaks through the wall nearby and is strong enough to flood the road. Above this whole area stands the little chapel known as St Mary Tory, but I cannot say whether the well was named after the chapel above it, or the chapel after the well below, as there is no written evidence one way or the other. The spring, of course, would predate the chapel, but when it got its present name it is impossible to say.

This is a strong spring, pouring constantly and noisily out of a pipe set into the wall, and it flows via a small grating into a channel where it can be seen between the flagstones running away down to the river below. On the wall beside the well is a charming glazed-earthenware plaque of the Virgin Mary, and tendrils of ivy mingle in summer with geranium and other flowers planted to adorn the well. When I visited the well in 1994 I dropped in a silver coin and made a wish, which came true the next day. Coincidence? Perhaps. There has been evidence during 1999 that others are visiting the well for ritual purposes. Once when I visited I found a small ribbon knotted onto the ivy beside the well. Leaving scraps of rag or ribbon at a well, usually on the trees nearby, is a long-standing tradition with obscure origins. Some see it as a form of offering, or as the final stage of a ritual of healing using the well water. My own feeling is that it may simply be a way of

showing that a visit has been made, rather as hill-walkers will add stones to the cairns they pass along the way. The willow-tree near Swallowhead Springs near Avebury has been turned into a rag-tree. In 1998 there were various bits of rag and ribbon tied to the tree, but also a child's glove and a postcard with a child's drawing of fairies and butterflies fastened to the trunk with a drawing-pin.

The monks' well of Our Lady

The grandest of Wiltshire wells sacred to Mary is at Edington under the edge of Salisbury Plain. Here Ladywell lies tucked close into a wooded fold in the land at the end of a small right-of-way leading down from the B3098 road (ST924530). In springtime this is a really lovely spot, with the well-stream flowing away at the foot of a bank where harts'-tongue ferns, wild arums and celandines grow. The well-house probably dates from the 14th century and is built of dressed stone, with a squared-off doorway out of which flows a vigorous stream. The roof is steeply pitched, much overgrown with ivy, and the simple cell-like building nestles into the slope at right-angles. Inside the well-house the roof is braced with stone struts. The water wells up in the back right-hand corner, pouring out over a natural-looking outcrop of stone some 2-3 feet high. A long stone trough is built against the

left wall, and the water flows into this as well as over the gravely floor and out through the entrance. Old pipes in and above the trough show that the water has long been pumped away from the spring. There is much graffiti scratched on the walls and over the doorway: 'Alf Oram', 'D. Wordley 1948'; '1917' etc. There is also a curious scratch of what looks like a spade handle protruding from a bucket, which perhaps has some earthy fertility significance.

The well stands on land belonging to a local farmer, W.J. Gale, who pumps water from the spring up to the hills on the edge of

Edington's Ladywell in its ferny hollow.

31

Salisbury Plain, to fill his cattle troughs. He told me that no matter what the weather, the force of the water never varies. One of the most common characteristics of holy wells is reliability – that the water supply is unfailing. Many springs are intermittent, flowing only when rainfall is plentiful. In previous centuries an unfailing spring would have been viewed as a gift from God and the tangible assurance of the security of the community. Indeed, it seems to have been only since the mains water supplies reached the villages in the 1930s that our wells have lost their importance. It is worth remembering that during the long hot summers of the mid-1970s, when water was rationed, many reliable wells were rediscovered and used once again. Ben Loring tells us that in 1976 they opened up a well in Keevil which turned out still to be unfailing, "which proved very useful". Ladywell's water has rather a strong, almost metallic taste, but is quite safe to drink – at least, I have never suffered any unpleasant after-effects.

The well does not seem to be generally known in Edington, and those who do know it tend to call it by the name Pevsner uses, Monks' Well. But in Bratton nearby, old residents know it as Ladywell, and confirm its status as a holy well. I was told that there once was a row of cottages on the road above the well, but these were all burned down. Apparently the firemen were all out having a good time and so nobody came to fight the fire – even with such an excellent supply of water nearby.

Talk of the Devil

...and he will appear. So goes the old proverb, and there is no doubt that the more folklore we encounter, the more often the Devil features in it. He is a most invasive character, and we find him all over the county, in sayings, place-names, plant names, at ancient sites, in houses, churches and pubs. The more elaborate tales about him clearly date from fairly recent times, from the 17th century and after, but place-name evidence show that the Devil, and creatures like him, were features of belief certainly from early mediaeval times onward.

The Devil in place-names

When seeking the Devil in place-names, there are various giveaway elements to look out for. *Puck* is one example. This comes from *puca*, which, like the Welsh *pwka* and Irish *phouka*, was a shape-shifting hobgoblin. Shakespeare turns Puck into a genial if mischievous figure, but in Middle English the name Puck was used of the Devil, and it is certainly as a denizen of hell that the early (and later) Church viewed all such goblins and nature spirits. The

similar-sounding *Bug* or *Bugge* is also a bugaboo or hobgoblin. Of more status was *Grim* or *Grimnir* 'the hooded one', for Grim was one of the by-names of the god Woden, and in this case we may be looking directly at one of the old gods who was demonised by the Christian church.

So where in Wiltshire does the Devil linger in place-names? He had a marsh (Bugmore) at Fisherton, and his church (Pucklechurch Field) beside Lyneham church. His pool or well lay in the field called Pucks (in 1232 Puckpole) in Bishopstrow, and he kept his cattle in a shippon or shed at Puckshipton. We find him at other landscape features: pits in fields at Milton Lilbourne (Pugpits), Purton (Quarry Farm was built on the field called Pukpitt) and in Pugpits Copse at Landford south of Whiteparish; and he had a coombe or valley at Poughcombe near Ogbourne St Andrew. His well, Puckwell, lies in Puckwell Coppice at West Knoyle (ST855319). Puckwell spring was very muddy and foul smelling when I visited it in the summer of 1994, and this may be the reason why it retained its association with the Devil.

A mover of stones

The Devil is often used in tales about large stones and other archaeological features to explain how they got there. He is supposed to have constructed various linear ditches around the county. Using only a spoon he dug out Grim's Ditch or the Devil's Dyke near Bishopstone in South Wiltshire. In the Devil's Ditch near Cholderton is a single stone that he dropped as he was on his way to build Stonehenge. You can visit the Devil's Waistcoat, a curiously marked sarsen stone, in a field beside Chute Causeway (SU303552). And of course Wansdyke, or Woden's dyke, the post-Roman frontier structure crossing the Marlborough Downs, was dug out by the Devil in a single night. In this case the Anglo-Saxon god Woden has been quite clearly equated with the Devil.

Devil's Jump

Many of the place-names above may well date from the mediaeval period or earlier. Later place-names are more specific and name the Devil unequivocally, and there is often a tale to explain how the name came about. Beryl Hurley, who lives on the Jump Farm estate, Devizes, told me in 1992 that a very old Devizes man, Ray Smith, had informed her the farm used to be called Devil's Jump Farm, although he gave no reason for this. But on an old postcard from Devizes we find a tale which may well have some bearing on the place-name, although the postcard locates Devil's Jump on Roundway hill. Perhaps Jump Farm is where he landed next.

Many years ago there lived at St Edith's Marsh, Bromham, a blacksmith whom the Devil was very anxious to convert for his purposes. The unfortunate thing was that all his envoys, the devilkins, could not win the blacksmith over. As a last resort the Devil called on the blacksmith at his forge in the shape of a very well-dressed gentleman. The blacksmith recognised him, however, and clapped the red-hot horseshoe he was making onto the heel of the Devil, causing him to jump into the air. Legend says that he landed on Roundway Hill, at the spot still known as Devil's Jump. As a result of this experience the Devil does not like the shape of the horseshoe and will always avoid it. Thus many people nail a horseshoe over the door of their house to keep this evil one away.

This tale appears to be a local variant of the story of St Dunstan seeing off the Devil, first written down around 1120 in Eadmer's *Life of St Dunstan*. In both cases the hero of the tale is a blacksmith, a worker of iron, which is traditionally a powerful charm against evil, and in both cases red-hot iron is used to see off the Prince of Darkness. In each case the blacksmith is canny enough to recognise the Devil in disguise. The tale demonstrates how the blacksmith is a powerful member of the community, with mastery over iron and fire and the power to use both to protect himself and those for whom he works, even to the point of being able to defend himself against the most powerful force for evil in existence. Perhaps what we see on this postcard is one of the last expressions of the traditional reverence for the blacksmith before the horse was replaced in the rural community by a culture based primarily on vehicles and machines.

The Devil's Dairyhouse

Dairyhouse Farm lies right on the edge of current-day Steeple Ashton parish (ST926551), and would never have come to my notice had it not been that I saw the intriguing name *Devil's Dairy House* on the 1773 map of Wiltshire by Andrews & Dury. Greenwood's map of 1820 also shows Devil's Dairy, although the Tithe Map of 1818 blandly calls it Dairyhouse Farm. So was Devil's Dairy a local nickname for the farm, and if so, why? It may be that some dark incident had taken place there in the past of which we know nothing. But I wonder whether the farm's geographical position may explain the name. When I was looking at the Wiltshire Record Office's 'Plan of Dairy House Farm in the Parishes of Steeple Ashton, Tinhead and Edington...' it struck me that at that time the farm straddled the boundaries of three parishes. Boundaries are very powerful places in folklore, and the

place where three boundaries meet is the most powerful of all, and most helpful in working magic. But the Church frowned on magic as the work of the Devil, so a place where it could be worked must belong to the Devil. Could this explain the name? Or perhaps it is simply that the farm is as far as possible away from each of the churches in the parishes – at the most benighted part of the parishes. Whatever the reason, our rural Devil now has a dairy house to go with his Puckshipton cattle pen.

Raising the Devil

Between Bratton and the Plain, near Luccombe springs, stands the Bloodstone. Jean Morrison told me about a local tradition, which says that if you run around the Bloodstone nine times, backwards, holding your breath, the Devil will appear. She also admitted to me that she'd tried it, but had never been able to hold her breath long enough. Doubtless that is all part of the joke... But the tradition nevertheless has the features of a genuine spell for raising a being of power. Circling has long been used in ritual and in magic to raise power, and nine is three time three, a most powerful number. Going backwards may well imply going widdershins,

 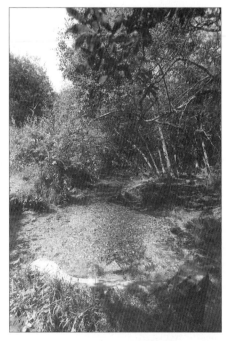

Left: Dare to raise the Devil at the Bloodstone; right: Ritual burials near Luccombe Springs, Bratton.

against the sun, and so suggests attempts to raise a dark power. So perhaps this tradition may recall dark rituals of long ago practised at the stone. Archaeological evidence may perhaps support this hypothesis. Annable writes in 1956 of burials uncovered near the watercress beds at Luccombe springs. Three skeletons were uncovered. They had been buried face downwards and the position of the upper arm bones indicated that at death both arms were bound behind the back. Are we looking at the remains of people sacrificed during rituals at the Bloodstone? Or were they, as local tradition says, some of the Danes who fought against King Alfred at the battle of Ethandun?

Big Belly Oak

Elsewhere in Wiltshire we find a similar spell, this time focussing on a tree. In Savernake Forest, beside the A346 road (SU214658), stands the Big Belly Oak. The tree is so named because of its greatly swollen trunk that gives it a most distinctive appearance. Kathleen Wiltshire records how the young lads of Wootton Rivers used to say that if you run seven times around the

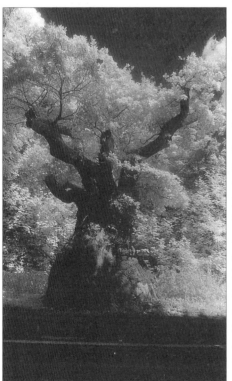

Big Belly Oak at midnight, the Devil would appear. Again, we have a convincing spell: seven is the third of the three very powerful numbers we meet time and again in legends and traditions, and again, circling is the method used to raise power. Those interested in the significance of trees will recognise the long-lived oak as one of the three trees sacred to the Celts: oak, ash and yew. The Druids traditionally revered the oak. To Germanic peoples, including the Anglo-Saxons, the oak was a symbol of Thor, the thunder-god, who struck lightning with his hammer, which may perhaps remind us of blasted oaks - oaks struck by lightning. Field names, such as Holy Oak Close at

The brooding presence of the Big Belly Oak.

Donhead St Mary, date from the times when people beat the bounds of the parish, stopping at set points for readings from the scriptures. We have no way of knowing whether these Oaks were sacred before the Christian parishes were laid out: but what we can say is that the oak continued in importance from pagan times into Christian. In John Aubrey's *Natural History of Wiltshire*, a very useful source of information about the county in the 17th century, he notes "when an oake is felling, before it falles, it gives a kind of shreikes or groanes, that may be heard a mile off, as if it were the genius of the oake lamenting". The idea that the oak is more than just a tree, that it may have some spirit or personality, seems clear enough here. In the case of the powerful Big Belly Oak, that spirit has been powerful enough to be identified with the Devil himself.

Driving out the Devil

Although we may think ourselves too sophisticated these days to have much belief in the Devil as an invasive malevolent personality, one still hears from time to time of people having their houses exorcised. It seems almost unthinkable here on the verge of the 21st century and a new millennium, but sometimes the circumstances are such that people are driven to seek the help of the Church or of powerful mediums to free them from what they perceive as some invasive personality that is dominating their lives and destroying their peace. This was brought home to me as recently as 1999 when I learned that one of my own friends, a most positive woman who enjoys life to the full, had once been exorcised in a (successful) attempt to free her from the unwholesome influence of someone who had come to dominate her life to the detriment of all other aspects of it. If this can still happen in latter half of the 20th century, when the majority of people retain little belief in the Devil, how much more likely such occurrences must have been in earlier times?

Around 1940, Canon Stuart, Vicar of Christ Church, Warminster from 1899-1941, notes how he had "twice had an urgent call on a Sunday night to drive a devil out of a house, and that within the last few years..." Back in 1891, Alfred Williams wrote of an old preacher named Maslin:

> Once when he had been called to see a sick man, and had not been able to make a very deep impression on the unfortunate, he attributed it all to the actual presence of the Evil One. 'I know'd 'a was ther', the old man declared most gravely, 'for I could smell the brimstone; the house was full on't.'

Soul for sale

Elsewhere Williams writes at some length about the old man Mark Titcombe of South Marston, who believed that he had sold his soul to the Devil, and that there was no way to free him from this dark contract.

> I often questioned the old man to know how the bargain was conducted, but he would never tell me that; he simply declared that he 'selled himself to Old Nick out in Maaster Pingedar's (Pinnegar's) ground, by the canal yander', when he was a young fellow. Oftentimes I tried to correct him from the error, and taught him to pray, and to think of Christ, Who came to save the world from sin, but he always burst out in piteous tears, sobbing like a child, and saying: ' 'Tis all right for t'other people, but nat vor I. Chent no good vor I. Old Nick got I right anough. He's allus along wi' ma, a waitin' vor ma, a swerin' and blerin' against God A'mighty; he won never let ma aloan no more'. And this delusion he continued in right up to the end, for, though many came to see him, clergy and others, and prayed no end of times, it made no difference; he was fully persuaded that he was bound to the Evil One, nothing could shake his belief in that.

Shameful behaviour on Good Friday

It seems too that it was only too easy to sell your soul to the Devil: you only had to persist in a sacrilegious act on a holy day, for example, washing clothes or collecting firewood on Good Friday.

> I have heard an old woman repeat a story, told by her mother, of a young woman she knew who 'went a-washing on a Good Friday. As she were about it, up comes a gentleman, and he asks the way somewhers, most pleasant like'. While he stands talking, the woman chances to look at his feet, and discovers that he has a cloven foot; so she answers him very shortly, and refuses the money he offers her. Whereupon the gentleman, who, of course, is the Devil, walks away, and the woman, in a fright, puts aside her washing. A somewhat similar story was told me by a servant, of a girl picking up sticks on that day, who unwisely listened to the voice of this same charmer, and taking his money, discovered too late that she had sold her soul to the Evil One.

Clearly here the Devil is being used as a bogey-man to frighten people into keeping Sundays and other holy days.

Devil take the Royalists!

Similarly, the Devil is used to demonstrate the irreligious attitude of Royalist soldiers in Salisbury during the Civil War. It is told how some soldiers were having a long drinking session at the Catherine Wheel inn in Milford Street. They had toasted the Royal family and all the Royalist generals and officers, the landlord, his wife, and all their own wives and families. They were just about to start again from the beginning of the list when one fellow remembered one personage they had not toasted, and proposed that they drink to the Devil. One of the troopers declined this toast, saying he could not drink to someone who did not exist. At this point a blue haze filled the room, then a cloud of sulphurous smoke, and the Devil himself appeared, snatched up the soldier who had proposed the toast and, roaring furiously, disappeared out of the window.

The Huntsman rides

The tale above is a fairly standard morality tale featuring the Devil, but occasionally he appears in a more ancient light, where his antecedents the old gods of woodland and chase dominate his character. Such tales are those which feature oaths taken while hunting, and show the Devil in his character as Huntsman, lord of the Wild Hunt. Tales of a hunt made up of ghostly or demonic characters have been absorbed into local folklore all over the country, and the huntsman can be not only the Devil himself, or an old god like Woden, but also a local hero or villain like Wild Edric in Shropshire, Sir Francis Drake on Exmoor, or Wiltshire's Sir Henry Coker. In all the tales, the hunt rackets endlessly across the sky or land, and those who meet the huntsman rarely escape unscathed.

In the following tale Squire Parker of Lus Hill takes a dreadful oath. The Squire was a great hunter, but he and his cronies were unable to catch a certain stag that would appear again and again, always escaping the hounds no matter how fast they ran. Finally the Squire took an oath that on the next day he would hunt the stag again and not rest until he had taken its antlers. They hunted all the next day, without success, and one by one the hunters gave up the chase until at sunset only the Squire and another strange horseman were left. They crossed the Thames and finally caught up with the stag at Lus Hill, where the Squire at last seized it by its antlers. At that moment there was a blinding flash of light, and both stag and his unknown companion vanished in a sheet of flame. But the Squire still held the antlers, and this is how he was found next morning on his own lawn, whether alive or dead the tale does not say. But it does say that neither the stag nor the strange horseman had left any tracks to show where they went, and nothing was ever seen of either after that day.

The Devil disguised

Occasionally the Devil chooses to appear in the form of a bird or beast. These are often black, like the crow that was the familiar of Joe the Marine in Blunsdon. Joe was a 'wise man', a clairvoyant who could tell where people could find the things they had mislaid. People said that Joe had dealings with the Devil, who often appeared in the form of a black crow that would perch on his chair-back in the firelight. We can easily understand how a pet crow could appear very sinister to already over-awed visitors, and how it could be a useful prop for someone who wanted to give the impression that he was a man of arcane powers.

Yet elsewhere the Devil or one of his minions has chosen to appear simply to terrify passers-by. The apparition encountered on Lords' Hill, Hindon, was an awesome but indeterminate figure, and all the more terrifying because of it.

> And did 'ee ever zee anythin? No, nothen wussern mysel. But what wer it as your vayther zeed? Aw, thur, vayther told I as how a wur drivin his ould measter to Hindon one night, an' zummat hung on to the coach behin'. 'Drive on Jim as hard as ee can', zays 'ee, and zummat come out and they never zeed the goin 'ont, an' the hosses ran wi' zweat when they got into Hindon. Aw, an' ther wer a Deverill man a courtin out t' Hindon, an' a walked whoam down Lard's Hill, an a' zeed zummat, an' a said 'Ef thou be the Devil appear bodily'. 'An a zeed zummat as had girt eyes zo big as a tea saucer, an' a didn know how a got whoam, an' the sweat poured down un like rain, an' every single hair o' his yead did stan' on end. An' a never zeed the goin ont.

Blame the Devil

It seems as though that the Devil was not universally feared. The final tale in this chapter shows how, if you treat him right, he will leave you to get a good night's sleep.

Around the time when the railway first came to Newton Tony, a fellow who was 'something of a character' shared a room in his mother's house with the lodger. The two men each had their own bed, and one night after the lodger had long since retired to bed, the son came home after a long session at the pub, took off his boots, and stumbled hazily upstairs to bed. Not long after he got into bed he fell out noisily onto the floor, and after he climbed back into bed it was not long until it happened again. The long-suffering lodger was well awake by this time, and was puzzled to hear his

room-mate potter unsteadily off downstairs. When the son blundered cheerily back into the bedroom, the lodger saw him place a glass of water carefully under his bed. 'Why, what be'st up to, thee gurt fool?' shouted the lodger, enraged by this performance.

'Well', says the son, 'It's like this. The Devil's in my bed. He knows I've had a good many drinks to-night, and he's jealous 'cos I didn't bring him one; and that's why he keeps tipping the bed up and me out. P'raps he'll bide quiet now.' And sure enough, he did. The son got into bed and was allowed to lie in peace.

References
Claim that Devil = old god: Whitlock (1979), p.16.
Histories of individual saints: these are all taken from Farmer (1992).
St Thomas Becket at Longbridge Deverill: Myatt (1982), p.105.
St Thomas Becket at Crockerton Revel: Noyes (1913), p.178.
Thomas a Beckett's Walk: Aubrey (1969), p.37; Yonge (1963), p. 198.
The blood of St Thomas of Canterbury: Noyes (1913), p.3.
Holy wells: for all kinds of further reading on holy wells, visit the *Holy Wells Web* at *http:// www.bath.ac.uk/~liskmj/holywell.htm*
Pagan sacred sites were deliberately Christianised: see, for example, Morris (1989), p.60; p.70.
Chronology of holy well names: Harte (2000), *http://www.bath.ac.uk/lispring/journal/issue1/research/ jharhpl4.htm*
Becket's Well: Mellor (1935-7), p.347-9; Pafford (1953-4), p.9.
Villa complex at Box: Alison Borthwick, *pers. comm.*, Box, 1999.
St Aldhelm found Box Stone: Aubrey (1969), p.42.
St Aldhelm's bell: Aubrey (1969), p.76
Bishop's Tree: quotation from William of Malmesbury taken from Noyes (1913), p.188.
The Maid & the Maggot: Noyes (1913), p.217-8.
The Laidly Worm: Westwood (1986), pp.325-6.
Wells of Malmesbury: John Bowen, *pers. comm.*, Malmesbury, 1997.
St Aldhelm's well: Gomme (1901), p.170; GWR (1908), p.80.
St Peter & Heaven's Gate: MM, *pers. comm.*, Bratton Historical Society, 1997.
Bishop Ken named Heaven's Gate: Farquharson (1882), pp.24-5.
Tunnels in folklore: Simpson (1973), p.26.
St Peter's well: Gover (1939), p.450.
St Peter's Pump: Walters (1928), p.147.
Fortuna at Marlborough: Parker (1993), p.157.
Katern's well: Goddard (1942-4), p.33
Cat's well: Jean Morrison, *pers. comm.*, Bratton, 1994
St Michael associated with high places, cult, pagan origins etc.: Aubrey (1972), p.150; Westwood 1986, p.185; Hutton 1993, p.286; Morris (1989), pp.52-6
Ley lines: you can get an understanding of how ley theory has developed over the years from Watkins (1974), Devereux (1979) and Sullivan (1999).
Michael & Mary currents: Devereux (1979), pp.36-7; Miller (1992), throughout.
Ogbourne St Andrew barrow and snakes: Goddard (1942-4), p.31
Cult of Mary: for a fine overview read Warner (1976).
Growth in number of Holy Wells of Our Lady: Rattue (1995), p.73
Ladywell, Salisbury Cathedral: RCHME (1993), p.145; Ladywell House Appeal (n.d.), p.1-2.

Merry well, Baverstoke: Wilkinson (c.1860), manuscript return for Baverstoke; Goddard (n.d.), p.114; Goddard 1942-4, p.34; Saumarez Smith (1984), p.22; D.A. Mills, *pers. comm.*, Dinton, 1997.
Ladywell, Bradford: Jackson (1867), p.262; Jones (1907), pp.37-8; Jones (1922), p.29.
Ladywell (Edington)'s architecture: Pevsner (1975), p.239.
Ladywell (Edington) never fails: W.J.Gale, *pers. comm.*, Bratton Historical Society, 1995.
Ladywell (Edington) is a holy well: Jean Morrison & Kathleen White, *pers. comms.*, Bratton Historical Society, 1995.
Keevil well still unfailing: Loring (1983), p.29
Cottages near Ladywell burned down: Kathleen White, *pers. comm.*, Bratton Historical Society, 1995.
Puck as a name for the Devil: Briggs (1977b), pp.326, 336-7.
Bug/bugge: Briggs (1977b), p.52.
Grim/Grimnir: Briggs (1977b), p.205-6.
Devil/goblin place-names in Wiltshire: all derivations taken from Gover (1939)
Devil and archaeological features: Burl (1999), p.118, Noyes (1913), p.152, and Olivier (1932), p.75. For more on the folklore of archaeology in Wiltshire see Jordan (1990).
Devil's Jump Farm: Beryl Hurley, *pers. comm.*, Devizes, 1992.
Devil's Jump legend: Davis (1965), p.224.
St Dunstan and the Devil: Simpson (1973), pp.63-4.
Devil's Dairyhouse: Andrews (1773), sheet no. 7; Greenwood (1820), p.124; WRO 130.8.
Power where three boundaries meet: Brown (1966), p.124; Opie (1992), p.298.
Bloodstone: Jean Morrison, *pers. comm*, Bratton, 1993; MM, *pers. comm.*, Bratton, 1997.
Danes buried near Bloodstone: Kathleen White, *pers. comm.*, Bratton, 2000.
Circling to raise power: Valiente (1973), p.77.
Burials near Luccombe Springs: Annable (1956), p.190.
Devil at Big Belly Oak: Wiltshire (1973), p.26.
Oak screams when felled: Aubrey (1969), p.53.
Driving out the Devil: Moonrake (1942-4a), p.286; Williams (1981), p.81.
Soul for sale: Williams (1981), p.97.
Shameful behaviour on Good Friday: Clark (1893-5), p.35.
Devil take the Royalists: Coleman (1952), pp.8-9.
The Huntsman & Wild Hunt: Briggs (1977b), p.437.
Squire Parker of Lus Hill: Williams (1922), p.205.
Devil in shape of a crow: Williams (1922), p.249.
Lords' Hill apparition: Goddard (1942-4), p.28-9.
Blame the Devil: Olivier (1932), pp.76-7.

Notes
[1] This is because 'going nutting' was a euphemism for making love – which must cast an entirely different light on the meaning of the apparently innocent nursery rhyme 'I had a little nut tree'.
[2] What exactly are ley-lines? Theories include: lines of earth energy, spirit paths, corpse ways, or the traditional Old Straight Track.

Chapter 2

Mother Church

Heart of the community

The archetypal country parish church has been for centuries the heart of the community it serves. Almost always the oldest building in the parish, it has been the focus of community life for much of that community's existence. Even today, when so many of us have moved away from the Christian Church as focus of our spirituality, the church still occupies a key place in the social life of any village. In earlier centuries the church was far more than this: it was the religious, social, and charitable hub of the community, and the lives of everyone in that community were bound up in the life of their church, from birth to the grave and beyond.

Small wonder, then, that so much folklore and legend can be found in and near churches. Remnants of paganism lurk in and around the building itself, and many of these take the form of carvings and paintings. I only have space to touch on a few of these, so I shall be considering only the most striking, or those that are particularly significant in Pagan belief today. Tales are told about the founding of some of our older churches, and the Devil and dark curses both make their appearance. Historical characters and events are remembered in relation to some carving or piece of church furniture. Chief among Wiltshire's churches is the great cathedral of Salisbury, which has its own suite of folklore and legends of many kinds. Ghosts linger in the shadows between the gravestones or move among the pillars in the buildings, and are not driven off by the sound of the church bells that ring to turn away evil, or to guide benighted travellers to a safe haven.

The pagan past, and present

When set against the long period of Wiltshire's pagan prehistory, it has to be recognised that Christianity is a relative newcomer to the county. Before the first missionaries to the Celts arrived in Britannia, pagan goddesses and

gods were worshipped here. They dwelled in the land itself, in the forest trees, in the springs of fresh water welling up from the earth, and in the stones that lay scattered across the downs. After an uncertain beginning – at Nettleton Shrub, for example, the pagan temple based around the spring was Christianised, but later became pagan again – Christianity prevailed to become the religion of the majority, enshrined in church and state, intolerant of any gods but its own, with no place for any goddess save as celibate Virgin.

Yet here and there, in and around churches across the county, we find lingering traces of those pagan deities. It is impossible to say with any certainty whether they were brought into churches deliberately, by people who were still essentially pagan, or whether they came there because they were mistaken for figures sacred in Christianity, or because they were expressed as symbols which, as is the nature of symbols, had taken on new layers of meaning over the years. My belief is that Christianity went deep enough to take the old symbols and reinterpret them so that all memory of their past pagan significance was forgotten. Yet today modern Pagans are rediscovering them and remaking the myths and beliefs surrounding them, creating in the process perhaps not a myth of unbroken pedigree, but something none the less real and meaningful.

We who live in Wiltshire are justly proud of Avebury and Stonehenge, the great stone temples built here by our pagan forebears. What some of us perhaps do not appreciate is that many more stones around the county were sacred. Terence Meaden is currently working with Peter Glastonbury to map and record all sarsen stones on the Marlborough Downs. He believes that each one of them was placed deliberately for some ritual purpose; and he warns that the current deplorable practice of dragging away and selling sarsen stones for use as garden ornaments must be seen as wanton destruction of a vast ritual landscape. While many of us may not take such an extreme view, there are certainly stones around the county that have had some pagan ritual significance in the past, and churches have been built close to others.

Stones and wells and forest trees

At Marlborough, outside the west door of St Mary's church, lies a shaped sarsen stone. Hughes, writing in the 1950s, wonders whether the sarsen may have formed part of a prehistoric monument that once occupied the site. Without archaeological evidence all of this is simply conjecture, and deliberate siting of churches on pagan sites is difficult to prove. But there is

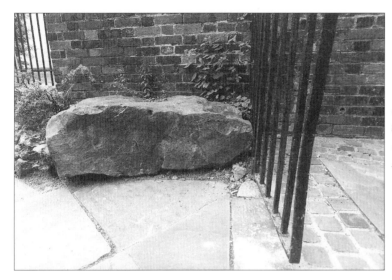

Sarsen stone at St Mary's, Marlborough.

no doubt that there are various curious aspects of Marlborough's history that point to a variety of pagan traditions here. The Marlborough mound, in the grounds of Marlborough College, may have become in its chequered lifetime both a Norman castle motte and an 18th century garden ornament, but in the beginning it was a great barrow hill like Silbury, and folklore tells us that Merlin the magician was buried there. And at Jacky John's fair, held in May, people would foregather in the meadows by the river Og, then join hands and dance through the town, 'threading the needle' (as children still do in the game 'Oranges and Lemons') as they went. When they returned to the river, they would throw (unspecified) articles into it. It all sounds very much like a ritual to petition the river-goddess for a continued supply of water. The river Og, it should be noted, is an intermittent stream, and tends to dry up completely in summer.

An example of a church built significantly near an important well can be found at Alton Priors, where the little church stands on a low island raised above the level of the field. Below the floor of the church, covered by wooden panels that can be lifted up, are great sarsen stones. Next to the church is an ancient yew-tree, whose age has been estimated at around 1,700 years. This would make the tree much older than the existing church building, and it may be that what we have here is not a tree in a churchyard, but a church in a tree-yard. Long-lived yews with their poisonous berries are linked in symbolism to both immortality and death, and we know that they were one of the three trees particularly sacred to the pagan Celts. Across the field at SU108623 lies the ancient spring known as Broad Well, a name

Under-floor sarsen at Alton Priors

that means literally 'wide spring', and which first occurs in a Saxon charter of 825 AD. It is a 'laughing well', one where the water bubbles up visibly from the sandy bottom. I remember visiting the spring several times back in the 1960s with my cousin Carolyn Whatley[1] who lived in Alton Priors, and we were warned by her mother Norah never to wade in the spring, because it was quicksand. How true this is I cannot say, because we were too afraid to risk it. We were perhaps easily impressed at that age by the relentless and rather sinister bubbling of the spring, but now looking back I wonder whether we sensed something of the ancient sanctity of the site. Here we have an ancient yew tree, an ancient well, an ancient (though not as ancient) church built over sarsen stones, all in close proximity to the route of the great Ridgeway which descends from the downs by Adam's Grave to pass through Alton on its way to Salisbury Plain. As usual, we cannot say for sure that this was a sacred place in earlier times, but the evidence certainly points towards the likelihood that here was a powerful combination of stones, well and tree, Christianised by a strategically sited church.

Some more ancient yews

The great yew-tree that stands in the churchyard at Tisbury is reputed to be over 1,300 years old. Some kind person has seen fit to fill the gaping crack in its trunk with concrete, perhaps in the belief that this will somehow prevent the tree from falling apart and dying. But yews are strange trees: they grow apart from the centre, gradually forming a hollow trunk, which some people maintain ultimately turns into a small grove of yews. It may be that our great yew forests, like those found along the South Downs, have slowly grown out of the apparent 'deaths' of ancient parent yews. Whatever

the truth of the matter – and nobody has, so far, lived long enough to verify it one way or the other – there is no doubt that the concrete in the Tisbury yew does little to enhance its appearance, and probably little to promote its longevity.

In the churchyard of St John the Baptist and St Helen, Wroughton, just outside the porch, stands a yew tree whose branches stretch nearly twenty yards. Kathleen Wiltshire notes that local people say their dogs refuse to go anywhere near this tree. The reason for this, if it is so, may be that the tree is haunted, for elsewhere we read that you can raise a ghost by walking three times around this yew tree and then pushing a pin into its trunk. Here again we meet with the concept of circling to raise some kind of occult power, just as we did at the Bloodstone, just as we will at other places before we reach the end of this book. The pin pushed into the trunk is an interesting motif: perhaps it is used to fix and bind the spell, or to control the ghost and prevent it from doing mischief. Radford tells us "Pins were used in numerous charms formerly, both good and evil… Being at once sharp-pointed and made of metal, they could be dangerous or protective according to the circumstances and the manner in which they were used."

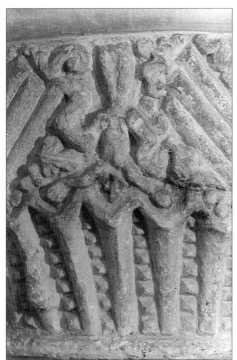

The Winterbourne Monkton 'goddess'.

Whores – or goddesses?

In one or two churches we find statues and carvings that seem for a variety of reasons to be entirely out of place in a church. One example is in the church of St Mary at Winterbourne Monkton, a little north of Avebury, where we find perhaps the most mysterious of carvings in any Wiltshire church. On the Norman font is a curious figure, apparently female. Her right arm is bent with the hand uppermost, her left is bent out and down, and she is apparently feeding a bird with this hand. Her legs are splayed, and from between them flows something like foliage or perhaps water or

blood. Is this supposed to depict a source of life, a living stream? We cannot say for sure, for we are too far distant in time from those who carved her to be able to see her as they did. She is similar in some respects to the female figures known as Sheela-na-Gigs that are found on churches throughout Western Europe, and certainly she resembles no other form of Christian iconography with which I am familiar. Sheela-na-Gigs have often been called fertility figures, but recent academic studies suggest that they are carefully chosen depictions of the grossness of the sins of the flesh. However, symbols change their meaning over time, and whatever the function of this strange figure in Norman times, a glance at the visitors' book shows that some present-day visitors see her as a depiction of the Great Goddess, and revere her accordingly.

Wiltshire has two undisputed Sheela-na-Gigs, both placed on the exterior of a parish church. At eye-level, just to the left of the church porch at Oaksey we see what has been described as a 'drastic figure' – but drastic in what sense? Certainly this Sheela is extreme in that she is blessed with the most enormous genitals of any known example of the type. In spite of her pendulous breasts, which are clearly visible in each armpit, one local writer, Elspeth Huxley, grew up believing her to by a priapic male figure. But she has all the typical features of Sheelas: a bald head, heavy shoulders, and large hands braced on and around thighs spread wide. The other Sheela, not far away on the north side of the tower of Stanton St Quintin church, is a rather sketchier figure, but the head, bent arms, indented vulva and splayed legs can all be made out from the ground. Both figures are placed on the exterior or the church, and on the vulnerable north side of the wall (the heathen gods lived in the north). This qualifies each Sheela for the role of apotropaic totem; that is, her role may have been to turn away evil by the exposure of her private parts, for people believed that the female genitalia could turn away evil. The French 17th century writer of fables, La Fontaine, tells the story of a young girl who frightens off the Devil by raising her skirts and showing him her secret weapon, and this tale has parallels in at least one Irish folk tale. The placing of Sheela figures high on walls, by windows, and on buildings worthy of protection supports the view of them as protective figures, and this is probably a key element, but not I believe the only one. Celtic myths often feature the crone, a hideous, aged, powerful and sexual goddess-figure. Significantly, many Sheelas can be found in Ireland where Christianity came relatively late, and I wonder whether some last traces of the ancient hag-goddess lingers in these exhibitionist figures, preserved in the traditional imagery of stone-carving long after the masons themselves had forgotten the original identity of the hag they were carving.

Above: Stanton St Quintin's little-known sheela-na-gig.

Right: Oaksey's famous sheela.

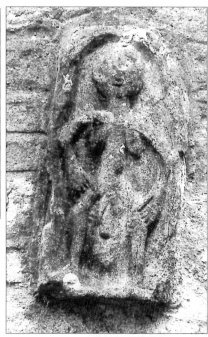

Left: The Devil deterred: Charles Eisen's illustration for La Fontaine's fable

The Green Man

One very widespread and equivocal image to be found on and inside churches is the type of foliate head known as the green man. He comes in two forms: the earliest kind, the foliate head, where the face itself is made up of leaves; and the green man proper, where he spews branches from his mouth (and sometimes eyes and nose). He certainly originated as a pagan woodland deity, but he was gradually taken over in the popular iconography of the Romanesque church. By the 13th century, he had become an image of the sin of *luxuria* (concupiscence or lust), his basic animal nature symbolised by the rampant and lush growth pouring from him. Later green men are often clearly in agony, torn apart by the writhing foliage bursting out of their mouths, but the early foliate masks are often enigmatically serene, and the superb mediaeval green man at Sutton Benger wears an expression of sorrowful patience.

Simple foliage-spewer from Great Durnford

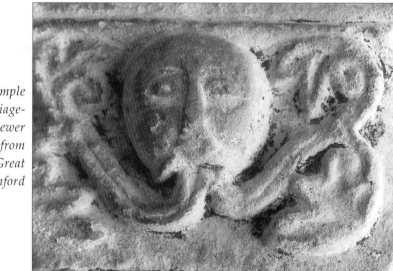

The earliest green men in Wiltshire are Norman. One is at Devizes St John's, on the capital of the pillar to the right of the sanctuary step, the other at Great Durnford. Besides the king of them all at Sutton Benger, you will find mediaeval green men at Mere (a misericord, and two small ones at either end of the chancel screen), and several among the roof-bosses in the cloisters at Lacock Abbey. Victorian green men are quite common: there are several on the outside of Sutton Benger church, another at the top of a water-pipe at Holt, and a fine grinning demon's head in a bracer of the wooden ceiling in the north aisle of Edington Priory church. No doubt there are many more that I have yet to discover.

Hawthorn king: Sutton Benger's melancholy green man.

Whatever the intentions of the Romanesque and mediaeval churchmen who commissioned carpenters and stonemasons to carve green men upon their churches, nowadays the green man has acquired a whole new suite of meanings. He is 'the symbol of our oneness with the earth', a powerful ecological 'green' image; he is a 'fertility figure', in parallel to the Sheelas we have already met; he is Robin Hood, the Jack-in-the-Green, the May King and a dozen other figures from English folklore. And Pagans today have woven him into their beliefs as an aspect of the woodland god, Herne, Cernunos, or Pan. I wear a modern pendant showing a foliate oak mask with tree-branch antlers, fringed with acorns arranged like knuckles: the green man as oak king and horned god of the woodlands. The green man is the most successful of symbols, reinterpreted and reinvented from the early centuries BC down to the 21st century, sometimes revered as god or nature spirit, sometimes reviled as an image of base lusts, but always present, always surviving, always reinterpreted in the architectural language of the time.

The god of the place

At Tockenham, built into the exterior south wall, just to the left of the porch, is another Romano-British deity. For a long time people had thought this was a statue of Aesculapius, the god of healing, but during the excavation by *Time Team* in 1993 he was identified as an unnamed *genius loci*, the spirit of the place. In the field nearby is the site of a Romano-British villa-complex of major importance, perhaps the palace of a provincial governor. Between the field and the church lies a pond that is fed by a strong spring, and core samples taken from the pond contained a quantity of charred grain, showing that burnt offerings had been made here and consigned to the spring. A beautiful Roman water pipe shaped like a fish was also discovered nearby, and it seems once again that what we may have is another composite site featuring a sacred spring, an old god, and a carefully sited church.

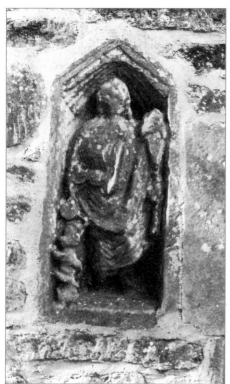

Tockenham's presiding genius loci.

*Dancing in celebration at
Codford St Peter.*

The dancing god

At the church of Codford St Peter, built into the north wall of the chancel, is one of the most beautiful pieces of stone carving anywhere in Wiltshire. Here we find the tapered shaft of a Saxon cross, which is reckoned to date from the 9th century AD. On it is carved the figure of a man, stretching up his right hand to hold aloft a twisting branch of leaves and fruit, while in his left hand he holds a mallet. His feet seem to dance in some kind of celebration. Who knows what or who he was intended to be when carved by the Saxon stonemason all those centuries ago? Sheridan and Ross see preserved in him some memory of the mallet god, Sucellos, the good striker, who with his mallet and goblet of plenty was one of the most powerful gods of the pagan Celtic world. But why should a Saxon craftsman carve a Celtic god with such accuracy? More likely he was originally some pagan Saxon god of fertile vegetation, who shared characteristics with Sucellos, or at the least the depiction of someone performing a dance in honour or hope of a good harvest. The power of symbols and images lies in their susceptibility to many different interpretations. Today, Christian worshippers may see in the carving the figure of Christ in the parable, tending the vines in his heavenly father's vineyard, or as Lord of the Dance; while Pagans visiting the church may see with Sheridan and Ross the dancing god of Celtic antiquity.

The magic of St Christopher

If thou the face of Christopher on any morn shall see,
Throughout the day from sudden death thou shalt preserved be.

This old rhyme, of which several variants exist, explains why the image of St Christopher was painted so often on church walls. The belief was that St Christopher would keep you from sudden death, but it was an automatic protection afforded simply by looking on his image. There was no necessity for either prayer or faith. The simple action of looking on his likeness would have the automatic result of protecting you for that day. This is pure magic: a guaranteed result following on from a set ritual action. The paintings were usually positioned opposite the church door so that people automatically looked on Christopher as they entered the church.

We have records of St Christopher wall paintings in a number of churches around the county, including Broad Chalke, Ditteridge, and Devizes St John.

But nearly all of them were destroyed in the 19th century during the restoration of churches by well-meaning Victorians. The habit of turning up one's eyes when mentioning Victorian church restoration has become ingrained, for we have forgotten that what they often inherited was a church with a splendid chancel (which had been paid for by the clergy) but tumbledown nave (which an impecunious congregation had been unable to maintain). Had they not stepped in, a fair proportion of our parish churches might now be semi-derelict. Yet there is no doubt that they cleared away many things that we wish they had left alone. Wall paintings are one of them. In Wiltshire only one St Christopher wall-painting remains, but he is magnificent. He stands not far from the Sheela at Oaksey, but he is inside the church, opposite the door, and has a winsome mermaid to keep him company. Over the door of Stanton St Quintin church is a statue of St Christopher, set in a good position to be seen and keep the faithful from harm.

The Salisbury Giant

We can still see a mediaeval St Christopher if we visit the Salisbury and South Wiltshire Museum in the Cathedral Close. Here is kept the pageant figure of the Salisbury Guild of Merchant Tailors. He was first recorded in 1496 when he was taken to meet King Henry VIII and his Queen, who were visiting the city during their stay at Clarendon Palace. Normally he was taken out in procession on the eve of St John the Baptist, 23rd June, and on the eve of the Translation of St Osmund, 15th July. He was bought by the Museum in 1873 for the grand sum of thirty shillings, and is quite the most imposing exhibit they have. By his side stands his smaller companion, Hob-Nob, the hobby horse.

The giant, or Sir Christopher, stands around 12 feet high, and is designed around a frame which sits on the shoulders of a man, so that he can move in procession, sway and turn around. His face is the oldest part of him, and is carved from a solid block of wood. There is little doubt that he is indeed an image of St Christopher, for that saint was the best known giant in Christendom, and so an obvious choice for the gigantic pageant figure.

Trampling the Devil

With all these old gods lurking illicitly in and around churches, it is not surprising that from time to time we find images that explicitly set out to reassure by depicting the Church vanquishing the Devil. St Michael the Archangel, who we have already considered in his role as patron saint of

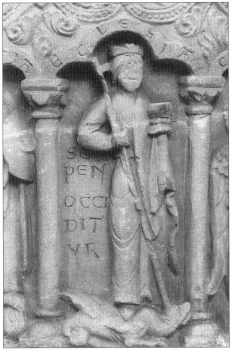

The Church tramples the serpent at Stanton Fitzwarren.

churches set in high places, is often shown throwing down Satan from heaven. Mere church is dedicated to St Michael, and over the South door is a 12th century statue of the saint, striking down the Evil One and vanquishing him. At Stanton St Quintin on the exterior west end of the church is a Norman carving of Christ seated with his feet upon the Devil portrayed (as he often was) as a dragon. Other dragons can be found on Norman fonts. At Stanton Fitzwarren the font shows virtues and vices, and includes the dragon/devil being speared with a lance. At Avebury, two winged serpents coil superbly on the font while a skirted Bishop spears the head of one with his crozier. At Avebury, where the pagan (and therefore devilish) monument has been systematically destroyed by good Christians down the centuries, this image is particularly poignant.

The Devil of Limpley Stoke

Over the font in Westwood church is a fine 16th century carving of a winged devil, with bull-like snout, who gnashes his teeth in fury at the sight of all babies baptised safely into the Christian faith. He is known as the Old Lad of Westwood, but he has the alternative name of the Devil of Limpley Stoke, and it seems that over the years he has become associated with one of the tales of the founding of the ancient church at Limpley Stoke, which is set high on the hill above the Valley of the Nightingale. In the Shaston Cartulary of 1322 it is recorded how the Saxons "commenced to build a church in a field down in the valley called Crockford, on the east side of the river, but that every night, the Devil, or some other ghostly form, came and removed the stones to the top of the hill. After persevering for some days, the builders resolved to use the site thus appointed."

There are a significant number of folk-tales across the country recording

The Devil of Limpley Stoke in Westwood church

just such an incident: how Christians began to build a church but the Devil came by night and moved it. Sometimes things get rather more out of hand than this. At Over, in Cheshire, the Devil actually flew away with the church. During the 14th century, in Oxfordshire, two brothers employed an itinerant mason who worked without payment and who, at the end of the contract to build the spires at Adderbury and Bloxham, disappeared suddenly, leaving behind him a characteristic whiff of sulphur and the memory of his oddly-shaped feet. But the basic characteristic tale usually stresses how the building began but the stones were moved to a new site, which was eventually adopted. It really does seem likely that what we have here is some memory of local people disliking the original site chosen, and taking it into their own hands to move the building stones to a more favoured site. We note that in the Limpley Stoke tale, it specifically says "the Devil, *or some other ghostly form…*" Local people, perhaps, shrouded in grey cloaks and working by night? It is one possible interpretation of the tale. What we can say is, whatever went on here, it happened at a lot of other churches around the country.

Some other foundation legends

One or two other churches preserve tales about their foundation. Limpley Stoke itself has another tale, which we will come to in due course. Tytherington's tiny church of St James is supposed to have been founded by the Empress Maud, back in the 12th century. Wishford church, further down the Wylye valley, is said to have been built with the pennies offered by thankful travellers who had made it safely through the wilds of Grovely forest.

Seven children at one birth

John Aubrey recorded during the reign of Charles II a curious tale about Sir Thomas Bonham, whose bones are said to lie in the tomb in the north aisle of Wishford church, where there is an effigy of a knight lying alongside his wife. In the floor of the church are brasses (and indentations) depicting the nine children of Sir Thomas, who died in 1473, and of his unfortunate wife Edith. Aubrey tells us: -

> This Mr. Bonham's wife had two children at one birth, the first time, and he, being troubled at it, travelled and was absent seven yeares. After his return she was delivered of seven children at one birth. In this parish is a confident tradition that these seven children were all baptised at the font in this church, and that they were brought thither in a kind of chardger, which was dedicated to this church, and hung on two nailes, which are to be seen there yet near the bellfree on the south side...

By the early 19th century when Colt Hoare recorded it, the tale had acquired a little more detail and a sinister witch: -

> ...their family coming on very fast, they were untrustful that they should not be able to maintain them, and so agreed to part for seven years, and if neither part was seen or heard of, to be at liberty to marry again. He went abroad, and she was in England; the time was nearly expired, and the lady on the point of marriage. The news was made known to him (report says) by a witch, who conveyed him home instantly, and found his lady to be married the next day. He was denied admittance, for he had not shaved himself the whole time, and no one remembered his person until he produced the ring they had broken. Then he was introduced to his lady, and at the next birth she had seven children.

The likelihood of septuplets being born, and surviving, in the 15th century is extremely slim. The tale doubtless grew up after the fashion of folk tales, to form some coherent explanation for a remarkable or unusual feature (in this case the tomb and the brasses). Besides that, we can detect a moral lesson in the tale: do not think that you can evade your God-given responsibilities by running away from them, because you will have to come back to the same situation in the end. And that might be all there is to say, except that this is not the only place where this strange tale can be found. Not far away in Wiltshire, at Upton Scudamore, two mutilated effigies in

Parents of Upton Scudamore's seven children.

the parish church were supposed to be the parents. At Chulmleigh in Devon a similar tale can be found, but here the father was a very poor man, and was stopped by the lady of the manor from drowning his 'whelps' in his desperation. Like many folk tales, it seems that this one may recur in variants across the country. Ettlinger sees the tale as one of the many types told as an expression of the rivalry which existed between different villages, rather like the rhyme I learned at school: -

Wilcot born and Wilcot bred,
Strong in the arm, but weak in the head;
Oare born, and Oare bred,
Weak in the arm, but strong in the head.[2]

The Odstock curse

Ralph Whitlock has narrated in great detail the story that explains why Odstock church door was kept locked, and I do not intend to tell it in full here. In essence, what seems to have happened is that a group of gypsies had got on the wrong side of the good people of the parish, tempers had flared, and after some destructive behaviour on both sides, the Queen of the Gypsies cursed the parson, the sexton and a local farmer. Next morning when she went to the church to collect her shawl, which had been dropped in the scuffles, she was forcibly ejected from the church by some constables, and the door was locked behind her. And so she pronounced a second curse: *any person who locks this door will die before the year is out.* It is recounted how

both her curses came true, but the one that has travelled down the years is the curse on the church door. Right up until the 1990s, Odstock church door was not shut or locked. Back around 1900, a carpenter locked the door, and he died within a year; in the 1930s, a temporary vicar laughed at the curse, and locked the door, and he died within a year. Or so it is said.

In 1994, I was told an interesting sequel to this tale. Apparently in the early 1990s, the Bishop of Ramsbury said it was ridiculous in this day and age that they should not be able to lock up the church, and so he gathered together the whole congregation of Odstock and performed some kind of 'exorcism'. Since then, my informant assured me, they have not been afraid to keep the church locked.

More than just church furnishings

The font in St George's church, Preshute, is a massive affair made of black basalt from Tournai. Tradition says that it originally stood in the chapel of St Nicholas at Marlborough Castle, and that the sons of King John were baptised in it. It is most unlikely that this should be the case, unless John had other sons we know nothing about, for he had none by Isabella of Gloucester, and his son by Isabella of Angoulême, Henry, was baptised at

Winchester. Once again a little rivalry between villages may be in evidence.

Between 1530-35, Latimer was rector of West Kington. He famously went on to become a Bishop, and be burned by Henry VIII for refusing to renounce Catholicism in favour of the new Church of England; but his days at West Kington were happier. The pulpit in the church is said to be the same one from which he preached his entertaining sermons.

Some fine pieces of stained glass depicting the upper half of a crowned female saint have been reset in the Decorated-style window on the north side of the chancel in

Preshute's font of Tournai stone.

Amesbury church. She has golden hair and a red robe and wears a crown like a queen. It is not surprising, then, that local tradition identifies her as Queen Guinevere, who lived in retirement at Amesbury Abbey after the passing of Arthur.

Source of entertainment at West Kington.

The ghostly voice

In 1969, the Devon folklorist Theo Brown[3] paid a visit to Langley Burrell church, and as she was looking quietly around she became aware of a woman's voice talking in a quiet monologue. At first she thought she was overhearing someone having a conversation in the vestry, but the door was locked and there was clearly nobody in there. Soon she heard the voice again, but as she listened, it faded, and she realised that she could only hear it when she was not really listening to it. Just to be sure, she checked outside (it was raining heavily) and made certain that there were no other doors through which the sound might have come. In the end she felt sure that she was not overhearing a living voice.

One very common characteristic of ghostly sightings is that they often occur when someone is relaxed, not concentrating, in the sort of trance-like state we often achieve when driving, for example. If you are thinking about seeing a ghost you probably will not see one. But if you are thinking about something else entirely, or not really thinking at all, you may see something on the edge of sight, as my colleague Betty Hubbard did in Bath one day. She was just turning to go up the steps of one of the houses in Mortimer Street, when she saw out of the corner of her eye the famous Man in Black, wearing a tall black hat and a cloak, standing about arm's length from her. When she turned to look at him, he wasn't there any more. [4]

The curfew bell

Two World Wars have done away with the traditional curfews which were rung from a number of our churches in the past, but in 1919 Hutton was still able to write lyrically about the comfort of hearing the friendly bell ringing from Berwick St John: -

> The bell rings in the low Perpendicular tower, and one reminds oneself that it is ringing for all who like oneself are wanderers upon these downs, and that so it has rung not only for near two hundred years as it still does in winter time 'to guide travellers over the downs' to this friendly shelter, but for near two thousand years to remind one, in the evening of the day, of the message of an angel. When the Rev. John Gane left his bequest in 1735 for the ringing of the great bell he was but confirming the custom of all the Christian centuries…

At Marlborough there were two curfews. The one rung from St Mary's church was not particularly ancient, but illustrates the way such curfews

often began, for it was endowed by a traveller who had been lost on the downs, and found his way to Marlborough by following the sound of the bells. He left money in his will for a bell to be rung every night at 9 pm, to guide travellers to safety. The curfew rung from St Peter's church was at 8 pm. Both were discontinued at the beginning of the First World War.

The Pancake bell

The bell of St Peter's, Marlborough, was also rung at noon on Shrove Tuesday to signal the start of the festivities. This was known as the 'Pancake Bell', and it must have been rung in many towns and villages all over the country. At Bradford on Avon they had particularly well-developed Shrove Tuesday rituals, as this account tells us: -

> When I was a schoolboy, as soon as the 'pancake bell' rang at 11 o'clock a.m., we had holiday for the remainder of the day, and when the factories closed for the night at dusk, the boys and girls of the town of Bradford-on-Avon - my birth place - would run through the streets in long strings playing 'Thread the Needle', and whooping and hollering their best as they ran, and so collecting all they could together, by seven or eight o'clock, when they would adjourn to the churchyard, where the old sexton had opened the churchyard gates for them; the children would then join hands in a long line until they encompassed the Church; they then, with hands still joined, would walk round the Church three times. And when dismissed by the old sexton would return to their homes much pleased that they 'clipped the Church', and shouting as they went:
>
> > Shrove Tuesday, Shrove Tuesday, when Jack went to plow
> > His mother made pancakes, she scarcely knew how,
> > She toss'd them, she turned them, she made them so black
> > With soot from the chimney that poisoned poor Jack.

This is a fascinating account, for as well as the usual Shrove Tuesday mayhem (and this was a day when much destructive play traditionally took place), we find the old ceremony of clipping the church taking place at the traditional time of year. To 'clip' means to embrace, and so apparently what we have here is an expression of affection for their church made by the congregation which is on the verge of entering the long period of lenten privation. But we find other ancient elements within the ceremony: they form a ring and circle around the church, a formula we have met several

times already; moreover the circuit is made three times, and three is a number which has been powerful since at least Celtic times. So it seems the roots of this ceremony go deep into the consciousness of the community. Certainly they were simply expressing their affection and commitment to their church, but they were doing so in ways that had been in general use in group ritual since well before the Christian era.

Clipping the church at Rode (photo KMJ)

In Rode, a village that straddles the border between Wiltshire and Somerset, they have revived the custom of clipping the church as part of their Millennium celebrations. On Wednesday 12th July, at 7 pm, the church was filled with villagers who held a short service and then poured out into the churchyard, joined hands and simply made a complete ring around their church. The revived ritual was unfamiliar to everyone there, and perhaps this is why it seemed to me, looking on, very unconvincing as a spiritual exercise. Friends who took part agreed with me, and said that it felt to them much more like an expression of community and village solidarity. Perhaps this is not so very far from the original purpose behind clipping the church.

What the bells say

The nursery rhyme 'Oranges and Lemons', which so many of us learned when we were small, tells us what some of the London bells were supposed to say when they rang. Wiltshire village bells too said particular things, and some were pressed into use in the traditional rivalry between villages. In Salisbury, the eight bells of St Edmund's church rang out 'Tall and slender, fat and tender'; while at St Thomas's they said 'Why won't you let your wife alone? She's ill in bed and can't get up.' Village churches often had fewer bells, so were more limited in what they could say. At Fovant, they rang a devout 'Come to church, come'. At Compton Chamberlayne, they

rang with some desperation, 'Who'll help we?' and kindly Baverstock answered, 'We two'. An element of gentle satire can be found in Clyffe Pypard's six bells, which at weddings rang, 'Why did you marry John?'

Francis Kilvert records in his diary the gentle rivalry between Langley Burrell and Kington St Michael, for when Kington bells sounded, Langley folk might remark: "The Kington folks have found a hen's nest." This was a long-standing joke against the Kington villagers, who were supposed to be all too ready to ring their bells "without just cause".

'Come to church, come' – Fovant church

Traditions of Salisbury Cathedral

It is to be expected that a great cathedral church like Salisbury's would have a rich collection of folklore and legend attached to it, but when I was pulling together the material for this chapter I was surprised and delighted to find that the Cathedral has examples of *all* the various kinds of tradition that we have met so far. There are several fine foundation legends, some traditions

relating to the structure and furniture of the building, a stone head with strongly pagan associations, a holiday custom, and two unusual examples of ghosts. The holy well of Salisbury, Ladywell, I will not mention here as we have already considered it in the previous chapter. I have gathered these traditions from a wide range of sources, and I believe this is the first time that they have all appeared in one place.

Foundation legends

I have already recounted elsewhere[5] how an arrow fired from Old Sarum was used to choose the site of the new cathedral of Salisbury. But I find there are at least two more foundation legends. Ella Noyes records the fullest of all.

There is an old narrative, preserved in a fifteenth-century copy, among the muniments of the Cathedral, which relates how the canons came one day to Richard Poore, soon after his appointment to the See on the death of his brother in 1217, with bitter complaints of the outrages and indignities which they suffered from the King's officers in the Castle. The Bishop wept, and said, 'When they persecute you in one city flee ye to another.' And comforting them with promises and words of hope he betook himself first to the King and then to the Pope, and obtained the licence of both for the removal of the See. As he was returning from Rome a messenger met him with the news that the King was dead. The Bishop began to be very heavy, fearing that he had spent all his labour in vain, but when evening was come and he laid himself down to sleep the glorious Virgin appeared to him and told him to fear nothing but to carry out his intended purpose, and promised she would be his aid in all his difficulties. Whereupon the Bishop, not a little comforted, hastened to the new King at Westminster and obtained his permission for the work, and a charter and many privileges for the new city. Then there was a question of a site, and over this the Bishop cogitated a long time. At length he determined to obtain a place from the Lady Abbess at Wilton, by reason of the advantages of that vicinage, viz., the water, woods, and the good town well supplied with all good things. One day when he went of this business to Wilton, a certain old spinning wife said to her gossip: 'I marvel,' said she, 'of this Bishop, that he goeth so often to Wilton; perhaps he means to marry the Abbess. Thinkest thou,' said she, 'that the Pope hath granted a dispensation that he may take her to wife?' To which her neighbour replied, 'Not so, thou thinkest falsely of this holy

man. But he means to remove the Church and Close from the Castle of Sarum to Wilton.' Then said that old wife, 'Hath not the Bishop any land of his own that he must rob the Abbess,' and added, 'God loves not him who grudges of his own.'

Having overheard these words, the Bishop resolved to choose a place in his own domains. But being in perplexity, he commended himself to God and the Blessed Virgin Mary. The following night he was comforted by a vision, for the Blessed Virgin appeared to him, telling him that he should choose a place named Myrifeld. A few days after he was meditating upon the church, but the name which had been revealed to him had gone out of his mind. As he walked along, one of his servants happened to point out an ass feeding in a meadow which he called Myrifeld. Immediately the Bishop remembered, and began to inquire of those around concerning the name of the place. Having made himself sure of it, the Bishop in this very place founded the Church of the Blessed Mary at Sarum in the year of grace 1220, viz., the day of St Vitalis the Martyr, in the month of April.

The Virgin was patron of the Cathedral even before it was built, it seems. Besides the field where the Cathedral was built, which some now called Mary's Field rather than Myrifeld, and the well of water sacred to her, she also watched over her Cathedral in more tangible form. In 1762, during repairs to the top of the spire, a leaden box containing a bit of woven material was found. This is supposed to have been a fragment of the Virgin's robe, put high up in the spire to protect it from harm. It was put back in its place, and presumably the holy relic still guards the spire today.

Another legend about the Cathedral says that it was founded on woolpacks. I have been told that the foundations are only six feet deep, and have heard various speculative theories which attempt to explain this tradition rationally, including the idea that bags of wool were sunk into the marshy ground to act as buffers or pillows on which to rest the foundation blocks. But I suspect Noyes is right when she says that this is simply a roundabout way of saying that the wealth that funded the building of the Cathedral came from the wool trade.

A calendar in stone

As many days as in one year there be,
So many windows in this Church you see,
As many marble pillars here appear,
As there are hours through the fleeting year,
As many gates as moons one here does view,
Strange tale to tell, yet not more strange than true.

This rhyme, attributed to a Salisbury man named Daniel Rogers, sets out in verse the tradition that John Aubrey also recorded in the 17th century. This says that "The windowes of the church, as they reckon them, answer just in number to the dayes; the pillars, great and small, to the houres, of a full year; and the gates to the moneths". This would mean that there are 365 windows, 8760 pillars, and 12 (or 13) doors. Has anyone ever counted them? I would like to know the truth of this.

Moulded not shaped

Aubrey also records another tradition about the Cathedral pillars: -

Tis strang [sic] to see how errour hath crept in upon the people, who believe that the pillars of this church were cast, forsooth, as chandlers make candles; ...and not only the vulgar swallow down the traditional gleb, but severall learned and otherwise understanding persons will not be perswaded to the contrary, and that the art is lost. Nay, all the bishops and churchmen of that church in my remembrance did believe it, till Bishop Ward came, who would not be so imposed on...

The triple head

In the chapter house, at the head of one of the columns, is a fairly small carving of a triple head, with four eyes, three noses, and three mouths all set under the one wide forehead. The tricephalos, of which this a fine example, has an ancestry that dates back to pre-Christian times, and it was taken into the iconography of the Christian church as an image of the Trinity. However, the Church authorities seem to have remained uneasy about the ancestry of the triple head, because it fell out of favour, and was eventually banned. This must be why this type of head is fairly rare. Besides the Salisbury example I have come across only one other in Wiltshire, and that is over the chancel doorway on the south side of Westbury parish church.

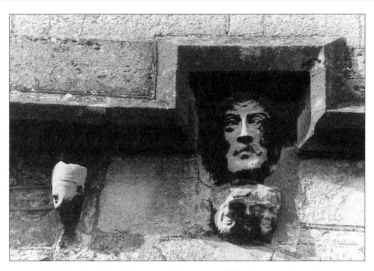

Triple head, with attendants, on Westbury church.

Fasting to death

As in many cathedrals, you will find in Salisbury some examples of effigies that are skeletal. Ella Noyes notes "the usual legends" which seek to account for their deaths and emaciated appearance with the explanation that they were effigies of people who had attempted to fast for forty days. In actual fact there are fashions in funerary monuments as in everything else, and these are simply effigies that conform to the rather grim fashion of their time.

Lord Stourton's tomb?

In the Cathedral nave stands a fine tomb, with three kneeling holes on each long side, which tradition says is the tomb of Charles Lord Stourton, who in 1556 was hanged with a silken cord in Salisbury market place for the crime of murder. A twisted wire with a noose hung over the tomb for many years, and Daniel Defoe saw it there in the 18th century. The six apertures in the tomb are supposed to represent the six sources of the river Stour, which appear on the arms of Lord Stourton.

However, this is folklore smoothly adapted to bind together different elements to make a good tale. The tomb predates Charles Lord Stourton by two centuries, and is actually all that is left of the shrine of St Osmund, Bishop of Salisbury who died in 1099. Pilgrims to the shrine would kneel at the holes and reach in to touch the inner shrine, trying to get as close as possible to the object of their veneration, in hopes of healing or some other blessing.

The boy bishop

A miniature effigy of a bishop, only three feet long, is supposed to be the tomb of one of the boy bishops who were chosen according to a curious custom here, as at other cathedrals in the country, during the mediaeval period. Canon Fletcher records the custom as practised at Salisbury: -

> ... we know that in olden days the Boy Bishop was for one day in the year a very real person in Salisbury, as elsewhere. The custom was in use at Old Sarum, before the cathedral was removed... on the Eve of St. Nicholas' Day (the patron saint of boys), the Boy Bishop, or 'Bishop of the Innocents', was chosen by the choristers from amongst themselves, and he retained his title for the next three weeks until Childermas, or Holy Innocents' Day (December 28th). But it was only on the Eve of that day and on the day itself that he acted as bishop. He was provided with full episcopal vestments and with a pastoral staff; little copes were found for the other boys, who assumed for the day the rank of canons. The relative position of the cathedral dignitaries and of the boys was completely reversed... The cathedral was crowded on the occasion, and great deal was thought of the little bishop's blessing.

The custom of the Boy Bishops has been described as a juvenile version of the disorderly Feast of Fools, which was held in January, and which (since it was a wholly adult celebration) was a much bawdier and more dissolute affair. Both traditions were based on the idea of topsy-turveydom, that the last should be first and the first last, thus enabling the lowly to remind the great ones that it was only by the grace of God and an accident of birth that they were people of rank and good fortune. Christina Hole tells us that "there is no doubt that the proceedings were strongly tinged with pagan notions derived from the Roman Saturnalia and the Calends of January." Although the custom of the Boy Bishops took place in a more reverent and controlled environment, it is hard to believe that the boys did not revel in their brief hours of glory and high status, and take full advantage of the powers granted them.

Chorister's holiday

In more recent years, there have still been opportunities for the children in the Cathedral to obtain some favour from an indulgent adult who, in this case, was the Judge of the Assizes. A tradition dating back several centuries allowed the members of the choir school to approach the Judge with a request for a day's holiday.

A pair of ghostly boots

I have a vivid memory of the time my father arrived home from work and showed me a photograph of the nave and east end of Salisbury Cathedral. He worked at Cross & Co. Manufacturing in Devizes, and a colleague of his was a good amateur photographer. Sometime during the late 1970s or early 1980s, early one morning when the Cathedral was empty of visitors, this colleague had taken a timed photograph from the back of the building looking directly towards the east end. A timed exposure lasts, in photographic terms, quite a long time, and it is easy to get a blurred image, as we see on old Victorian photographs when one person has moved slightly during the exposure.

This photograph was remarkable because, across the field of view, just about where the crossing is between the west door and the door to the cloisters, a pair of great boots were marching, clearly visible, as if caught at the widest point of the stride for two or three strides. They appeared to be thigh-high boots, and extremely large – too large to be of human scale for where they seemed to be. No other part of the body was visible. All that could be seen was the boots, and they gradually faded as they progressed towards the west door.

I have puzzled over various aspects of this photograph for years. If someone did move across the field of view during the long exposure, why did they not appear as one continuous blurred image? Recently I have found an explanation. In his analysis of the famous 'ghostly monks' photograph taken of the Tulip staircase at the Queen's House, Greenwich, Ian Wilson explains that during a timed exposure, "if someone moves across the camera's field of view while the shutter is open, he or she is likely to appear ghost-like two or three times, as if in a slow-motion replay of their movements." So this is how someone wearing boots might appear as several separate images. But I still cannot explain why only the boots appeared, or why they were so huge, or indeed why someone wearing thigh-boots was moving around the Cathedral so early in the morning.

The white birds of Salisbury

It is said that, when a bishop of Salisbury dies, great white birds are seen soaring on motionless wings. Miss Moberly[6] saw them when her father Bishop Moberly died in 1885. They rose from the garden of the Bishop's Palace and sailed off into the west. In 1911, Edith Olivier, who apparently was a most psychic woman, saw them flying over Hurdcott meadow. She saw how they soared, their wings motionless, but knew nothing about the

tradition of the birds and so suspected nothing. When she reached home, she learned that Bishop Wordsworth had died unexpectedly. It was only later that she learned of the legend and realised what she had seen.

The Pear Tree church

And finally, a curious incident which is not exactly folklore, not exactly history, but one of those examples of synchronicity and human tidy-mindedness that combine both history and folklore and which can make us wonder sometimes whether more is going on in life than is outwardly apparent in our everyday world.

During the last years of the 10th century, King Elthelred the Unready gave lands to the Abbess of Shaftesbury, and to mark the borders of these lands she planted pear trees. A little later, at the turn of the millennium, she built churches beside the pear trees. One of these was at Limpley Stoke, and parts of the small church there (the same which was moved by the Devil to the top of the hill) certainly date back to the Abbess's time. So much is history.

In May 1995 I was in Puckle-wood above Limpley Stoke looking for Shingle Bell well. After I had been through the wood twice in both directions I was starting to get very dispirited, and I was just about to give up and go home when I met a man walking his dog. Sheer desperation made me hail him and ask whether he knew of the well, and together we re-traced our steps to the area of the wood where he believed it to be[7]. As we walked he told me he was Brian Combe, the church-warden of Limpley Stoke, and when he learned of my interest in folklore he told me the following tale about the church.

Pear Tree church, Limpley Stoke.

A few years previously they had decided to plant a pear tree in the churchyard, so that Limpley Stoke could truly become a pear tree church again. Brian discussed with the sexton where to plant the tree, and the sexton was of the opinion that there was only one place possible, in the corner where the flagpole used to stand. So this is where they dug, and when they had dug down a good way, the spade struck something large and unyielding. With some difficulty they rooted out the object, and it proved to be an old tree-stump. It is strange that, in all the places where they might have chosen to plant their pear-tree, they picked the very spot where a tree had grown long years before. Brian Combe kept the stump, and he wondered aloud to me whether this could possibly be the remains of the pear tree planted a millennium ago by the Abbess of Shaftesbury.

It would be delightfully romantic to be able to confirm that this was the case, but it is not so. Recent research into the history of Limpley Stoke church has unearthed a photograph that shows a great tree growing in the spot where the stump was found. It was an elm. Yet to me this is almost as poignant an identification as the pear tree would have been. The elm is the lost giant of the Wiltshire countryside, one of the commonest of trees when I was a child. But Dutch elm disease took them all, and now they live only as ghosts in the landscape of memory.

References
Pagan temple at Nettleton Shrub: Hutton (1993), p.259
Sarsen stones form a ritual landscape: Terence Meaden, *pers.comm.*, Rollright Stones, 2000.
Sarsen stone at St Mary's church: Hughes (1953), p.20.
Marlborough mound: Burl (1979), p.133, 135.
Jacky John's fair: Millson (1982), p.71
Church in a tree-yard: Parker (1993), p.7.
Celtic sacred trees: Ross (1992), pp.59-61.
Tisbury yew: Hutton (1919), p.192
Age and growth of yew trees: read Chetan (1994) for more about yew trees and how to date them; but balance it by also reading Harte (1996), pp.1-9.
Haunted yew at Wroughton: Wiltshire (1984), pp.117-8; Lees (1996), p.8.
Pins used in charms: Radford (1974), p.266.
Sheela-na-Gigs: the best interpretative books on the subject are Weir (1993) and Andersen (1977).
'Drastic' Oaksey Sheela: Andersen (1977), p.100.
La Fontaine fable: Andersen (1977), p. 138.
Goddess as Crone: Ross (1992), p.297
Green Man: two very different interpretations are in Weir (1993) and Anderson (1990), but the definitive work is still Basford (1998).
God of the place: Time Team (1994), p.12
Dancing god: Sheridan (1975), p.98.
St Christopher: Hole (1965), p.57.
Salisbury giant: Shortt (1972), pp.5-7.
Devil moves or helps build churches: Simpson (1976), p.30; Readers' Digest (1977), p.172.
Maud founds Tytherington church: Noyes (1913), p.192.

Foundation of Wishford church: Noyes (1913), p.221.
Seven children at one birth: Aubrey (1969), p.71; Ettlinger (1970).
Seven children at Upton Scudamore: Whitlock (1976), p.100.
Odstock curse: Whitlock (1976), pp. 135-146.
Odstock curse revoked: Name withheld, *pers. comm.*, University of Bath, 1994.
Preshute church font: Hughes (1953), p.27.
Latimer's pulpit: Hutton (1919), p.433.
Guinevere in glass: Noyes (1913), p.161.
Ghostly voice: Brown (1985), p.30-1.
Man in Black: Betty Hubbard, *pers. comm.*, University of Bath, 1992.
Curfews: Hutton (1919), p.210; Hughes (1953), p.23.
Pancake Bell & Shrove Tuesday celebrations: Hughes (1953), p.23; Goddard (1942-4), p.26.
Clipping the church: Hole (1978), p.76.
Rode church clipping: Helena Cave-Penney & Simon Best, *pers. comms.*, Rode, 2000.
What church bells say: Goddard (1942-4), pp.38-45.
Foundation of Salisbury Cathedral: Noyes (1913), pp.60-2.
Virgin's robe protects Cathedral: Noyes (1913), p.84.
Founded on woolpacks: Noyes (1913), p.62.
Calendar in stone: Coleman (1952), p.15; Aubrey (1969), p.97.
Pillars were moulded: Aubrey (1969), p.97-8.
The triple head: Sheridan (1975), p.52.
Fasting to death: Noyes (1913), p.100.
Stourton's tomb: Hutton (1919), p.232.
The boy bishop: Fletcher (1933), p.73-4.
Chorister's holiday: Coleman (1952), p.7.
White birds of Salisbury Cathedral: Wiltshire (1973), pp.114-5.
Pear tree church: Historical details from Limpley Stoke church guide leaflet; Brian Combe, *pers. comm.*, Limpley Stoke, 1995; Elizabeth Combe, *pers. comm.*, Limpley Stoke, 2000.

Notes
[1] It was Carolyn who once told me that if you hear a cow cough you should go to bed for a week.
[2] I of course came from Oare!
[3] It was the article from which this account is taken which started me collecting folklore again, back in 1990.
[4] On the other hand, it is quite possible to be mistaken. I walked into my kitchen one evening and was horrified to see a figure standing motionless by the fridge. When I looked again it turned out to be the ironing board, propped up against the work surface.
[5] Jordan (1990), p.46
[6] This was the same Miss Moberly who with her friend Miss Jourdain saw the ghosts of Versailles and wrote about them in their famous book, *An Adventure.*
[7] We did find the well.

Battlesbury hill at harvest time.

Chapter 3

Echoes of War

The bloodstained land

There can be few corners of the British Isles that have not been fought over at some time in their long history. The human race is formed of all kinds of social groupings: couples, families, communities, political parties, nations, races. Social groups have their own rules, customs, and mutually acceptable ways of behaving. When someone oversteps the acceptable norms, there is disagreement, and the larger the social grouping, generally speaking, the more drastic the effects of the disagreement. When a family falls out, the row may be prolonged, with people refusing to speak to each other, or even leaving home, but few other people are involved. When communities fall out, we may find the kind of rivalry expressed in ritual destructiveness or in competitive and scurrilous rhymes and tales, but few people outside the immediate communities are involved. But when political parties, nations or races fall out, whether motivated by greed or differences in politics or racial hatred, they have a tendency to go to war. Then whole nations suffer, either directly, by being caught up in riots, skirmishes or invasion, or indirectly, in the destruction, famine and poverty which follows on the heels of war. The history of humankind has left behind it a trail of rebellion, war and bloodshed, and the history of the British Isles is no exception.

Folklore, as we have already said elsewhere, is an expression of the concerns and beliefs of society. So we might expect that traditions and legends about battles and war would permeate the folklore of the British Isles – and so they do. Tales of heroism and self-sacrifice, of cruelty and extreme barbarism, are found in every county. Wiltshire has its fair share of these, tales ranging from those unfixed in time, or belonging to the distant past, through to the World Wars of the 20th century. In the next few pages we shall read of invasion battles between Romans and Britons, Britons and Saxons, Saxons and Danes, and then pick our way through the various civil wars and rebellions of the intervening years before our journey ends in

flames over Salisbury Plain.

Fortunately folklore is not factual history, so we shall be spared, by and large, the hardest and bloodiest aspects of war. Instead we shall see the events through the eyes of those who came after, who understood or grasped only imperfectly what had happened, yet who remained haunted by the lasting force of the events. What we shall find is a quirky vernacular mosaic of the violent past, where some events are missing entirely, and others illustrated by tiny vignettes which feature some of the great heroes and villains of the military past – King Alfred of Wessex, the invading Danes, Oliver Cromwell and Judge Jeffreys.

How traditions start

Very often, we find folklore explaining how features in the landscape got their names, and this is most likely the case at Battlesbury Camp (ST897457), an Iron Age hillfort on the edge of Salisbury Plain near Warminster. Ella Noyes tells us "There is a popular belief that a great battle was fought 'once upon a time' on Battlesbury Hill... the idea must have arisen from the name of the hill... and has been corrupted through similarity of sound to a familiar word." The place-name evidence supports her supposition: the name probably contains the personal name Paettel, and so means the camp or *burh* of Paettel. Of course battles have been fought nearby, in the time of Alfred the Great and during the Civil Wars, so the folklore may (accidentally) be correct, and certainly demonstrates the preoccupation of humankind with war and conflict.

The Eagles of Rome

Near Woodminton is a small valley known as Patty's Bottom. Here the Romans and Britons are supposed to have fought, and "on certain moonlight nights tramping is distinctly heard and horses without heads can be seen rushing madly about". The headless horses are a common formula in ghostlore, and probably a late addition (or devised by smugglers to keep people at home!) But the sound of Romans marching is a relatively common phenomenon out on the downs. I once read of people who camped near Wayland's Smithy, the long barrow beside the Ridgeway at Uffington, and heard Roman legions tramping past; and various people have seen the tired and footsore soldiers who march on the old Roman road through the cellars of the Treasurer's House in York. Elsewhere in Wiltshire, the folklorist Kathleen Wiltshire has recorded how an old shepherd saw Romans marching along the Roman road behind Oldbury Camp and Cherhill. His description

is apparently that of tunic-clad legionaries, wearing plumed helmets, marching behind the eagle-standard of their legion: "They did wear skirts!... they did have beards, some on 'em, and they wore girt helmets – wi' 'air across the top... and had a girt bird on a pole a'front on 'em!" We do not know exactly when Kathleen Wiltshire collected this folklore, and it may be that the shepherd was describing a scene from a film seen at Devizes cinema, but enough ghosts of Roman soldiers have been seen across the country for us to consider this a genuine and detailed sighting.

Treachery at Amesbury

After the departure of the Romans from Britain, the invasions of the Saxons began. A whole mythology has grown up around the figure of 'King' Arthur, who was probably a British war leader fighting against the influx of Saxons. The tales we are mostly familiar with, those of the Knights of the Round Table, are a mediaeval and romantic construction, largely created by Sir Thomas Mallory, and embroidered later by writers such as Tennyson. But

the tales derive from earlier writers like Geoffrey of Monmouth, and his version of events is cruder and bloodier. He tells not only of Arthur, but of other British kings such as Vortigern, who invited Hengist the Saxon to a great feast at the 'Mount of Ambrius' – supposedly Amesbury. During the feast the Saxons, obeying a signal from their chief, drew their daggers and killed 350 British warriors. Amesbury, and nearby Stonehenge, feature strongly in the earlier Arthurian writings, Stonehenge as the burial-place of Aurelius Ambrosius and Uther Pendragon, and Amesbury Abbey as the retreat of Guinevere after the passing of Arthur.

"Guinevere" remembered at Amesbury church.

A churchyard battlefield

What appears to have been some kind of archaeologically significant burial, of bodies with helmets and weapons, was unearthed in the churchyard of St Edmund's, Bedwin Street, Salisbury in 1771. Noyes believes that this may have given rise to the local belief that the churchyard was the site of a great battle between Britons and Saxons in 552 AD. The very exact date is a nice touch, and suggests an antiquarian hand in the making of this particular piece of folklore.

Earliest battles ever fought

According to Aaron and Daniel, the haymakers of Lus Hill, "The earliest battles fought were those between King Alfred and the Danes". This is a fine example of a common phenomenon: that people tend to look back to the earliest times they have ever heard of. We find it in the writings of the antiquarians Aubrey and Stukeley, who ascribed the construction of monuments like Stonehenge to the ancient Druids. We find it in the 'Roman camps' that were an early name for what we now know to be Iron Age hillforts. In the case of Aaron and Daniel, we meet for the first time two very strong threads in Wiltshire battle-lore: the heroism of Alfred of Wessex, and a strong antipathy to the Danes.

Alfred of Wessex, 849-899

Alfred was the fifth and youngest son of Aethelwulf, king of the West Saxons. Had he lived later in history, it would have been extremely difficult for him to have become king, but to the Saxons it was essential that their king should be a capable military leader. To avoid the situation where any underage children might succeed to the throne, Aethelwulf stipulated in his will that all of his sons should succeed each other to the kingship. They did indeed all reign after him, but not, as we shall see, in the order their father had intended.

In the winter of 870 AD, the Danish armies attacked Wessex, and the long period of invasion and battle began. King Aethelred and his younger brother Alfred gathered an army and met the Danes in battle at Ashdown, near Uffington. Alfred led an assault against the Danes while his brother was still at his prayers, and won the battle for the Saxons. Tradition says that the great white horse carved on the downs at Uffington commemorates Alfred's impressive victory over the invaders. In fact we now know this horse dates from long before Alfred's time, as it has recently been convincingly dated to around 100 BC. Later in 870 Aethelred died, and the

West Saxon councillors passed over all the other brothers to the one man who had proved his strength in battle: Alfred.

The next few years were marked by battle and retreat, with the Danes advancing for a while and then going off to Mercia and Northumbria to consolidate their inroads there. 878 AD was the crisis year, when the Danes under their leader Guthrum reappeared in Wessex in force, seizing Chippenham after the Twelfth Night celebrations. The West Saxons were in disarray, reduced to hit-and-run attacks on the Danes. Alfred retreated to the marshes around Athelney in Somerset, and it is here that the famous 'Alfred burning the cakes' incident took place – if the folklore is true. In May began the events that we find enshrined in Wiltshire folklore. Alfred gathered another army that he met at a place called Egbert's Stone, close to the boundaries of Wiltshire, Hampshire and Dorset. They then marched to Iley Oak near Warminster and rested the night there. The following day before daybreak they pushed on to Ethandun, and here defeated the Danes in battle, pursued them to the Danish stronghold of Chippenham, starved them out, and drove them finally from Wessex.

So much for the history books. Turning to folklore, we find that the memory of Alfred and the Danes has lingered very persistently in folk memory, in the names of fields and stones and wells and plants, and in all cases the Danes are most definitely the villains.

Swanborough Tump

At a corner of Frith Wood near Woodborough in the Pewsey Vale (SU13056015) is an almost imperceptible mound that played a great part in the history of Alfred. This is Swanborough Tump, named *swanabeorh* in 987 AD, the 'barrow of the peasants'. It was the meeting-place of Swanborough Hundred, the group of hides that covered most of the west end of the Pewsey Vale. It was here that Alfred and Aethelred met in preparation for their battles against the Danes, as we know from a passage in Alfred's will: "when we assembled at Swanborough, we agreed, with the congnizance of the West Saxon Council, that whichever of us survived the other was to give the other's children the lands which we had ourself acquired, and the lands which King Aethelwulf gave us." Alfred was a great landowner in the Pewsey Vale – his statue stands in Pewsey market place – so this would have been a familiar meeting-place for him and his brother.

So here the great effort to expel the Saxons from Wessex could be said to have begun, at a small barrow in the quiet Pewsey Vale. Down the centuries Swanborough Tump remained a significant meeting-place. *Wiltoniensis*

Tree and stone at Swanborough Tump.

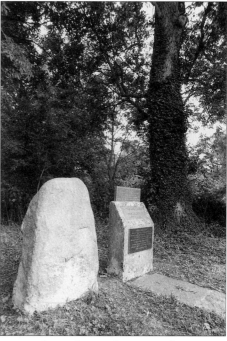

(a pseudonym which simply means 'Wiltshireman') noted that in 1764 a document proclaimed that the "tithing-man of Cheverell Parva in the said Hundred of Swanborough" was "required to be and appear before the said Steward at a Court Leet to be holden at Swanborough Ash..." This later form of the name, Swanborough Ash, derives from the three ash trees that grew on the mound. At the time when I still lived in the Pewsey Vale back in the 1970s, the original Swanborough Team of Parishes (Wilcot, Huish and Oare, Woodborough, Beechingstoke and Manningford Bohune) took as its emblem the mound of Swanborough Tump with its three ash trees. The image was designed to echo the Christian symbol of the hill of Golgotha surmounted by the three crosses, and on the Swanborough banner each tree bears a cross upon it. So Swanborough Tump is still a significant symbol in the parishes of Swanborough Hundred, although many who worship at those churches must be unaware of the long history behind the emblem on their banner.

Alfred and the cakes

The famous incident when King Alfred burned the cakes is supposed to have taken place in Somerset, while he was in hiding in the marshes of the Somerset Levels during 878 AD. The tale is told in the *Annals of St Neot's*, which date from the 12th century.

> It happened one day that a certain peasant woman, wife of a certain cowherd, was making loaves, and this king [Alfred] was sitting by the fire, preparing his bow and arrows and other instruments of war. But when the wretched woman saw the loaves which she had put on the fire were burning, she ran up and took them off, scolding the invincible king and saying 'Look man, you see the loaves burning but you are not turning them, though I am sure you would be charmed to eat them warm!'

The reason why I am relating this tale when it is based in Somerset, is that back in 1889, a folklorist called Powell collected a tale from the Deverill area which said that the place where this incident happened was in Brixton Deverill, on the grass ground south of the rectory. Alfred himself was known simply as "him of Stourton". And we shall meet more folklore that links Alfred strongly with the Stourton area.

Egbert's Stone

The location of Egbert's Stone, where Alfred gathered his army before the battle of Ethandun, has been a subject of debate for many years. There are several possible locations, but clear evidence is very slight, and the conclusions drawn by historians are really only based on calculated guesswork. Wiltshire folklore indicates two sets of sarsen stones which are in the right general area and which might be Egbert's Stone. The first is the boundary stone (ST773312), which was traditionally set up by Egbert at the side of the river Stour where the borders of Wiltshire, Somerset and Dorset meet. The place where three roads or boundaries meet is a powerful place in folklore, and this might indeed be a favoured location for a meeting-place. The other place is at Kingston Deverill, where some sad-looking

sarsen stones are propped together in an enclosure near the church. We are told in *Wiltshire Archaeological Magazine* that in 1877 "certain large stones were examined: they are called 'Egbert's Stones' or 'King's Stones' and are spoken of by the Saxon Chroniclers; they were brought by a farmer from King's Court Hill, where King Egbert is traditionally said to have held court..." By the time Maud Cunnington examined the stones in the 1920s, the folklore had become a little more general, and the saying was simply that the stones on the hill had been the meeting-place of kings.

'Egbert's Stone' where three boundaries meet

In this case we are probably seeing an instance of misinterpretation of the place-name Kingston, which means not the 'King's Stone' but the 'King's enclosure of land'. On the other hand, ancient sites, stones and barrows and hillforts, have been used as meeting-places down the centuries, and misinterpretation of a site's place-name does not preclude use of that site as a meeting-place.

'Egbert's Stones' at Kingston Deverill.

Six wells

John Leland tells us "The source of the river Stour is six fountains or springs which all lie on the north side of the park... Lord Stourton, whose family name is of great antiquity in the region, has the six fountains on his coat of arms." These six fountains or wells link in legend back to the time of Alfred's battles with the Danes. The six wells were to be seen in Six Wells Bottom west of Stourton village, three on one side of the county boundary, and three on the other. Olivier tells us "It is said, when tired from fighting with the Danes, King Alfred and his soldiers prayed for water, and up came six wells or springs. If legend is true, if this is not a holy well, surely a heaven-sent one." In fact, this tale is entirely in the tradition of holy well creation legends, when often a saint prays for water, and a well is formed in answer to her prayers.

Only one of the six wells is now readily located in Six Wells Bottom (SU761354), for it is marked by a most bizarre confection consisting of a shallow well-shaft covered by a grotto-like construction, topped off with a

15th century spire-like well cross which originally came from Bristol. The appropriately (if curiously) named well historian Skyring Walters tells us what is known of its history. "In 1474 a certain William Canynge left money to be expended by the Mayor for some good purpose, and William Spencer, the Mayor, chose a water-supply. He sank a Well, erected a Pump, and built Almshouses in the town [Bristol] at the junction of Dolphin Street with Peter Street; the well was called St Edith's Well and the pump St Peter's Pump. In 1586 Ralph Dole gave 20 shillings per year for the upkeep of this supply. In 1755 the stone cross that was over St Edith's Well was taken down and re-erected over the source of the River Stour, in Wiltshire, by Sir. R.C. Hoare. St Edith was a Saint of Wilton, near Salisbury, and lived c.968." So here we have a curious conglomerate of the well-cross of St Edith now standing over what we might call Alfred's well and locally known as St Peter's Pump in spite of the marked lack of pump. The history and the name are as oddly put-together as the well structure itself. The well, like so many in these days of excessive water-extraction, is now quite dry.

King's Hill or Kingsettle Hill?
Having gathered his army, and refreshed them with pure spring water from the six wells, the next vital step for Alfred would have been to ascertain the enemy's location. Myatt tells us "There is a strong oral tradition at Kingston [Deverill]... that Alfred the Great, before the battle, climbed King's Hill [ST848363] with his captains to look at the Danish position." But was this his lookout point, near the sarsen stones where he gathered his army, or was it just into Somerset at Kingsettle Hill near Stourton and the six wells, the hill now crowned by the 18th century folly named Alfred's Tower? Local tradition says that Alfred settled here before the battle, but this is most likely yet another example of a place-name which gives rise to explanatory folklore.

Iley Oak
"Iley is haunted by the tradition of King Alfred and his army on the eve of Edington", so Noyes tells us. This last resting-place of Alfred on the night before the battle of Ethandun is relatively easy to locate, as Iley Oak existed as a meeting-place until the 17th century, when non-conformists from Crockerton held their religious meetings secretly in the earthwork known as Robin Hood's Bower[1]. It was the Hundred Oak, the meeting-place of the Hundreds of Warminster and Heytesbury, which traditionally was by Lord Heytesbury's Lodge at Southleigh wood. Gover locates this at the place where five roads and footpaths meet, perhaps at ST882418. A henge is

marked in a field nearby.

Readers on the lookout for echoes of pagan beliefs in folklore will have been taking note of the regular appearance of wells and stones and trees (particularly oak, ash and yew) in the tales we have considered so far. These we know to be the three types of pagan sacred site, and they feature, either singly or in combination, in many folk tales. It was not until I sat down to write up my notes on Alfred, that I noticed how these various scraps of folklore, put together, have this Christian king, as he sets out to fight the pagan Danes, visit first a stone, then a well, and on the very eve of battle, an oak tree. Let us not imagine that this indicates that Alfred was a closet pagan – on the contrary, all his actions speak of him being a most devout Christian – but what we see here is an indication of the continued significance of these types of site in folk life and folklore and folk belief.

Victory at Ethandun

The Anglo-Saxon Chronicle tells us briefly that at Ethandun, Alfred "there fought with the whole force [of Guthrum's Danes] and put them to flight." It seems an unenthusiastic tribute to the decisive battle of the whole Wessex campaign. Ethandun has been fairly confidently identified as the downland near the village of Edington, which in a Saxon land charter dating from 880-885 AD was named *Ethandune*. The battle probably took place near Bratton Camp, the Iron Age hillfort in the next parish east from Edington. Peddie has reconstructed the events of the day, placing Guthrum and the Danes on

The vulnerable east side of Bratton Castle.

the high ground at Bratton Castle, which left Alfred no choice but to approach from the vulnerable east side, marching up from of Battlesbury Camp. "Both sides would have employed the shield wall formation. It would have been, for Alfred's men, an exercise in muscle and mobility, the men moving relentlessly forward, shoulder to shoulder in 'serried ranks'... with shields overlapping. It was the practice for shields to be drummed to intimidate the enemy: taunts and ruderies would have been hurled from side to side and there would have been many individual boasts of prowess. The clash and sound of battle, as the two sides came together, can only be imagined." And as we know, on this occasion the Saxons were victorious.

Local tradition tells us that the Bratton[2] White Horse was cut in celebration of this victory. This may indeed be the case, but it is unlikely that the Bratton horse is particularly ancient. The current horse was cut in 1778, an uninspired remodelling of a much more interesting earlier horse which some people believe to be genuinely ancient, contemporary with the Uffington figure. This seems doubtful: there is no documentary evidence for the earlier horse's existence before Wise wrote of it in 1742, when locals said that "it had been wrought within the memory of persons now living or but lately dead". The early horse was somewhat like the Uffington figure in that it was a long and low-slung, dachshund-like stallion with a tail that finished in a crescent moon. It was probably cut in the same spirit in which follies were constructed during the 18th century, as a fake antiquity, maybe even actually as a memorial of victory at Ethandun.

Danes at Winsley

Local place-names may, once again, have inspired the folklore from Winsley that a battle took place between the Danes and the Saxons at the time of Alfred. Danes Hill takes its name from the family of John Danys (noted in 1523); and Dane Bottom was plain Dean Bottom in the Tithe Award c. 1840. So neither name has anything to do with genuine Danes, yet we find quite a well-developed and neatly constructed tradition recorded in the *Winsley Scrapbook*.

Tradition tells of a great battle fought between the Saxons and the Danes at Turleigh Crossroads and the lane below still bears the name Dane's Bottom. In the field near this site... swords and weapons are reported to have been found... In the three-cornered plot of land known as 'The Piece'... King Alfred is said to have signed a proclamation of 'Peace' with his foes.

Danesblood

"Danes-blood (ebulus) about Slaughterford is plenty. There was heretofore… a great fight with the Danes, which made the inhabitants give it that name." John Aubrey notes this neat blending of two bits of folk etymology to explain the plant name and the place-name. 'Slaughterford' has nothing to do with any kind of slaughter, but means 'the ford by the sloe-thorn bush'. But putting it together with the Wiltshire dialect name for the dwarf elder, locals have created a fine tale to add to the catalogue of folklore about Alfred and the Danes.

The related name *Danewort* seems to have appeared first in the 17th century, so Aubrey must be one of the first to note the use of the local version, *Danesblood*, to designate the dwarf elder, *sambucus ebulus*. It is a herbaceous plant that grows in wet places and reaches about 4 feet tall. Its pinkish-white flowers appear in July and August. It was known for its strong purging effect, so much so that its most extreme effects – diarrhoea – was known, in Wiltshire as elsewhere, as 'being troubled with the Danes[3]'.

We find the same kind of tradition at Sherston too, this time dating from around 1800 when J.O. Halliwell wrote: "When a schoolboy… with other boys [I went] in quest of a certain plant in the field where the battle was said to have been fought, which the inhabitants pretended dropt blood when gathered, and called *Danesblood*… supposed to have spring from the blood of the Danes slain in that battle."

A full century later, Alfred Williams notes yet another similar tradition, this time at Highworth, where the local names Eastrop and Westrop contain the element 'thorpe' indicating a Danish settlement. Here the Dwarf Elder is known as *Danewort*, and "is said to have been introduced by the Danes and never to be met with but in the regions which they occupied".

Fight well, Rattlebone

The figure of a saint or bishop carved upon the east side of the church at Sherston holds a book, and seems quite a normal depiction of a church dignitary. But it has become mixed up in the tradition of Danes that we have already met at Sherston. This tradition dates at least from the times of John Aubrey, who tells us the statue is called "Rattle Bone, who… did much service against the Danes when they infested this part of the countrey… The old woemen and children have these verses by tradition, viz.

Rattlebone on Sherston church.

Fight well Rattlebone,
Thou shalt have Sherstone.
What shall I with Sherstone doe
Without I have all belongs thereto?
Thou shalt have Wych and Wellesley,
Easton toune and Pinkeney."

Later traditions tell us that the warrior is called John Rattlebone, and that a timber chest in the church, marked with the initials R.B., contains Rattlebone's armour. The story goes that in the course of fighting the Danes, Rattlebone was terribly wounded in the stomach. Rather than stop fighting, he snatched up a tile and pressed it to his wound to prevent his intestines from spilling out. It seems that in spite of the wound, he survived, for he is said to have been given the manor of Sherston as a reward for his efforts in battle. The carved statue on the church is supposed to show Rattlebone pressing the tile (book) to his side, and the rhyme noted by Aubrey tells of his reward, the manor of Sherston and associated lands. The Rattlebone Inn opposite the church has a brightly painted pub sign that shows Rattlebone in action.

'Fight well, Rattlebone'.

Athelstan's court

There is a tradition of a court held four times a year at the old Court House in Malmesbury. Athelstan, grandson of Alfred the Great, granted five hides of land to Malmesbury in recognition of their part in defeating the Danes. Ashworth tells us of the tradition as it took place in the mid-20th century: -

> When one of the plots of land becomes vacant, lots are drawn for it; the fortunate one goes to the King's Heath with the Under-steward, who cuts a turf from the plot, and handing it to him beats him three times with a twig cut from a tree on that piece of land with the words which have been repeated on such occasions from time immemorial:
> "This turf and twig I give to thee,
> The same as King Athelstan gave to me,
> And a faithful brother I hope thou'lt be."
> The under-steward then strikes the heel of his shoe into the ground, the new owner drops a two-shilling piece into the hole thus made, and all adjourn to a near-by inn to celebrate.

John Bowen tells me that this is called the Commoning Ceremony, and that it still takes place today. It is no longer a land-lease ceremony, but is now an initiation ceremony for a person to become a Freeman of Malmesbury. Since 1940 it has been held in the Court House rather than on the common, and the "near-by inn", the Royal Oak (known locally as the 'Slappy' after the back-slapping which went on there), closed many years ago. Applicants now place a coin upon a sod of earth, and are beaten (gently) three times on the back. On 20th July 2000 the conditions for application were amended to allow women to become Freemen:

> The applicant shall be a person of the lawful bloodline or a child by legal adoption of a freeman of Malmesbury. They shall be over 18 years of age and permanently residing within a radius of one and a half miles of the centre pinnacle of the market cross of Malmesbury.

On 28th September 2000, the first women were be given the freedom of this historic borough.

Crossed with the Danes

The Danes are remembered primarily for their warlike behaviour, but we should not forget that, like all the 'Northmen', although they came first as

raiders, they came secondly as settlers. Like all who have settled in these lands, they intermarried with the people they found here, and so, at least in popular understanding, children born of that bloodline were likely to have red hair. The nickname 'Daners' for red headed folk has been recorded at Marden in the Pewsey Vale and at Hill Deverill. Both these locations are interesting as they both have strong links with Alfred, as we have already seen. And at Chippenham, which was the stronghold of the Danes for so long, comes this account.

> When at the Cheese School at Chippenham, conversation turned on some one who happened to be red haired. The cheeseman, a native of Chippenham, said: 'he be crossed with the Danes', and upon my remarking about the matter, all present, I think, natives of Chippenham, Calne and Melksham, were of the opinion that red hair was a proof of Danish descent, or of a person being 'crossed with the Danes'.

Red folk from over the sea

The popular tradition of 'misrule' where the normal rules of society are turned upside down, used to be quite generally observed at Hocktide, the two days following Low Sunday, the first Sunday after Easter. On this occasion, single-sex groups of people would set out to catch members of the opposite sex, and release them on payment of a forfeit. In some places, men caught women on the Monday, and women caught men on the Tuesday, but equally often it was just a women's festival where they were able for once to overturn social norms. Hutton tells us that "they not only seem to have taken on the role of captors with gusto but to have found more willing victims"!

The tradition seems to date only from the later mediaeval and early modern period, but right from the start people claimed that it commemorated the struggles of the Anglo-Saxons against the Danish invaders, in particular the massacre of the Danes in the reign of Ethelred the Unready. There seems to be no historical evidence to support this origin, but we have evidence that it was believed in Wiltshire around the middle of the 19th century, as this account of Hocktide in Tilshead demonstrates.

> On the second Tuesday after Easter the women and girls used to run after the men and tie their ankles together, also their wrists, leaving them helpless. They used to band themselves together for mutual protection or climb trees out of the way. Often they would sleep in the plantations

and not return from their work in the fields. Next day the women were the victims. In old days no one was safe from this outrage. An old man who was asked the origin of this custom gave the following explanation: 'Ever so long ago a lot o' 'urd (red) folk from over the sea used to keep on a comin' and a upsettin' o' we, so at last we 'ouldn' stand it no longer, we up and at 'em, tied 'em up to posteses and cut their draughts [throats]'.

A refuge for an Empress

Devotees of the *Cadfael* novels of Ellis Peters will be quite familiar with the struggle for power that took place between King Stephen and Empress Maud during the 12th century. The focus of those tales is by and large in and around Shrewsbury, but some readers may remember that the Wiltshire market town of Devizes played a role in that civil war, for it was Maud's stronghold. After the raising of the seige of Winchester in 1141, Empress Maud headed towards Devizes, and it may be during this journey that she lodged, as recorded by Manley in 1924, at Parsonage Farm near Warminster (ST883462).

An indelible bloodstain

We shall probably never know whether King Richard III was guilty of having murdered his nephews, the 'princes in the tower'. They were certainly lodged during his reign in the Tower of London, which was a royal residence, and by the end of his reign they were no longer in evidence (although this view has been contested). The Constable of the Tower during their residence there was the Duke of Buckingham, and it is his rebellion and later execution that is remembered in Wiltshire folklore.

In 1483, Buckingham and his force rose against the crown, and he was officially proclaimed a rebel on 15th October. He marched with his rebels with some difficulty from Brecon to Weobley in Herefordshire. Meanwhile more rebels from East Anglia, Kent and Surrey were headed off and prevented from joining with him. His forces, depressed by the lack of support for his cause, began to melt away and soon Buckingham was handed over by one of his servants to the sheriff of Shrewsbury.

Meanwhile, Richard III had marched into Wiltshire and occupied Salisbury, and it was here that Buckingham was brought for trial. His pleas for mercy were rejected, and he was beheaded in Salisbury market place on 2nd November 1483. His defection and rebellion had barely lasted a month, a mere blink of an eye in historical terms, yet Salisbury and Britford retain vivid folk memories of his execution.

According to tradition, Richard III is supposed to have stayed in the

King's House on the West Walk in the Cathedral Close. The present house at 65, The Close, dates from the 15th to 17th centuries. It used to be called Sherborne Place in memory of the time when this property was the prebendal residence of the Abbot of Sherborne. It has been called the King's House since the 1780s, and the King after which it is named is not Richard III, but James I, who stayed there when he was visiting Salisbury in 1610. Nevertheless, Noyes tells us "An indelible mark on the floor is said to have been left by Buckingham's blood following his beheading in the market place". How his blood is supposed to have stained the floor here when the execution took place in another place entirely, tradition does not explain. Elsewhere Noyes continues: -

> The stone on which he is supposed to have suffered stands in the yard of one of the shops in Blue Boar Row… he was buried in the church of the Grey Friars, afterwards pulled down. Some years ago, however, a headless skeleton was dug up in the kitchen of the Saracen's Head – an inn, now long gone, which is thought to have formed part of the old Blue Boar – and this is conjectured to have been the remains of the beheaded Buckingham.

The row of shops known as Blue Boar Row still stands on the north side of the market place, although it is much changed since Buckingham's time.

Tradition also has it that Buckingham was buried not in the church of the Grey Friars, but in the splendid altar tomb in the chancel of Britford church. This is demonstrably not true, as the tomb was moved into the church only at the end of the 18th century.

What we see in these traditions is the neat way in which outstanding features of the locality (the King's House, the stone at the Blue Boar, the fine tomb in Britford church) are woven together with outstanding heroes or villains (Richard III and Buckingham) to make a pleasing and coherent whole – coherent in folklore terms, that is. Historically it is a complete disaster, but when have we ever let historical fact stand in the way of a good tale? The eclectic adaptability of folklore is one of its enduring charms.

The English Civil Wars, 1642-51

The English Civil Wars between Royalists and Parliamentarians seem of all conflicts fought in this land to have left the most lasting marks on the national consciousness. Perhaps because they were the last real wars to be fought here, and were fought relatively recently, folk memories of the time abound.

Battlefields across the country are haunted by restless ghosts of men and horses, and many buildings and topographical features keep some tradition of association with the heroes and villains of the time. The ubiquitous pub name, the 'Royal Oak', recalls the famous incident of the young Charles II hiding from his Roundhead pursuers in the Boscobel Oak, and there are many dilapidated castles across the country that purport to be 'one of the ruins Cromwell knocked about a bit'. Members of the English Civil War Society and the Sealed Knot meet to re-enact the various battles, and I suspect many of us 'support' one side or the other.

Why are memories of this time so persistent? Perhaps it is because this was not only a war over a struggle for political power, between King and Parliament, but because it was also a religious war, Catholic against Protestant, King against country, old faith against the new. Moreover this war was fought on everyone's doorstep, and nobody could ignore it. These things leave their mark, on the land, and on memory. In Wiltshire, as elsewhere, the memories run deep and bloody, and the ghosts scream in the darkness.

Oliver's Castle

Nowhere do they scream louder than at Oliver's Castle, on the edge of the Marlborough Downs overlooking Devizes. Here it was that on 13th July 1643 the battle of Roundway Down was fought. The Royalist forces under Lord Hopton had recently fought and won the Battle of Lansdowne. Understandably weakened by this effort, they had retreated to Devizes. The Parliamentarian commander, Sir William Waller, pursued them and besieged them at Devizes, resting his troops and using artillery to weaken the defences. Devizes was unfortified and could not long resist a siege, so Hopton sent his cavalry to Oxford, the King's base, to ask for reinforcements. Lord Henry Wilmot, Earl of Rochester, returned to Devizes bringing more cavalry, and the battle was joined on the high escarpment of Roundway Down.

It should have been an easy victory for the Parliamentarian forces. They were rested and had been able to choose their position. The Royalist cavalry were tired from their 40-mile ride from Oxford, and they were considerably outnumbered. But something went wrong. The Parliamentarian troops were scattered by two cavalry charges, and fled to the west. When Wilmot rallied his brigades and charged the Parliamentarian horse a third time, they were routed off the field. They too fled west, over the earthen banks of Oliver's Castle, and pitched headlong down the scarp to their deaths in the ditch

Haunted Oliver's Castle.

The long expanse of Roundway Hill with 'white horse' on slope to left.

below. Although all this happened over 350 years ago, people still from time to time hear the frantic thunder of hoof beats, and hear the screams of men and horses in the still of the night. Over 800 of Waller's men are said to have been buried where they died in what is now known as Bloody Ditch.

It was on Roundway Down in the early 1970s that a young couple were suddenly surrounded by mist, out of which came trotting several white horses. This was a strange and uncanny experience, but the horses simply disappeared into the mists again. Whether these ghostly horses were connected in any way with the battle is uncertain, but there is no doubt that the Civil War battlefields are badly haunted by apparitions ranging from single soldiers to entire armies. My colleague, Betty Hubbard, regularly used to hear the Parliamentarian cavalry riding up the road below the Lansdowne monument near Bath. She never saw anything, but she would hear the hoof beats and the jingle of bits, and smell the leather of their buffalo-hide tunics. Such experiences are not uncommon at Civil War sites.

Oliver the villain

The Oliver of Oliver's Castle is, of course, Oliver Cromwell himself, and it is typical of folklore to name an ancient site after him even though he never fought in the famous battle associated with it. After the Devil, this admirable though fallible man is probably the most famous folk villain in England. Like many folk villains, he is connected with many sites and incidents that have no links with him in historical fact. Alan Smith tells us, "These are perhaps the strongest Cromwell traditions: that he was a furious destroyer of castles and a cynical desecrator of sacred places." He seems generally to have become a symbol of the spirit and attitudes of the Parliamentarians, or at least a symbol for the destructiveness, narrow-mindedness and bigotry with which the 'Puritans' are credited in common belief. His role as desecrator of churches may spring in part from confusion with Thomas Cromwell who under Henry VIII was prime mover in the dissolution of the monasteries, most of which fell readily into decay as a result. Certainly Oliver Cromwell is credited with destroying various buildings that were in ruins long before his lifetime.

Cromwell's Yew

I have three different versions of a tradition about a yew tree. The first is from Ella Noyes, who records in 1913: "A certain not very venerable-looking yew tree, close to the road between Bishopstrow and Norton Bavant, is reputed by local tradition to have been breakfasted under by Oliver

Cromwell on some occasion when marching through this part." Manley, writing in 1924, and a resident of Warminster, is able to locate the tree exactly for us: "Where the Norton-Bishopstrow boundary post stands on the Salisbury road is a small yew tree which folk refuse to have cut down. A reliable authority speaks of Cromwell having rested in the shade of a yew hereabouts after his defeat at Roundaway [sic], and this tree is claimed to be the one." Finally, Leete in 1979 records: "Cromwell breakfasted under a yew tree here after the Battle of Newbury."

What fascinates me about these various accounts is that in spite of the existence of two published versions of the tale, Leete who writes over 50 years later manages to find a third version. If he is recording a true local tradition (as Noyes probably was and Manley certainly was) then what we see here is an example of how folklore changes over time. As I have commented elsewhere, none of these tales is the 'correct' version. And if a tradition still attaches to the yew tree, which still stands beside the B3414 road at ST90254395, it may well have changed again. It is noticeable too that Cromwell is playing the role of a personification of the Parliamentarian forces, for he was not personally involved in the defeat at Roundway.

A town for King Charles – or for Cromwell?

Marlborough was strongly Parliamentarian during the Civil War, and there are several tales about Cromwell attached to buildings in the town. It is said, however, that the Royalists once entered the town crying 'A town for King Charles!', which must have enraged the inhabitants somewhat. Not all seem to have been Parliamentarian, though. Where the Roman Catholic church now stands in George Lane was the site of the Old George Inn. "It is said that Cromwell slept at this inn and the smith at the forge... refused to shoe his horses." Inn names change all the time, but the George in George Lane bore that name between 1614 and 1675, so the period is right, and maybe there is a grain of truth in the tale. Cromwell seems to have liked inns, for he is also said to have stayed at the Rose and Crown, No. 112 High Street, which is now called Cromwell House.

Cromwell's Rest

Almost at the bottom of the steep village street at Conkwell is a small house called Cromwell's Rest, and it is recorded in the unpublished *Winsley Scrapbook* that "Cromwell is said to have stayed at Cromwell's Rest before going on to Farleigh Castle. He watered his horse at the wishing well." The wishing well is the beautiful little dipping well that lies in the green

Conkwell's dipping well with Cromwell's Rest above.

triangle at the foot of the village street (ST79156260), just above Spring Cottage and close by Cromwell's Rest. It is certainly the spring after which Conkwell is named, and the name means simply 'well on the steep hillside'. The name contains the very ancient element *cunuc*, which is pre-Saxon, and suggests that Conkwell may be a very old settlement based around this spring. Cromwell's men are supposed to have poisoned all the wells in the area, except for this one at Conkwell.

Yet again we find key figures and key features of the locality woven neatly together to make a pleasing whole. Though I have no record of this, it is likely that the well has 'never been known to fail', as this is so common a feature of significant springs. The variant on this, woven into the Cromwell tradition here, is that the well was not poisoned, that it did not fail the community in that way. The activities of Royalist troops in this area close to Lansdowne and Roundway are personified by the figure of Cromwell himself yet again, and it is pleasing that this time he is not a destroyer but a preserver of the landscape, even if it was only so that he could water his horse.

Civil War at Hill Deverill

There are a handful of Civil War traditions around Hill Deverill, which perhaps date from the time of a cavalry skirmish that took place near the Deverill road above Warminster Common. Certainly there is a tradition that Cromwell stabled his horses in the old Manor House barn – a tale that seems to indicate cavalry activity in the area, if not the presence of Cromwell himself. The farmer's house associated with the mill at Hill Deverill is supposed to have been "a rendezvous or headquarters". On the hill south-east of Manor Farm, "cannon were said to have been mounted, and to have

battered down the 'houses' which stood on the rising ground south of the church." Powell, who noted this tradition in 1889, comments that the 'houses' are "really the site of a British village". He appears to have been referring to the mediaeval village of Hill Deverill, which is clearly marked to the south-west of the church, with many earthworks and house platforms, on the Ordnance Survey map in the area of ST866403.

War scars at Salisbury and Netherhampton

Olivier provides two tales about the Civil War activity around Salisbury. Leading from Netherhampton to the racecourse is an old Roman Road (SU105285 area) and it is here that a running fight is supposed to have taken place.

> When a Netherhampton farmer was digging chalk for his farm at the side of this road, helmets, breast-plates, arm and leg pieces, etc, were discovered in addition to human bones which were collected and buried in the churchyard. The stone on the main road to Harnham at the foot of this old road is said to be a memorial of the fight.

This may have been linked to the skirmish led by Waller, which Olivier tells us left bullet-marks on the wall of the Bishop's garden in the Cathedral Close.

Cannons at Castle Hill

Alfred Williams records how two haymakers from Lus Hill believed that "the prehistoric camp at Blunsdon was made by Oliver Cromwell". This is Castle Hill, north-east of Broad Blunsdon at SU157912. Williams notes elsewhere how a cannon-ball hanging in chains inside Highworth church is the missile which made the hole in the stonework of the church tower, and that the shot was supposed to have been fired from Blunsdon Hill. This must be sheer fantasy, for we know that the cannon of that period could not have hit a target three miles away. This seems to be the only Wiltshire tradition I have yet located which portrays Cromwell in his role as desecrator of churches, and it is also pleasing to find him (as we have found Robin Hood earlier in the chapter) incongruously associated with a prehistoric monument. Besides building the hillfort at Castle Hill, he and his army are supposed to have camped in one of the Common Farm group of earthen circles (SU210932) while they were attacking Highworth. Once again key features of the landscape and community, and folk villains, are woven together to make one consistent (if not coherent) tale.

Cannonball damage on Highworth church tower.

Civil war fantasy: replica cannonball in Highworth church.

The Gibbet Oak

Our last tale of Cromwell shows him as a responsible General keeping order in the countryside. Journeying on the *Highways and byways in Wiltshire*, Hutton tells us: "From Melksham I went out to Seend, passing on the way Bower House, a red brick building of 1631, and the oak upon which Cromwell is said to have hanged three men for pillaging." Bower House, now renamed Woolmore Farmhouse, is a glorious building which stands beside the A365 road to Devizes at ST917624. A little further on to either side of the road are several fine oak trees, though whether any of these is the Gibbet Oak mentioned by Hutton I am unable to say.

Charles II: defeat and flight

We move forward in time now to the year 1651. Charles I has been beheaded, and his son Charles II is king in exile. In an attempt to regain the kingdom, Charles marched south into England with a mostly Scottish Army (his grandfather James I was also James VI of Scotland) and met General Cromwell and the Parliamentarian forces in battle at Worcester on 3rd September. The Parliamentarians outnumbered the Royalists by two to one, and although the Royalists held the bridges across the river Teme for several hours, Cromwell finally succeeded in driving them back into the city. The Royalist cause was lost, and many units that fled to the north were captured by the Parliamentarian troops that now surrounded the city. The English Civil Wars had ended.

Charles himself managed to escape, and he spent six weeks crossing England on his way to the coast where he found a boat to take him to France and safety. It is fascinating to find that we can track his flight across Wiltshire from the folklore that remains.

Time for a game of cards

We first meet the young king in flight through the Pewsey Vale. In the church at Manningford Bruce is a tablet to the memory of Sir Edward Nicholas and his wife Mary, who was the sister of the famous Jane Lane. Jane was instrumental in helping Charles II to escape after the Battle of Worcester, for she passed him off as her manservant and rode pillion behind him through countryside teeming with Parliamentarian troops. The tale itself is the stuff of legends. Charles is supposed to have stayed the night at Manningford Bruce rectory while on his perilous journey to the coast. Kathleen Wiltshire recounts how a Miss Coles once spent the night in what is reputed to have been the King's chamber at the rectory. She woke on two

occasions during the night, and both times saw a group of gentlemen in 17th century costume, playing cards by the fire. One of them was the image of Charles II.

Warminster to Netherhampton

Charles obviously had to take a wandering course across the county, for we hear of him next at Warminster in the south-west. Here he is said to have stayed at Yard House in East Street, before going on to Netherhampton House near Salisbury where he was in hiding for some days. The King's Arms in Salisbury is where his friends are supposed to have met to plan his escape.

King Charles and the pond

Finally we find Charles close to the Wiltshire border, in the parish of Farley to the east of Salisbury. This account dates from the late 1980s, and is almost certainly still current in the area.

> In this area there is a very strong folk memory – indeed it is suggested that it had been passed down from father to son in these villages – that at the time of the Commonwealth, King Charles disguised as either a farm labourer or forester was seen by Commonwealth soldiers when working around the pond in Blackmoor Copse. The leader of the gang was asked 'Who is this man?' and he replied that he was a new recruit but that he was quite a good worker, or such words to that effect. The soldiers were persuaded that that was the position and went off.

Treasure on Knook Down

Our last tale of the Civil War is an odd one, related by an old shepherd named George Pearce as part of his personal reminiscences, and published by Olivier in the 1930s. Pearce tells of a strange incident that led to the discovery of buried treasure.

> Many curious things have happened to me when out with sheep at night. When on Knook Down, I could see little lights seeming to bob up and down. I would go where I thought I saw it, and then not see it. I told master one day. He said, 'I'll spend a night with you, not to-night – I'm busy; perhaps tomorrow.' So he did, and saw the lights.
> 'Do you think, George,' he said, 'if we went over you could tell the place then?'

'Yes,' I said, going there; and I showed him the spot I'd marked.

What did he do then but write up to London, and the Government folk sent lots of soldiers with picks, spades and lots of things, and they dug about and found guns and swords and dead bodies, and where the lights were a large box of valuables and money. I had all I wanted to eat and drink free while it was going on. They gave me £2. My master thought they ought to have given me more, and tried to get me more, but it was no use.

In folklore, dancing lights often indicate the location of buried treasure. The Danish folklorist Johansen explains, "It has obviously a physical as well as a psychological basis. Whenever organic matter decays in graves and bogs, gases are produced which in certain conditions are luminescent. When people have observed these phenomena their imagination has been vivid enough to encourage them to interpret various sense-impressions as lights, especially where and when they expect them to be there. Thus light and treasure are often found in combination."

If, as I am simply guessing, the bones and weapons found on Knook Down dated from the Civil War period, any bodies would have decayed long ago, and surely could not have produced in any physical sense the lights which George Pearce saw. So what did he and his master see? A will o' the wisp? The spirits of the dead men flickering over their unquiet grave? We cannot know, but it is interesting that this tale from Wiltshire, told as a factual reminiscence, complies with the traditions of buried treasure-tales from Denmark (and elsewhere) as well as from England. These tales seem to rise from a common archetypal level of consciousness that goes deeper than nationality, perhaps coming from our common ethnic origins as Indo-Europeans. Folklore is demonstrably more than just quirky stories for long winter evenings: it follows identifiable patterns and repeatedly incorporates specific motifs.

The hanging judge

There is a tale that Judge Jeffreys stayed in Bratton at the time when he was doing the rounds of the Assize courts on the West Country circuit. In this case the tale most likely arose because of the existence of Court House, where the Manor Court was held. Nowadays people assume that a court must be a court of law, and it is a small step then to associate it with the bloodiest and most ruthless judge the folklore of the western counties can provide. He can be tracked in folklore all around the villages of the West Country.

One typical example comes from just over the county border at Norton St Philip. Mike Mayo told me that it was here, at the George Inn, that Jeffreys condemned several men to death. When the soldiers marched the men out of the George and through the pub opposite to be hanged in the orchard behind it, they also took and executed the man who held open the gate to let them pass. It is his ghost that is said to haunt the George.

Death over Salisbury Plain

Much of the rest of this book will be given over to ghost stories, so it seems appropriate to set the scene by ending this chapter with a sighting of a ghost which is linked to military activity of the 20th century. Moreover this is a ghost with a difference, for it is a ghost of a machine, not of a human being. Sir Michael Bruce wrote to the *Evening Standard* in 1953 about a strange experience of his during the Second World War.

> Shortly before D-day I was sent on a course of instruction at Larkhill. Four of us went with an RAF W/O in a jeep to select suitable gunsites; we were coming up from the north towards the road which runs past Stonehenge, and between us and the road lay a small copse; suddenly we all saw a very small aircraft dive straight down into the wood and

> disappear in the trees; we raced the jeep up to give assistance; there was no sign of a crash – nothing – nothing flying away to the south. Suddenly I heard the W/O shout; he was standing white-faced before a large stone cairn commemorating the first death from an aeroplane accident in this country in 1912...the monument refers to Captain B. Loraine and S/Sergeant R. Wilson, who died in 1912, the first members of the RFC to do so.

Memorial at Airman's Corner.

We can see the monument to Loraine and Wilson, because it stands on the green triangle at the junction of the B3086 and A344, at SU09854290. The spot is still named Airman's Corner.

We need not be too surprised to read of the ghost of an aircraft, or of any machine. Ghostly vehicles of all kinds – not just the ubiquitous coach-and-four, but cars, buses, trains and ships – abound in ghostlore, and force us to question the traditional view of the ghost as the spirit of a person who has died. So now let us leave (thankfully) the stresses of war behind, and set out on a journey across the fields and roads of Wiltshire in search of the many ghosts and legends that can be found there.

References
Battle at Battlesbury: Noyes (1913), p.186; Gover (1939), p.158.
Battle at Patty's Bottom: Olivier (1932), p.74.
Romans at the Treasurer's House: Wilson (1995), pp.152-7.
Romans at Cherhill and Oldbury: Wiltshire (1973), p.20.
Hengist and Vortigern at Amesbury: Geoffrey of Monmouth (1966), pp.164-5.
Churchyard battlefield: Noyes (1913), p.131.
Earliest battles ever fought: Williams (1922), p.28.
History of Alfred of Wessex: compiled from Wood (1981), pp.104-125, Savage (1995), pp.90-96, and Peddie (1992).
Swanborough Ash: Wiltoniensis (1896-8), pp.243-5.
Alfred and the cakes: Powell (1901), p.77. The tale from the *Annals of St Neot's* is quoted in Peddie (1992), pp.112-3.
Egbert's Stone: Myatt (1982), p.47; Anon (1877-8), p.275; Cunnington (1927-9), pp.261-2.
Six wells: Leland (1993), pp.502-3; Olivier (1932), p.83; Walters (1928), p.147.
Kings/Kingsettle hill: Myatt (1982), p.50.
Iley Oak: Noyes (1913), p.178; Myatt (1982), p.44; Gover (1939), pp.154-5.
Battle of Ethandun: Savage (1995), p.96; Peddie (1992), p.134-7.
Bratton white horse: Marples (1981), pp.67-76; Bergamar (1997), pp.90-4.
Danes at Winsley: Wilson (1994), pp.43, 136.
Danesblood: Aubrey (1969), p.50; Jones (1987), pp.110-1; Westwood (1986), p.61; Williams (1922), p.34.
Rattlebone: Whitlock (1976), p.99.
Athelstan's court: Ashworth (1956), p.202.
Commoning Ceremony: John Bowen, *pers. comm.*, Malmesbury, 2000.
Crossed with the Danes: Wiltshire (1973), p.25, Whitlock (1976), p.118, Goddard (1942-4), p.29.
Red folk from over the sea: Goddard (1942-4), p.29; Hole (1978), pp.144-8; Hutton (1997), p.207.
Maud at Parsonage Farm: Manley (1924), p.11.
An indelible bloodstain: historical details taken from Jacob (1961), pp.625-6; folklore from Noyes (1913), pp.106, 122; Hutton (1919), p.87.
The English Civil Wars: an excellent concise overview (for GCSE students!) is at *http://www.aber.ac.uk/~ednwww/PGCE/ohc94/ecw/history/ecw.html*
Battle of Roundway Down: Leete (1979), p.122; history taken from *http://www.aber.ac.uk/~ednwww/PGCE/ohc94/ecw/battles/roundway.html*
Oliver's Castle ghosts: Wiltshire (1984), pp.10-11.
Ghosts on Lansdowne: Betty Hubbard, *pers. comm.*, University of Bath, 1992.
Oliver the villain: Smith (1968), p.27.
Cromwell's yew: Noyes (1913), p.190, Manley (1924), p.11, Leete (1979), p.98.

A town for King Charles: Hughes (1953), p.54.
Cromwell and the smith: Hughes (1953), p.12, Chandler (1977), p.70.
Cromwell House: Hughes (1953), p.15.
Cromwell's Rest: Jones (1990), p.56; *Winsley Scrapbook* quotation read to me during a telephone conversation with Margaret Wilson, Winsley, 1994.
Civil War at Hill Deverill: Myatt (1982), p.76-7; Powell (1901), p.77.
War scars at Salisbury and Netherhampton: Olivier (1932), pp.46-7.
Cannon on Castle Hill: Williams (1922), pp.28, 34; Allen (1935-7), p.115.
The Gibbet Oak: Hutton (1919), p.402.
Charles II: defeat and flight: once again the historical facts are taken from *http://www.aber.ac.uk/~ednwww/PGCE/ohc94/ecw/battles/worcester.html*
Time for a game of cards: Mee (194?), p.240; Wiltshire (1973), p.69.
Warminster to Netherhampton: Manley (1924), p.11; Olivier (1932), pp.46; Hutton (1919), p.61.
King Charles and the pond: Cory (1988), p.29.
Treasure on Knook Down: Olivier (1932), p.40; Johansen (1991), p.229.
Jeffreys at Bratton: Jean Morrison, *pers. comm.*, Bratton, 1994.
Jeffreys at Norton St Phillip: Mike Mayo, *pers. comm.*, University of Bath, 2000.
Death over Salisbury Plain: Whitlock (1976), p.187.

Notes
[1] Robin Hood was a very popular folk hero. His tales were spread all over the country in the form of ballads and on broadsheets, so we need not be too surprised to find him here in Wiltshire.
[2] Bratton people insist, with justification, given that the horse is in Bratton parish, that it should definitely not be called the Westbury white horse.
[3] In 1980, when I was on a language course in what was then the Soviet Union, any of us suffering from this complaint would say we had 'the Trotskys'. Blaming the villains (preferably making a good pun in the process) seems to be a perennial tradition.

Chapter 4

Out and about

Fear lurks in dark and lonely places

Nowadays we live in a world flooded with artificial light. Our homes, workplaces and the towns and cities where we live are all brightly lit to enable us to continue our work and leisure activities well into the hours of darkness. It is seldom that we experience real darkness any more: where I live in West Wiltshire, for example, the light pollution from the many towns and villages glows against the night sky, and it is never really dark. And even when we drive across lonely areas like Salisbury Plain, the strong halogen beams from our headlights ensure that the road is clear before us. A journey by night is not, by and large, the difficult, dangerous and frightening undertaking that it used to be in years gone by. Modern society's fears centre on the violence done by one human being to another, but fear of the uncanny creatures lying in wait for us on roads, and in fields, has largely left us.

But it is clear from Wiltshire's folklore that going out and about used to be a very unnerving business. There were all kinds of ghosts to be met with at crossroads, stiles and trackways. There were strange tales of the ancient earthworks, barrows and stones that are scattered across the county. And there was always the chance that you might meet and offend the local witch, who might be in human form or have transformed herself into a hare, toad or crow.

Let us not be too confident of our immunity from such encounters in the 21st century. There are still plenty of strange experiences to be had out and about in Wiltshire, as you will see from the personal accounts among the tales that follow. Let me set the scene with an odd event from my own childhood…

Woden sleeps in Woden's Barrow (now Adam's Grave) above Alton Priors.

A lone footprint in the snow

I grew up in Orchard Cottage in Oare at the heart of the Pewsey Vale. I was out with two friends one winter's day in the mid-1960s, and we were walking through the snow alongside the hedged bank at the edge of one of the fields near my home. We were all under 10 years old, but even at that age we knew when we found the footprint that it was very bizarre indeed. For this was just a single footprint, of a naked foot, in the snow by the hedge. There were no prints leading towards or away from it. Moreover the foot that had made the print had been twisted up oddly, more like an ape's paw than a human foot. I remember bending over looking at this footprint with my friends for a few seconds, and then we took fright and headed off back up the field to the safety of home. How a solitary print of a naked foot got into the snow that day is something I have never been able to work out.

Folklore of archaeology

The barrows, earthworks and standing stones in the county have attracted all kinds of folklore and legend over the centuries. I have already collected together many of these tales and they were published in 1990 as *Folklore of ancient Wiltshire*. Since then I have found some more folklore of this kind, which illustrates the continuing power of ancient sites to fascinate, inspire and haunt us. I can, for example, add some new accounts to the store of published folklore about Stonehenge.

The Slaughter Stone

The folklorist Theo Brown recorded a "curious little incident" told her by the antiquarian T.C. Lethbridge: -

> A vicar he knew accompanied a small party there for a couple of days. The first day they wandered round the stones till they came upon the so-called Slaughter Stone. Here they paused, until a small dog in the party sat down and howled dismally.
>
> The next day they returned to the same spot and the dog repeated its performance. Everyone was most impressed and told Mr. Lethbridge about it later. 'The dog knew!' they said.

Lethbridge had been very amused by this tale, because the stone's name is simply a piece of romantic supposition, and there is no evidence that the stone has ever had any sacrificial function. His interpretation of the event was that the dog had sensed the mood of the people as they looked at this

'site of slaughter' and had howled in response to their unease.

The gods are angry

When excavations have taken place at ancient sites, particularly in earlier years, locals have often warned the excavators that there are likely to be dire consequences if they continue. There was a famous incident at Silbury Hill in 1849, when the final stages of the excavations there took place in a very violent thunderstorm, "much to the satisfaction… of the rustics, whose notions respecting the examination of Silbury…were not divested of superstitious dread." An incident very much in this tradition took place at Stonehenge itself in 1987. At that time, Brian Davison was Inspector of Ancient Monuments at Stonehenge, and in 1995 he told me the tale of how a team from the University of Bristol came to do some petrological work on the bluestones. This involved taking small samples from the stones themselves, and not surprisingly there was a fair amount of mock apprehensiveness about the whole exercise.

> We joked and said, 'Well, you know, even if people don't see us, the gods will see us and we'll be struck down.' Well, we finished our work about 9 o'clock at night, and cleared it away, and said 'Well, there you are, it's all superstition. Nothing's happened. No thunderbolts. No claps of thunder.'
>
> That was October 1987. Six hours later we had the hurricane!

It is very satisfying to speculate that the Great Hurricane of 1987 might have been caused by unwary archaeologists sacrilegiously chipping bits off the stones of Stonehenge. Let others beware!

We are profoundly unimpressed

It is fairly normal for people to travel miles to visit famous places, but to neglect the sites on their own doorsteps. I grew up within 10 miles of Avebury circle, but didn't visit it until I was 16 years old. I used to be rather ashamed of this, but then I found a tale about someone who was even more apathetic.

> The story goes that in days when travel was less easy than it is at the present time, a Wiltshire man journeyed to Rome. He was entertained on his arrival by a company of distinguished Italian archaeologists and proposed to listen eagerly to their talk. But they did not discuss Roman

antiquities as he had anticipated - they wanted their guest to tell them about Stonehenge, which, they declared was more wonderful than anything in Rome. The Wiltshireman, with regret, had to confess that he had never troubled himself to visit Stonehenge. So the Italians threw him out of their gathering.

I am reminded by this of the incident recounted to me by someone who happened to be in the car park at Stonehenge when a party of Americans got out of their coach. One man took a single unimpressed look at the stone circle and exclaimed incredulously, "That's Stonehenge? Everybody back on the bus!"

W.H. Hudson, who wrote *A Shepherd's Life*, was also unimpressed by the great henge.

How did these same 'few old stones' strike me on a first visit? It was one of the greatest disillusionments I have ever experienced. Stonehenge looked small – pitiably small!... Was this Stonehenge – this cluster of poor little grey stones? ... How incredibly insignificant it appeared to me, dwarfed by its surroundings – woods and groves and farmhouses, and by the vast extent of rolling down country visible at that point.

Although I have seen Stonehenge more times than I can count, I too am still surprised by how small it seems, overshadowed by its celebrated reputation and the wide expanse of the Plain.

But for some of the visitors to Stonehenge it is not the stones themselves that are a disappointment, but the human-created mess of roads, car park, tunnel and surrounding fencing. When I stopped briefly at Stonehenge a few years ago, I was fascinated to read among the various social documents inscribed on a door in the Ladies' toilets[1], the following plaintive lines: -

Stonehenge that I've come from Manchester to see,
Why is it the people that have disappointed me?

Let us hope that the current plans to remove all these modern accretions are successful, so that we can see Stonehenge stand once again within its ancient landscape, as it did for so many centuries, solitary upon the Plain.

A scattering of stones

Everyone knows Stonehenge and Avebury, but there are plenty more stones scattered around the county that have names and traditions to mark them out as significant. Most I have mentioned already in *Folklore of ancient Wiltshire*, but I have since identified a few more, or found more details about ones already listed.

Passmore tells us of a standing stone at Stanton Fitzwarren. "NE of the Church about 400 yards, in a hedgerow by the footpath leading from the village to the Highworth-Swindon Road, stands a large sarsen stone 4 feet 6 inches above ground. It is a rough brown stone in its natural state." This may be the stone after which Stanton ('the farm by the stone') takes its name, and is probably the one on which 'Stivvy' Legg sat all night so that he could see it turn round at cock-crow. Stones often have the reputation of being able to move, and this may stem from some residual belief in their powers.

A stone in Cley Hill bottom is supposed to have a rude face carved on its underside. How people know this, if the face is underneath, is hard to say.

Cuckoo Stone

A stone known as the Cuckoo Stone stands near Durrington at SU14654335.

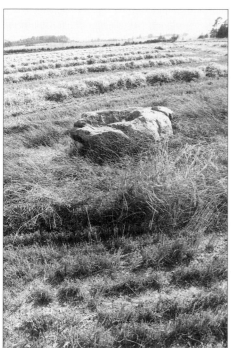

"… a huge sarsen stone is marked on the southern border of the parish on a line from the river to the avenue of Stonehenge, and at no great distance from Durrington Walls. This stone has long been called the Cuckoo Stone. Whether it was removed from, or, as is more probably, was dropped on the way to Stonehenge, must be uncertain." It is one of the few sarsens on Salisbury Plain outside Stonehenge itself, and its name suggests that it is out of place, an interloper, like a cuckoo in the nest.

The stone is also significant in the field of earth mysteries, for it lies on a Watkinsian ley that stretches along

Cuckoo Stone, Durrington.

the Stonehenge cursus, through the Cuckoo Stone, then through Woodhenge and on east to Beacon Hill. Dowsers have found 49 coils of energy spiralling out around the stone and leading off towards Durrington Walls and Woodhenge.

Work of the Devil?

Aubrey Burl notes "unsubstantiated reports" of a bluestone, called the Devil's Whet Stone, somewhere in the Summerham Brook near Seend.

It may be that this stone, and the Cuckoo Stone, were dropped by the Devil on his way to build Stonehenge, like the sarsen stone in the river at Bulford. "The traditional explanation is that the Devil, having, by Merlin's command, bought the stones from an old wife in Ireland, bound them in a withy and flew hither with them, and as he was crossing the river at the point the withy slackened and one of the stones dropped out."

Another stone dropped by the Devil in this way stands in a field in East Knoyle (ST883312). Locals still remember the tale, but it seems to have lost some detail over the years. Wiltshire author and historian John Chandler told me how he heard two local farmers saying that the stone was supposed to have 'dropped out of the sky'. They also said that there is supposed to be as much stone under ground as above.

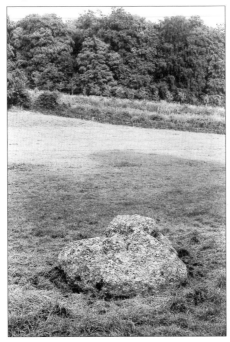

Dropped by the Devil at East Knoyle.

The Blowing Stone silenced

Near Crown Inn at Aldbourne, on the pavement east of the village pond, is a large sarsen stone with a small deep hole at one end of its upper surface. This is a blowing stone, not as powerful as the one at Uffington (which sounds like a tuba – take along a good orchestral brass-player if you visit it) but it was quite powerful enough to really get on villagers' nerves when small boys repeatedly sounded the stone. In the end the blacksmith plugged the hole, and although the plug was later removed, the hole's contours had changed and the stone is silent now. Indeed, when I asked about it at the pub, nobody knew where it was, or anything about it.

Aldbourne's blowing stone, silenced forever.

Old May Day at Durrington

Durrington used to celebrate May Day on the 13th May, a custom which we can deduce dates from before the calendar changes of 1752, when we 'lost' twelve days. 'Old Christmas' now falls on 6th January, which we know as Twelfth Night, and Old May Day on the present 13th May. Men would fetch a may-bush from the downs on the previous night, and fasten this to a maypole that was set up on the Cross Stones. On Old May Day itself, villagers would dance around the stones to music of concertinas and whistle-pipes, and then feast on cakes and ale.

Does the Gladiator still walk?

One of the features which we have already noted about archaeological folklore is the tendency people have to associate any earthworks, barrows or stones with the earliest civilisations of which they are aware. We have seen how various earthworks were associated with the Danes, and another favourite nation for such associations is the Romans. Just as the earthworks of Figsbury Ring are known as Chlorus' Camp, so the long earthwork which

runs down into the Avon valley at East Chisenbury (SU140523 area), and crosses the avenue to Chisenbury Priory, is locally known as the Gladiator's Walk.

Tormented by guilt

The only way Gladiator's Walk can claim to be Roman is by its name, but there are plenty of Roman remains in Wiltshire. The most remarkable for me is Chute Causeway, which breaks all the popularly understood rules of road behaviour in that it is both Roman and curved. The hill above Chute Causeway was the site of a tragic incident during the plague years of 17th century. The folklorist Christina Hole tells the story: -

> A pathetic and terrible legend accounts for the ghost of a clergyman who haunts the Roman Road known as Chute Causeway, near Vernham Dene. In Charles II's reign the plague which devastated London fell also on this remote parish… When this dreadful scourge broke out in Vernham Dene, the Rector persuaded his stricken parishioners to isolate themselves on the top of the hill along which Chute Causeway runs. He undertook to look after them and supply them with food, and perhaps he really intended to do so when he gave that promise. But when the time came, his craven fear of the disease was too much alike for his courage and his honour. He could not bring himself to go near the pest-ridden camp for fear of infection, and he left his wretched people to die one by one of starvation and plague. His betrayal of those who trusted him did not save him; the disease seized on him and killed him like the rest. Since then his ghost has been seen from time to time walking up the steep hill towards the site of the camp, repeating perhaps a journey which he may have started many times during that terrible time and never had the courage to finish.

This tale stands in stark contrast to the well-known story of the Derbyshire village of Eyam, where the villagers also isolated themselves from the rest of the surrounding countryside so as to contain the plague and prevent it spreading to their neighbours. But at Eyam their clergyman, the Rev. Mompesson, stayed with his congregation and suffered with them, for though he survived, his beloved wife was one of the last to die of the plague. In this Wiltshire tale – for though Vernham Dean is in Hampshire, Chute Causeway and the hill above it (SU320560) are in Wiltshire – we find the rector being punished for his cowardice and neglect. Moreover he suffers both in this life and the next, for not only does he die horribly of the plague

in spite of his cowardice, but also his ghost does everlasting penance by retracing the route that he had so feared in life. If, as Claire Russell asserts, ghost traditions arise from emotional interactions between two or more living people, this tale may have grown up spontaneously as a means of comforting the relatives of the plague victims.

Three barrows

Many of the barrows in the county have individual names, or some specific tale attached to them. Gawen's Barrow, at Broad Chalke, was named after the Gawen family of Norrington; but John Aubrey apparently thought it had something to do with a Knight of the Round Table, for in his notes about it he quotes a few lines of Chaucer that allude to Sir Gawain.

There is a barrow near Figheldean that in 1704 was known as Gallows Barrow, and it forms part of a small group of Wiltshire ancient sites that are associated in fact or folklore with executions. Others are Wansdyke near Devizes where there was a gibbet, Grim's Ditch that aligns on Gallows Hill (SU136214), the Hanging Stone between Alton Barnes and Woodborough (SU099605), and the King Stones near the church at Kingston Deverill.

On Copheap, the hill above Warminster on the edge of Salisbury Plain, there is a tumulus (ST880455). Shuttlewood writes, "tradition has it that an early Saxon chieftain and his family were interred in the bald patch of earth on the top of the mound in the midst of tree growth." This is typical of the burial tales associated with barrows. They rarely tie in with the actual age of the archaeology, but look back to the earliest society known to the local populace – in this case the Saxons who, as we have already seen, were so active in this area in their battles against the Danes.

These three sites are good examples of the different types of folklore associated with barrows: they are named after historical or mythical characters; they are associated with violent death; they contain burials (often, although not in this case, of treasure). Much of the folklore that follows will be concerned with death and burial, and as tale follows tale we shall begin to understand just how haunted the countryside was for our forebears.

Kit's Grave

We go now to another of those places of power where three boundaries meet. Kit's (or Kitt's) Grave is the name given to the meeting-point of Hampshire, Wiltshire and Dorset, at SU132212 on the edge of Vernditch Chase. It is also a crossroads, for tracks follow the three boundaries and a fourth road meets them at the crossing-point. There is a barrow here, and

in 955 AD it was listed on a Saxon land charter under the name of *Chetolesbeorge*, the barrow of Ceotol. It is fairly easy to see how Ceotol's Grave could over the centuries become Kittle's Grave and finally Kitt's Grave, and the name of a copse nearby, Chettle Head Copse, suggests that this is just how the name was modified. Nevertheless, local folklore has developed various versions of a folk tale that explains just who Kit was and why she was buried in this out-of-the-way place. Kit is the first of the many suicides we shall meet in the tales that follow.

Edith Olivier has recorded two versions of the tale: no doubt others exist.

Some time, before the memory of living man can definitely fix, a suicide was buried in Vernditch at the spot where meet the boundaries of three counties, Wilts, Dorset and Hants. The mound above the grave was to be seen there in the early days of the present generation, but since that time Dame nature has seen fit to cover it with a pall of bluebells and nut bushes. No tombstone marks the unhallowed ground there at the lane's end, leading to the open down, but the place is marked on the Government Ordnance maps as Kit's Grave. An avenue of trees leads to this eerie spot, and no bird is ever heard to sing there. Legend has it that a girl from the village of Bowerchalke, finding life too sad, drowned herself in a well near the church-yard. But suicides were not buried in consecrated ground, superstition so decreed. No parish claimed her remains and uncertainty existed in Bowerchalke, bordering as it does on the intersection of three counties, as to which county she belonged to, so she was interred where no one should remember her, at the junction of the three counties of Wilts, Dorset, and Hants. And, as often happens, a result opposite to that intended has come about, in that her sad end has give a place-name to un-named ground, and the name of Skit's Lane to the lane by the Church near the well in which she sacrificed her young life, - names that remind everyone of the terrible thing that happened to her.

Clearly this is an example of folk etymology, and a very advanced one. The tale is complex and well thought out, finding both a reason for the curious name and the explanation for burial at so isolated a spot. Other key elements of folk tales are included: for example, the motif that 'no birds sing' can be found at many reputedly eerie locations, such as Sally-in-the-Woods[2] between Bradford-on-Avon and Batheaston.

This first account seems to me to be just a little too good to be true, as if a simple tale has been embroidered by the teller to make it more coherent and

moral. But the second tale recorded by Olivier seems much more authentic.

> Kit's Grave, at the cross-roads near Vern Ditch Down. An old gipsy
> woman who used to frequent the Chalke Valley was found in a well near
> Bowerchalke Church. It was thought that she had committed suicide, so
> she was taken and buried at the cross-roads at night, with a stake through
> her heart. An avenue of trees leads to the spot, and no bird is ever heard
> to sing there. (This is indeed a very weird, eerie spot).

Here we have the same basic elements: the suicide in the well, the burial
at the distant location, and the same insistence on the eeriness and silence
of the place. But the suicide was of an outsider, a gypsy, and she is treated
with the suspicion due to an outsider and one who has committed the crime
of suicide. She is buried, as many such were, at the crossroads with a stake
through her heart. This was a double precaution: the grave would try to
reject her sinful and restless corpse, and so the stake was intended to hold
down her body and stop her 'walking'; and if it failed in its duty, the location
at the crossroads would confuse her ghost, for she would not know which
road to take.

Highworth roads
Roads themselves, not just crossroads, seem to have been seen as potential
or actual burial sites. " 'There's nar a road neether comin' in, ner it gwain
out o' Hywuth, but what carpses lays at,' says 'Old Jonathan'." Nevertheless,
the unquiet burials with which we are largely concerned in these pages, can
be found almost exclusively at crossroads.

Parker's stone
Whenever I cross Salisbury Plain I am struck by its loneliness and desolation.
It seems that I am not alone in feeling this, for Goddard records the sad fate
of one inhabitant of the Plain.

> There is a short stone post (? part of a pillar or stem of a cross) in the
> grass just south of Netheravon track and east of the old Devizes and Sarum
> turnpike road, near Shrewton. It is said to mark the grave of a Mr. Parker,
> curate of Rollestone, who went mad, from loneliness, and having killed
> himself was buried at the cross roads. Canon Bennett, Vicar of Shrewton,
> wrote to C.V. Goddard that he had heard this from his predecessor, Mr.
> Matthews.

This is a magnificent tale, because as far as can be ascertained, none of the details are true. Mr Parker does not seem to have existed at all. There was a Rev. F. Perrot Parker who officiated at a burial service at Rollestone in 1870, but he was curate of nearby Maddington, not of Rollestone itself. And far from committing suicide, he left Wiltshire to become rector of a parish in Staffordshire. Nobody else named Parker had officiated at Rollestone since 1654, as far as we can tell from the parish registers. So we appear to have a tale about a suicide that never was, of a curate who never existed. Perhaps the point of the tale is to 'explain' why the stone post should be at the crossroads. As we have seen, the crossroads was the traditional burial place of suicides, therefore (people would reason) a stone like a gravestone must mark a suicide's grave. And why would anyone commit suicide at Rollestone? John Chandler tells me that the parish registers show how "it was very seldom that anyone was baptised, married or buried at Rollestone (hence Parker's loneliness?)". The enforced solitude and isolation of the place must have struck people strongly, since it seems to play such a key role in the sad tale. Parker is one of several suicidal clergymen we shall meet in Wiltshire folklore.

More suicides' graves

Near Redlynch, where the steep lane from Bohemia crosses the B3080 in the direction of Hatchet Green (at SU 204191?), is a spot called Strawn's or perhaps Strachan's Grave. In 1922, the Rev. A.C. Muller said that this was a suicide's grave. The steep lane was known as Hangman's Hill. This spot is at a crossroads, and the county boundary runs nearby. Both of these are favoured traditional sites for hangings and burials.

At the crossroads[3] in Wootton Rivers a suicide was buried, "and every night, at the hour when he took his life, his corpse is said to swing". At Newtown in Warminster, "human bones unearthed at a cross roads reminded a man of a suicide who was buried there with a stake through him."

Gammer Piper's Grave

In the manuscript return for Allington near Amesbury that forms part of *Wilkinson's Parish Questionnaire* of around 1860, the incumbent, Alfred Child, has recorded the history of Gammer Piper.

> If from Allington Tree (one of five among the houses) one walks one mile on the way to Amesbury over the downs you come to a small mound of earth called Gammer Piper's Grave, Gammer Piper being a suicide

whom old Roger Rumble, the Churchwarden of Parson Garson, notoriously and quasi King of Allington, had buried in the cross-down tracks one mile from the village with a stake through her body, the grave is very insignificant in fact a stranger would not notice it at all…

Indentifying Gammer Piper's Grave nowadays is complicated, as this part of Wiltshire has changed a great deal because of military activity: Boscombe Down airfield is just to the west of Allington. Older Ordnance Survey maps show a crossing of tracks at SU 189406 that would be about a mile from Allington and so in the right place. Whether there is anything to be seen now I think unlikely, particularly as the grave was difficult to find back in 1860.

From suicide to vampire?

But these few examples (there must be many more across the county) show the consistency of this particular folklore motif: you bury a suicide, who has broken the law of state and church, at a crossroads, and stake them through the heart to hold them down. Students of vampire-lore will be familiar with the technique, which is deeply ingrained in folk tradition as well as fiction and film. Vampires are few and far between in England, although there have been a few recorded, notably at Berwick on Tweed where there was a veritable epidemic in mediaeval times. Vampires in folklore – 'genuine' vampires as opposed to those in fiction or on film – are destroyed not by a stake through the heart, but either by burning or by decapitation. The stake is used solely to hold the unquiet corpse in its grave. Traditionally, suicides are prime candidates to become vampires, and these tales of staked-out suicides are the nearest I can come to examples of proto-vampires in Wiltshire.

The place where the grass will not grow

> *Salisbury Plain*
> *Never without a thief or twain.*

The truth of this little rhyme has been proven again and again by stories of travellers waylaid by footpads on the Plain. One such incident is commemorated in an entry in the church register of Maddington: *William Lawne, sonne of Giles Lawne, barbarously slaine neere ye Windemill, Sept 23ʳᵈ, and buried ye 24ᵗʰ of ye same, 1666.*

A correspondent writing in *Wiltshire Notes & Queries* of 1899-1901 gives

the contemporary local tale that relates to this simple entry: -

> Canon Lowther informed me that the old clerk of Orcheston St. George, whom he found in office when he took the Rectory in 1830, told him that the man who was murdered at the Gibbet, had taken a large sum of money at Warminster market. The ostler of the inn where he put up knew this, and after he had left Warminster followed him, and shot him at the place where the Gibbet now stand, making off with the money. The murderer was apprehended, and hanged in chains at the crossways of the London and Warminster and Shrewton and Devizes tracks. Old people remembered the stump of the Gibbet there when I came to Maddington, and there is still a tradition that where it stood, 'on a place like a grave (which I could never find) nothing will grow.' Canon Lowther told me that the story was stated to him by the clerk in Orcheston St. George churchyard, who pointed out a place to him, saying, 'And here, sir, lies the man that heard the shot fired.' The Canon had no idea that it took place so long ago as the entry in Maddington Register Book proves it did, and he believed that the clerk claimed to have known the man who heard the shot fired.

The Gibbet is clearly marked on the Ordnance Survey maps at the place where the roads from Chitterne and Devizes meet just north-west of Shrewton (SU 059446). Some years ago I drove out there and investigated, and found a wooded triangle where the roads join. I wandered among the trees, hoping against hope to find 'the place where the grass will not grow', but all was entirely normal and the ground beneath the trees showed the usual mixture of undergrowth and leaf-mould. But I find that Andrews & Dury's map of 1773 shows a 'Gibbet Tree' marked just to the south of the Chitterne road at this point, so perhaps I was looking in the wrong place.

Disruption to natural growth caused by the spilling of blood is a common feature in folklore. We find it at Dragon Hill near Uffington, where the dragon's blood was spilled, for there is a bare patch on the flat top of Dragon Hill that never gets overgrown. At Edington in 1449, Bishop Ayscough was killed by rioters on the hillside near the Priory church. Noyes tells us, "A spot used to be pointed out as that which had been watered by the Bishop's blood; people said the grass grew there so rank that cattle would not eat it." The message seems to be that when an evil being dies, or evil is done, the earth is poisoned by it.

Dor's grave

This small clump of trees in Aldbourne parish has a tombstone hidden in the undergrowth, and it is here that Dor is supposed to haunt. Gandy relates how the Vicar of Baydon at the end of the 19th century met the ghost of Dor. When walking home one night, the Vicar saw a man in a snow-white shirt standing beside the tree clump. Coming up beside the figure he was stunned to see that it had no head. Knowing that Dor was supposed to have hanged himself here, and realising that this must be the ghost, he spoke to the figure, asking if he could help it. At this the ghost faded away.

From the details Gandy gives in her text, we can place Dor's Grave on or close to the parish boundary on Green Hill, partway between Peggy Knowle Copse and White Pond Buildings, in the area around SU 274763. No trees are marked on the maps, but this may mean nothing, for there can be errors and omissions on Ordnance Survey maps.

The Vicar related this short account in the *Marlborough Times*, apparently with the aim of challenging the spirit of rationalism in his readers. It was presented as a genuine experience, and since a clergyman is speaking, how can we doubt his word? But it bears the hallmarks of ghost-lore of its time. Judging by the tales, ghosts have changed their behaviour over the centuries. Ghosts of the 17th century might harangue their listeners with awful warnings: 'as I am now so shall you be'. The Christianity of the time was full of such dire moralising. In the 19th century, when muscular Christianity was in vogue, they would fade away if challenged by someone with the courage to say, 'In the name of God, why troublest thou me?' Our modern-day ghosts are usually mysterious, independent beings that surprise us, but generally do not interact with us. Each century generates ghosts that are in tune with the social attitudes of the times, and in this at least, ghosts are part of folklore.

The Three Graves

Our last burial tale relates to a place-name from the parish of Urchfont, and we find it in three variants. The first was published in *Notes & Queries* in 1820: -

> In a field in this parish, adjoining to Wickham Green, the property of Wm. Tinker, Esq., of Littleton, in this county, are three graves, of John, Jacob, and Humphry Giddons, who are said to have died of the plague. It appears, indeed, from the parish register, that this disorder raged in the parish in the year 1644, and it is natural to conclude that the above-

mentioned persons were buried at that time, though there is no mention of the names in the register.

This is a neatly historical tale, which even gives the names of the three men. But folklorists might look thoughtfully at the number three, which with seven and nine recurs so often in folk tales, and wonder just how much of this tale is history and how much folklore. We note that their names are not mentioned in the parish registers, which is a little odd. So which came first: the place-name or the story? We have seen how old names acquire very detailed explanatory legends. It might easily be that the tale had grown up to explain why three graves were to be found outside the bounds of the churchyard: plague victims were not to be buried near dwellings. It might even be true. We cannot know. But the tale has changed a little since the early 19th century, as this account from 1984 shows: -

A little further on were the three graves where lie the bodies of men who died of the plague. They fled from London only to die in a lonely spot, where they were buried. A resident put a brass plate with a memorial verse on one of the three trees...

Now we have three nameless plague victims who fled from London, and the graves have acquired three trees and a memorial plaque. But Doris Sevier, who grew up in Urchfont, sent me this version of the tale in 1995: -

In Urchfont there are three trees linked to three men. One died and the other two buried him; the next one died and the last one buried him. Then he died, and three trees grew on their graves.

This is clearly the same tale, but we have lost the cause of death, the names, and the place of origin. What we have instead is a beautifully balanced account of death and rebirth, as each man dies and is buried in turn, and the three trees grow to mark their graves and perhaps symbolise life rising out of death. Of the three tales, it is the most elegantly crafted.

The Three Graves is marked at SU023569. A footpath leads from a trackway towards Oakfrith Wood, but does a curious dogleg at the start, for no apparent reason, unless it is to go first to the Three Graves. However, there is nothing to be seen in the field nowadays, no trees and no graves. Unless the Ordnance Survey has got it wrong, the Three Graves have gone. But if you are lucky, like me, you might see a hare[4] and a deer instead.

Fellow travellers

There can hardly be a village in the whole of Wiltshire that does not have its tale of a ghostly horseman or of a coach and horses, which rumbles through the lanes nearby. In Oare in the 1960s I was told of the coach and horses which crosses the main A345 at the top of Granham Hill above Marlborough, and of another which travels the old coach road which runs from the crossroads on the Pewsey road towards Draycot. In 1997 I gave a talk in Oare for members of Wiltshire Farming Club, and I took the opportunity to ask about this last ghost. Michael (Mick) Giddings, who has lived in Oare and Huish all his life, confirmed the story. He told me that Jim Ferris (whose family moved down from Huish hill to live in one of the houses by the post office) saw it, but it was crossing the road, not travelling down it. Mick also volunteered the information that at Draycot crossroads a man rides by at midnight on a white horse. Back at the other end of the coach road, a 'black funeral' would turn onto the Marlborough road towards Oare, then turn up the drive of Highleaze. Joan Gradidge knew of this haunting all her life, and says, "So many were said to have seen this and it's explained as a duel having taken place at Stowell, a fatality. The hearse was hastened away in order to avoid being found out. How did the miscreants get out of that one?"

A midnight rider haunts Draycot's lonely crossroads.

These are typical stories, which conform so strongly to the stereotypes and motifs of traditional ghosts that we might easily write them off as local legends. But now and again we find that people do see ghosts of this kind. It seems that the old coaches still travel the lanes.

Hoofbeats in the snow

Kay Wells once told me about the time her newspaper delivery man saw a ghostly coach and horses.

It was...when there was a lot of snow about. Coming out of Pewsey, do you know a place called Little Ann? Well at the top there, he had just delivered a paper to that bungalow. Well as he came out, he heard the sound of horses - so much so that he stepped back - and it was of course a carriage that came past. And that was about 6 o'clock in the morning. It was probably about 10 years ago, in the winter when there was snow on the ground. And that was why he couldn't make out - he thought, you know, why can I hear this? And he stepped back, and it was just a ghost. He was really frightened, because when he told my husband, he said he was really scared. After that, for a little while, he was quite scared of delivering the paper there. At the time, my husband came and told me how scared Mr B[...] had been, and he wasn't a man who actually believed in that kind of thing.

The sound of hoofs striking hard on the road when they should have been muffled in snow was clearly a disturbing experience. I wonder whether this haunting is in any way connected with the 'white funeral' that was said to appear here, moving down the Fyfield to Little Ann brow. Joan Gradidge tells me that a local policeman fainted when he saw the white funeral, and this is clearly a very similar incident to the one in Kay Wells's tale.

Omen of the headless horsemen

A Bratton resident told me of the experience a neighbour of hers had after moving away from the village.

There's the headless horsemen at Bishops Cannings. Some people from Bratton went to live at Bishops Cannings and, 'I didn't really want to go,' she said, 'because they've got ghosts there.' 'Don't be ridiculous', I said, 'you're supposed to be a Christian, not to believe in things like that.' But she was gone about 6 months or so, and I met her in Devizes market, and she said, 'All that tale,' she said, 'you were scoffing at me,' she said, 'it's true', she said, cause her great-aunt had come out to stay with her - she'd come from London or summat - and she only stayed two days cause she'd seen these headless horsemen and carriage, and it means a death in the family if you see it, so she went home!

This tale seems to be an example of belief in the Death Coach, which was (and apparently still is!) fairly widespread over Wales and the West Country. This black coach was driven by a headless coachman, or occasionally the Devil, and would carry away the souls of sinners. It is similar to the belief in the Churchyard Watcher, who was the last man to be buried in the churchyard. He would drive an invisible, but audible, cart around the countryside by night, and if the sounds halted outside your house, there would indeed be a death in the family. The Watcher was only relieved of his duties by the next man to be buried in the churchyard.

With these contemporary sightings in mind we may be a little more inclined to believe the older tales of coach sightings. Here are a few places where you might go to look for phantom vehicles and horsemen.

Phantom hearse

Bratton itself has a ghostly vehicle, of which I have been told by several inhabitants of the village. Kathleen White, for example, told me, "We do have a hearse drawn by black horses, you know, come along the lower part of the village, at midnight on midsummer's day."

This seems to be another variant on the death coach, this time transformed into a hearse. In midsummer's day it has also acquired a most significant time to appear, the time of greatest light when nature is at the height of her vitality. Perhaps this tale is designed to remind us that 'in the midst of life we are in death'.

Echoes of death

There are two ghostly vehicles in the area of Heale House in the Woodford valley. An 18th century chaise, with either headless coachman or headless passengers - or perhaps both - crosses Bowles Bridge east of Heale House (SU129364). The Bowles family lived at Heale House itself.

Nearby Saltern or Salterton Hill was haunted by the sound of a dreadful accident.

> There is a tale told that late one night a carter and his team were returning from market, and coming down Saltern Hill, when something frightened the horses and they bolted, throwing out the driver and killing him; so for some time afterwards folks were afraid to go along the road after dark, as they declared they could hear the rumble of the waggon, and hear the horses galloping, so they said it was haunted.

The carter would have taken the trackway from old Sarum, rather than the modern metalled road, and so Saltern Hill must be the trackway down the steep hillside from the downs leading to Salterton Farm, at SU130355.

A wager that went wrong

Another ghost that appears only on a given night of the year appears in the parish of Stourton with Gasper.

> A headless horseman is said to haunt the Sloane Track, which leads from Penselwood to the lower end of Stourton (known as Gasper), followed by a black dog. The history is that this man made a wager at Wincanton Market-place to ride his horse to him home at Stourton in seven minutes. He took a cross-country route and broke his neck galloping down the Sloane Track. So now his ghost haunts the road - but on New Year's Eve only.

The Sloane Track does not appear by name on the Ordnance Survey map of the area, but I wonder whether it is the trackway that leads from Pear Ash Farm to Bottle's Hill and down the hill and across the river Stour to join the lane south of Stourton. It is a steep trackway, like Saltern Hill, and I suspect that both these tales may have served the purpose of warning local people of the dangers of driving or riding recklessly on steep hills at night.

The Double Shutte

No social purpose that I can identify seems to be implicit in the tale of the Double Shutte. It seems simply to have been the site of a repeated uncanny experience.

> Some seventy-five years ago a young man who lived at Newton Toney was in the habit of using the path through the Wilbury Estate to get to his work at Cholderton. He was working for a farmer and often had to rise very early in the morning to walk to Cholderton to take a load of corn by road to Devizes. To cross the Drive one has to go through two gates which are called the Double Shutte to this day. At night, as soon as he opened one gate, there was a tremendous pattering, just as if invisible hands were picking up handfuls of stones and throwing them up to fall again on the drive. He invariably took to his heels and ran, but as soon as he was safely through the second gate, the pattering ceased... I knew the man who told the tale, and he was quite incapable of imagining this.

As we have seen before, gateways, portals and boundaries are uneasy places. We use them to pass from one place into another, and this crossing-over is a chancy business. Here at the Double Shutte we find a double crossing-place, with two gates and an area of nomansland in between them, a place that is in a sense between realities, and where strange things may happen.

I have experienced something less dramatic, but similar to this, on the road between Beckhampton and Devizes. At one time I used to travel this road quite often at night, and after passing the Beckhampton roundabout I would usually start to feel uneasy, as if there was something in the car behind me, and I would find myself looking in the mirror to check. This feeling of uneasiness would not lift until I crossed Wansdyke, and for some reason I always associated it with the round barrows in the area. Quite recently, and without knowing of my experience here, my friend Alison Borthwick told me that she often hears people calling to each other on just this section of road.

Two Wilbury ghosts

Perhaps the occurrences at the Double Shutte were linked to another haunting at Wilbury House, which seems to have greatly disturbed the villagers who lived nearby.

> ...they say a black retriever then keeps them company, and a phantom clergyman is seen between the house and the lodge gates. They seem both to have been seen very recently, and graphic accounts were given by near relations of those who saw them.

With this account we look forward to a type of ghost we shall consider in some detail later, the black dog. Let us just say for now that this is a typical example, in that it is a retriever-like dog that accompanies travellers on their route. The ghostly clergyman is one of various sad clerics that haunt the county. He seems to have been unnerving, but harmless enough, unlike the disruptive Squire Crowdy of Highworth who had to be dealt with very firmly indeed.

Squire Crowdy returns

> When the squire died his spirit returned and continued to haunt the drives, as is seriously believed by the townspeople. Sometimes he

appeared holding the shafts of the coach and drawing that noisily up and down the yard and before the house; at other times he walked the streets at midnight, with the halter [his customary sign of self-abasement and humiliation] around his neck, and struck fear into those who happened to be abroad at that hour. At last it was decided to lay the ghost. The Vicar, bailiff, and jurymen were approached, and one dark night they set out for the squire's house - locked up and deserted - and attempted to carry out the rite. But it proved a difficult matter, for the spirit was sulky, and resisted the efforts of the parson to pacify it. Finally, however, it consented to be laid on one condition, namely, that it might be allowed to enter a barrel of cider and remain there. So they proceeded to the cellar, where stood a large barrel full of apple juice. Someone took out the bung, the spirit entered, and the hole was securely stopped up again. Then the mason and his men were fetched out of their beds and the door of the cellar was bricked up; that was the last ever seen or heard of the squire's spirit.

Here we have the tale of a squire who was so full of life that he refuses to lie down and die. But nobody thinks of staking out this one, for he is no suicide, and although he is troublesome, you get the feeling that the townsfolk regard him with affection. So the parson and his helpers are called upon to lay the ghost. Very often ghosts are laid in the Red Sea (how this is achieved I am unsure) but in this case they are able to persuade him, in death as in life, no doubt, to take refuge in a barrel of cider. Let us hope he rests in peace and true refreshment of spirit.

A ghostly sack - of what?

It is difficult to classify this next ghost, if ghost it is. Truly bizarre entities do seem to walk the Wiltshire downs. In 1864, Edwin Meyrick, the Vicar of Chisledon, recorded in *Wilkinson's Parish Questionnaire* a very strange ghost indeed. He writes of "a gulley in which a row of elm-trees stands, called Pinham Bottom, up which a *sack of water* is said to walk at midnight." And clearly not believing it, and perhaps embarrassed at writing this on a serious survey sheet, he adds, tongue-in-cheek, "The object of this strange peripatetic, this deponent knoweth not."

I wonder whether this sack of water, which suggests a being that has some kind of coherent shape, but which moves and flows in an amorphous way, is in fact a Wiltshire example of the Boneless. Briggs tells us that Boneless was a "formless thing whose chief function it was to terrify

travellers, or children in their beds", and she gives examples from Somerset and from Oxford. The Oxford Boneless is described as "A shapeless Summat as slides behind and alongside in the dark night. Many's have died of fright through his following on."

When us got together...

But as we know it's easy to be mistaken when you first catch sight of something. Here's a tale from Bishops Cannings, that famous village of fools.

> When I were walking whoam to Cannings t'other night across the vields, ther come on a bit of a vog, but 'twer not so bad that I coudn't zee my way, and when crossing the second vield I seed our Jim coming t'ords I. But on getting a bit nearer he didn't zeem to me to be quite like our Jim, and when we met, why, dang me, 'twernt neither of us!

This is a tale that used to be told – and still is – in my family, and our ending is better balanced and more satisfying: -

> ...'ee looked at I, and I looked at 'ee, and when us got together, 'tweren't narn on us!

Considering witches

There are, of course, a fair number of witches in Wiltshire. We need not be alarmed at this prospect. Most witches one encounters these days are Wiccans, working within that tradition of witchcraft that has grown up during the 20th century as part of the renaissance of nature religions in this country and elsewhere. Wiccans are Pagans, and live by the Pagan Ethic that states simply, 'Harm none'. So if you discover you have witches living next door, there's no need to worry, any more than you would if you lived next door to Moslems, or Buddhists, or Hindus, or Christians.

The problem is that we have all grown up with the image of the witch as a malevolent old hag cackling wildly in the corner of some dank and tumbledown cottage as she stirs her foul and evil-smelling cauldron. Fairy-tales and folk tales are all full of such images. We assimilate them in our childhood, and they lurk in our subconscious ready to poison our perceptions in later life. In his hugely detailed study of modern witchcraft, Hutton tells us that by far the most common question he is asked about modern witches is not 'How does their religion compare and contrast with

others?' or even 'What do they believe?' It is, again and again, *'Do their spells really work?'* We seize on the thing we fear – magic – and forget that magic, if it exists, is simply a tool in the hands of a human being. Like any tool, pen or axe or knife or shotgun, it is only as dangerous as the person wielding it.

As well as Wiccans and witches in similar traditions, there are one or two of the old-style traditional village witches still around the county. A friend (who I shall not name for obvious reasons) has told me that in her village people cross the road to avoid meeting one such witch. These witches are strong-minded women who certainly have some kind of power. A village witch told me once that she could silence dogs simply by looking at them. "I have startled some dog owners by walking up to the door when the dog didn't say a word: I'd looked at it." Is this magic, or will-power? It seems to me that they are the same things, for what is magic but a way of achieving results by the concentrated power of the will?

After all this well-balanced commentary and attempt to dispel stereotypes, I fear I must admit now that in these pages we shall largely be concerned with the witch in the folk tradition, and these witches tend to be, if not malevolent, at least rather contrary and difficult characters. Unlike the witches in fairy tales, these are recognisably ordinary human beings, but with some extraordinary powers. Folk-tales of witches, like other folklore, recur as variants of the same basic type over and over again. Shape-shifting is one common characteristic of these tales, and the ability to freeze a horse to the spot, to find lost possessions for people, and cast or lift a spell.

The Witch of Winterslow

Liddie Shears is a typical witch in the folk tradition, clearly based on a real person, neither good nor evil, but regarded with some awe and suspicion even when she was working for people's benefit. Olivier records one version of her story, collected from an old Winterslow inhabitant: -

> As a boy, in 1872, he [Mr. S.J.Collins, the informant] remembers seeing Thomas Shears, Lydia's son, who was then about 70 years of age. He used to haunt the neighbourhood of his mother's old cottage, which was standing until a few years ago. Mr. Collins also remembers hearing an old poacher speaking of his early poaching days, referring to 'old Liddie Shears', and saying if the poachers did not take old Liddie some 'snuff and baccy' there would be no hares. If the 'snuff and baccy' were

forthcoming, old Liddie used to go round the fields on moonlight nights with a flint and steel and strike sparks, which caused the hares to sit up, only to be shot down by the poachers. The approximate date of the story would be about 1810. There are farmers now living who attend the Winchester and Romsey markets to whom the story of the Winterslow Witch is quite familiar.

Over the Downs at Winterslow, some little distance from Farmer Tanner's homestead, there stood a lonely cottage occupied by Lydia Shears, of whom the village people had a dread. Farmer Tanner, who kept a stud of greyhounds for coursing, always passed her house several times a day. 'Shall I find a hare to-day, Lydia?' he would shout. 'Oh, yes, farmer; you will find one in the middle of that field', was her usual answer. And sure enough he did, and the hare was always lost in one particular spot at the back of the witch's cottage. The farmer could never understand it, so he mentioned the matter to the Rector of West Tytherley, who advised the farmer to make a bullet out of a sixpence, and to get someone to shoot the hare when it came in sight of the cottage. This advice was acted upon, and the hare was shot dead as it entered the garden. But afterwards, as they called at the cottage, there was the body of Lydia Shears lying on the floor dead, and upon examination the silver bullet was found to have caused her death.

So let us examine this tale and pick out some of the characteristic features of the village witch. She required some kind of payment or bribe in return for her services; she lived apart from the villagers; she had power over animals; she could shape-shift (in this case into a hare) and she was typically slain by a silver bullet fired at her when in animal form, but the bullet is found lodged in her human body.

Hares were so much associated with witches, that Trevelyan records Welsh women saying of a hare that was slow to cook, "This old witch has many sins to answer for." Indeed, although witches could take the shapes of other animals, the hare was the most common. So Liddie Shears is absolutely typical of her kind. The bullet that slays the hare must be silver, for silver is protective, and turns away the Devil. Thus it is clear why a silver bullet must be used to shoot a witch-turned-hare, as witches were popularly believed to be the servants of the Devil. But silver is generally lucky, and used in a great many ways for protection and good fortune – this is just one of its powers. Poor Liddie was unfortunate in being killed by the bullet. Some witches escaped with being left lame or disabled.

The witch of Tidcombe

A similar tale is told of the witch who lived at Tidcombe in the east of Wiltshire, and she seems to have inspired so much awe in one of her neighbours that even after her death he was unwilling to speak of her. It is largely the same tale as that of Liddie Shears, but this time the wounded hare is followed to the witch's cottage, so that we are left in absolutely no doubt that the witch and hare are one and the same.

> J.L. was a farm labourer who was positively scared if anyone referred to his having any knowledge of the witch of Tidcombe. Yet, with bated breath, he was on one occasion prevailed on to tell what he knew to his master. Hesitant and reluctantly, he related that when a boy he used to work for Mr. Tanner of Tidcombe, and that at this particular time they had been sowing towards the bottom running to Martin, and that the rooks were following them doing much damage. The foreman decided to get up early before break of day to set about these rooks. He was standing in the shelter of the hedge running from Martin to Tidcombe, when he saw a hare. He shot at it and could see he had wounded it, for it crept away at the side of the hedge, but not going too fast for him to follow it. He followed it, and to his astonishment it went into a cottage at Tidcombe. The same day, later, he heard that the old woman who lived in the cottage was ill, and the following day she died. Unfortunately, the master, who tells this story, has forgotten the old woman's name, although J. L. did give her name and firmly believed the story – so much so, that it was a slip when he first referred to her, and a long time after before he would tell the complete story.

Stopping every team

Alfred Williams's books are full of tales of witches, so many that I cannot include them all here, and will have to content myself with a selection of those I believe to be most authentic. So I must leave out Bet Hyde, Poll Packer, Peggy Tawnley the hermaphrodite, and even the beautiful young woman who took her newly wedded husband riding on milk-white calves in the starlight. They seem almost too good to be true. Williams writes beautifully, but I suspect that the tales he heard have been recrafted by him to create pleasing vignettes, which though charming, do not always bear the stamp of authentic folk narratives. This is not always the case, and the following tale is an example of one where the folk-tale appears almost unreconstructed.

A witch was in the habit of stopping every team that passed the road near her dwelling. This she did with her magic, simply by drawing a line across the road with her enchanted staff. One day, however, the carter, after stroking his horses and speaking kindly to them, cracked his whip loudly and fell upon the witch, striking her violently. Thereupon she ran and crept into a culvert and died there, and the teams were never afterwards molested.

This tale does not explain why the witch should wish to stop every team of horses passing her house, but it does give us a lesson in the traditional way of breaking a witch's spell: you must draw blood. We meet this again and again in folk tales, and it must be the reason behind all kinds of violence to marginalised women over the years. This poor wretch was beaten until she died of her injuries.

Bleeding the pig

The following tale, also from Alfred Williams, combines the animal/witch idea with the concept of drawing blood to break a spell. Here, wounding the pig wounds the witch, and terminates her power (and her too) in the process.

Jonas, the ox-carter, had heard of a witch who had tampered with a neighbour's pig and caused it to go mad in the sty. The owner of the animal, a farm labourer, was distressed at the occurrence and uncertain what to do. At length it occurred to him to bleed the pig. Accordingly he took the scissors and snipped a piece out of its ear, causing it to bleed profusely, when behold! out of her house ran the old woman, grasping her fingers, which were streaming with blood. It appears that when the swine's ear was cut the witch, being in spirit within the pig, was also injured. The pig recovered, but the villagers left the old woman alone, and she soon bled to death.

Again we see the witch-as-outcast, someone outside the village society, who was regarded with suspicion, and left to die of her wounds – although how you die of cut fingers unless gangrene sets in I am uncertain.

The witch's faggot

Here is a witch-tale that turns up again and again: there must be examples from every county. This version is set in Knook, a village south of Warminster on the edge of Salisbury Plain.

A carter... was coming home one day from fetching a load of wood, when an old woman asked him to put her faggot on the waggon. She was a witch, so the carter was not willing to oblige her, but when he tried to go on he found that his horses could not move the waggon, though they pulled even to breaking the harness. At last he was forced to take the horses out and go home, leaving the waggon where it was. His master was angry, believing the tale an excuse for some foolishness, but when the farmer went himself next day, he too found that the waggon would not move until the witch's faggot was put on it first.

This seems at first reading to be another example of the witch's power over animals, until we realise that it is the wagon that is immovable this time, and not the horses.

Bewitched and couldn't get home

Another power witches were believed to possess was that of bewitching people so that they did not know who they were or where they were. It is a power also shared by the fairy-folk, who confuse poor travellers so that they cannot find their way even out of a field. Our next tale comes from Baverstock, a small village to the west of Wilton.

Tom Lever (aged about 75, in 1922) recollected a little woman named Charlton, living with a family of that name at the 'Barracks', in Baverstock, who was disliked and feared. When they were working in the fields they would get as far away from her as they could! They said she could bewitch. She herself claimed to be able to tell one all sorts of things if one would cross her palm with silver, but if there was no silver there was no story. She would make a fine long yarn if the silver was about.

A man who lived next door to the Levers (in the small brick end of the second cottage) didn't come home one night. When he did come next morning her was that wet, O lor! said 'he'd been bewitched, couldn't get home, been through the water, he didn't know where'd been, but er couldn't get home'.

A witch's ghost

Here is an example of less-than-benevolent witchy activity from recent years, told me in 1994 by the witch in question. A very unpleasant woman had moved into a nearby cottage, and the witch and her friend one day told the woman that her cottage was haunted. The ghost was pure invention, nothing more, but the suggestion was enough and the woman began to see the ghost. She even got the Catholic priest from a nearby town to come and exorcise the ghost for her, and for a while all was quiet. "But as I'm a witch," said the witch to me, "I can project my mind, so when the exorcism was over, I projected the ghost again." The woman she didn't like doesn't live in the village any more.

Does he not love ringing?

Not all the witchcraft of previous years was done by women. Some witches, then as now, were men, although they tended to go by the title of Cunning Men rather than witches. Here is the tale of one of the most famous, who caused the celebrated ringing of bells at Wilcot.

About the year 1761, in the parish of Wilcot, which is by Devizes, in the Vicar's House there was heard for a considerable time the sound of a bell constantly tolling every night. The occasion was this:

A debauched person who lived in the parish came one night very late and demanded the keys of the Church of the Vicar, that he might ring a peal. The Vicar refused to let him have the keys, alleging the unseasonableness of the time, and that he should, by granting his desires, give a disturbance to Sir George Wroughton and his family, whose house adjoined the churchyard. Upon this refusal, the fellow went away in a rage, threatening to be revenged of the Vicar, and going some time after to Devizes met with one Cantle or Cantlow, a person noted in those days for a wizard and he tells him how the vicar had served him, and begs his help to be even with him. The reply Cantle made to him was this: 'Does he not love ringing? He shall have enough of it!' And from that time a bell began to toll in his house, and continued to do so till Cantle's death, who confessed at Fisherton Gaol, in Sarum (where he was confined by King James during his life) that he caused the sound and that it should be heard in that place during his life.

The thing was so notorious that persons came from all parts to hear it, and King James sent a gentleman from London on purpose to give him satisfaction concerning the truth of the report. Mr. Beaumont had likewise

this story, as he tells, from the mouth of Sir George Wroughton's own son, - with this remarkable circumstance, that if any in the house put their heads out of the window they could not hear a sound, but heard it immediately again as soon as they stood in the room.

Bells are curious things. When rung by human hands they drive away evil, and so we ring them at weddings, and for church services. Ghosts are exorcised by bell, book and candle, and in general the sound of a bell is a fortunate thing. But if they sound by themselves, it is a different matter entirely. The sound of a bell booming when nobody had touched it was a sure sign of a death in the parish before the week was out. At the very least, it was a bad omen. So here we have more than a tale of occult mischief-making on the part of the wizard and his client, for we deduce that the sound of bells was designed not merely to annoy the Vicar, but to threaten him with impending death and disaster.

Witchcraft in the 20ᵗʰ century

From south Wiltshire comes this very detailed tale of two male witches whose spell is broken by one benevolent female witch.

It was the duty of a doctor to call weekly on a 'panel' patient to give him his certificate of incapacity for work.

This patient had already been 'on the funds' three years. He had the reputation, when in good health, of being a very hard and conscientious worker. His disability was neurasthenia, but the doctor was inclined to think the condition verged on chronic melancholia, so uniformly apathetic was the patient's demeanour at each interview; indeed, the doctor had reason to believe the man seldom left his fireside except for the necessities of his existence.

One day the doctor, sitting in his consulting room was surprised at the arrival there of the patient, – we will call him Dobson - who announced briskly that he wished to return to work. No explanation of his cure was immediately forthcoming, but a few days later a neighbour confided in the doctor that Dobson's return to work was accounted for by the burial a day before Dobson's visit to the surgery, of 'the man who had put the witchcraft over him.' Needless to say, this explanation was not entered amongst the details in the patient's Insurance Record Card! Subsequent enquiries in the neighbourhood elicited the curious details which follow:-

There were *two* witches concerned, and they were *men*, named Cobley

and Brewster. One day when Dobson had been 'on the funds' of his Club for five years, his wife was approached by a woman neighbour - who owed Mrs. Dobson a return, at least in kind, for much help in household affairs - with the suggestion that she (the wife) should visit a Mrs. Williams in order to 'get the spell removed.' Mrs. Dobson said she would not go as she did not believe in witchcraft, and her lack of belief might hinder the removal of the spell, so the neighbour volunteered her own services in the affair, and they were gratefully accepted.

Mrs. Williams was accordingly approached, and said that she must not mention the name of the witch concerned (for fear of adding to his 'power?'), but would produce his photograph, and actually did produce a photograph of Cobley. She then proceeded to break the spell. (Details of method not divulged to the writer). The spell may have been 'broken' [by] the well known method of witchcraft practitioners, viz., mutilating or destroying the image (e.g., photograph) of the person whom it is desired to injure - in this case the witch who placed the spell.

Shortly after this, Cobley died, and not very long after him Brewster also. Mrs. Dobson expressed the opinion that the manner of Brewster's death – 'He died raving!' - was a 'judgment of God on him for the wickedness he had done', a curious opinion, perhaps, for one who had professed that she did not believe in witchcraft.

The year of the above spell-breaking was 1922, approximately, and it is remarkable to find the existence, not only of alleged witches in these days but of a person prepared to break a spell, and that out of charity for she explained that she could not accept payment for the service.

With our present-day knowledge of psychology and the power of the mind we can look at this tale and perhaps see how a man who was formerly active, when suffering from long-term depression, might come to believe that his uncharacteristic melancholy had been produced by a spell – that he had been ill-wished. And we can also see how a practical woman with some knowledge of the workings of the human mind (a witch has to be a good student of human nature) might be able to convince him, with a carefully-constructed ritual, that the spell had been lifted and he was well again. We might even call such a process a form of magic. What is certain is that Williams, and in the end his wife too, believed that he had been ill-wished and that the spell had been lifted. For them, as for many people, magic was a reality and a great threat to the security of their lives. It explains much of the violence to village witches in the past. Perhaps it also explains why

people are still afraid of witches nowadays.

It's all right

Here is an example of a cunning man who seems to be stronger on the psychology than on the magic. It comes from Clyffe Pypard in north Wiltshire.

> Soon after H.N. Goddard came to live at Clyffe he had a great number of turkeys at Nonsuch Farm, 40 or more. One day these all suddenly disappeared and no clue could be found to the thief. Farmer Cullen, the bailiff, had, however, a strong suspicion that the thief lived not far away, and he asked H.N.G.'s permission to go and consult a 'cunning man' about it. He was asked where the cunning man lived, but declined to say, as 'that was part of the secret', but he wanted the day off to go and see him. So he went, presumably to Cricklade, which was his own home. On his return, H.N.G. said, 'Well, what about the turkeys?' 'Oh', he said 'Its all right'. 'All right!' said H.N.G., 'but where are the turkeys?' 'Oh you'll never see the turkeys no more, sir, but it's all right. The cunning man, he said twas all right, twas not as I thought.' 'Well', said H.N.G., 'It may be all right, but I should have been better pleased if you had brought back my turkeys.'

The wise man and Squire Crowdy

Our final tale comes once again from Alfred Williams, and concerns Squire Crowdy, whose unquiet ghost we last met being laid in a barrel of cider. He seems to have been a great joker in life, and not averse to making fun of the cunning men of his vicinity. This one was quick-witted enough to get the better of the Squire, and score a few social points into the bargain.

> At that time there was a 'wise man' of Highworth, who was given to star-gazing and fortune-telling. Meeting him one day, the squire thought to have a joke at his expense.
> 'Well, and what have you been dreaming about now?' said he.
> 'I dreamed I was in hell', the other soberly replied.
> 'Ho! Ho! And what was it like there?' asked the squire.
> 'All they that had most money sat nearest the fire,' the dreamer answered.
> 'Is that all?' the other inquired.
> 'Not quite,' said the dreamer. 'I walked about and found a beautiful

golden seat and was going to sit down when somebody took hold of my shoulder and said: 'You mustn't sit there! You mustn't sit there.' 'And why not?' said I. 'That's reserved for old Crowdy of Highworth,' the other quickly answered.'

References
Slaughter stone: Brown (1985), p.29.
Silbury Hill thunderstorm: Merewether (1851), pp.35-6.
Stonehenge and the Great Hurricane: Brian Davison, *pers. comm.*, Freshford, 1995.
Never troubled to visit Stonehenge: Coleman (1952), p.1; Hudson (1924), pp.236, 239.
Stanton Fitzwarren stone: Passmore (1922-4), p.50; Williams (1922), p.270; Gover (1939), p.30.
Cley Hill stone: Manley (1924), p.38.
Cuckoo stone: Ruddle (1900-1), p.331; Gover (1939), p.365; Sullivan (1999), pp.68, 215.
Devil's Whet Stone: Burl (1999), p.118.
Bulford stone: Noyes (1913), p.152.
East Knoyle stone: John Chandler, *pers. comm.*, East Knoyle, 1990s.
Blowing stone: Gandy (1975), p.16.
Old May Day: Coleman (1952), p.12.
Gladiator's Walk: Noyes (1913), p.114.
Rector of Vernham Dean: Hole (1950), pp.89-90
Emotional interactions give rise to ghost traditions: Russell (1981), pp.113.
Gawen's Barrow: Aubrey (1969), p.119.
Gallows Barrow: Gover (1939), p.366.
Copheap: Shuttlewood (1979), p.55.
Kit's Grave: Gover (1939), p.204; Olivier (1932), pp.72, 74.
Highworth roads: Williams (1922), p.39.
Parker's Stone: Goddard (1942-4), pp.32-3; Rollestone parish registers.
Strawn's Grave: Goddard (1942-4), p.32.
Suicide at Wootton Rivers: Olivier (1932), p.86.
Suicide at Newtown: Manley (1924), p.34.
Gammer Piper's Grave: Wilkinson (c.1860), manuscript return for Allington, pp.35-6).
Vampires: anyone wanting to learn more of vampires in fact and folklore, as opposed to fiction, will find Barber (1988) the most illuminating book on the subject – but be prepared to learn far more than you have ever wanted to know about the various stages of decomposition of the human corpse, and how it is likely to behave after burial.
Salisbury Plain rhyme: Bett (1952), p.122.
The Gibbet, Maddington: F.B. (1899-1901), pp.333-4.
Dragon Hill, Uffington: Bord (1974), p.172.
Bishop Ayscough: Noyes (1913), p.282.
Dor's Grave: Gandy (1975), pp.10-11.
Three Graves: Clericus (1820) **in** Gomme (1901), pp.346-7; Ramsay (1984), pp.52-3; Doris Sevier, *pers. comm.*, Holt, 1985.
Fellow travellers near Oare: Michael Giddings, *pers. comm.*, Wiltshire Farming Club, Oare, 1997.
Black funeral: Joan Gradidge, *pers. comm.*, Pewsey, 2000.
Coach at Little Ann: Kay Wells, *pers. comm.*, Wiltshire Farming Club, Oare, 1997.
White funeral at Little Ann: Joan Gradidge, *pers. comm.*, Pewsey, 2000.
Headless horsemen of Bishops Cannings: M.M., *pers. comm.*, Bratton, 1997.
Death Coach/Churchyard Watcher: Radford (1974), p.101.
Phantom hearse: Kathleen White, *pers. comm.*, Bratton, 1997.
Chaise on Bowles Bridge: Margaret Briggs, *pers. comm.*, Middle Woodford, 1994.
Haunted Saltern Hill: Olivier (1932), p.49.
Haunted Sloane track: Olivier (1932), pp. 82-3.
The Double Shutte: Olivier (1932), pp.75-6.

Voices calling near Beckhampton: Alison Borthwick, *pers. comm.*, East Knoyle, 2000.
Wilbury House ghosts: Olivier (1932), p.75.
Squire Crowdy: Williams (1922), pp.41-2.
Sack of water: Wilkinson (c.1860), return for Chisledon.
Boneless: Briggs (1977), pp.33-4.
When us got together: Moonrake (1942-4), p.414.
Modern Wicca: Hutton (1999), p.271. This is the definitive study of modern witchcraft as nature religion.
Witch of Winterslow: Olivier (1932), p.84-5.
Hares and witches: Opie (1992), p.190; Radford (1974), p.181.
Powers of silver: Opie (1992), pp.357-8.
Witch of Tidcombe: Moonrake (1942-4a), pp.282-3.
Stopping every team: Williams (1922), p.126.
Bleeding the pig: Williams (1922), pp.125-6.
The witch's faggot: Olivier (1932), p.39.
Bewitched and couldn't get home: Goddard (1942-4), pp.41-2.
Doth he not love ringing: Olivier (1932), pp.83-4.
Witchcraft in the 20th century: Olivier (1932), pp.80-2.
It's all right: Goddard (1942-4), p.25.
The wise man and Squire Crowdy: Williams (1922), p.41.

Notes
[1] I believe that the Gents' are a centre of even more cutting and entertaining social commentary, but I have never been brazen enough to investigate…
[2] Actually, birds do sing at Sally-in-the-Woods. I checked.
[3] Presumably the crossroads by the village pub – three ways now, but a track makes a fourth arm.
[4] To meet a hare is supposed to be *un*lucky, but I don't subscribe to this belief.

Malmesbury Abbey, haunt of monks and music – see page 142.

Chapter 5

Uninvited guests

Are ghosts folklore?

In previous chapters we have met a fair number of ghosts, and this chapter will deal almost exclusively with ghosts that haunt buildings: not just traditional ghost locations like historic abbeys and country houses, but everyday places like shops, farm buildings and our own homes. Ghosts are often uninvited guests, and while this can be an unnerving experience, some people seem to adjust quite well to living with them.

I have never seen a ghost myself, but they have fascinated me for most of my life. They are so difficult to define, and seem to belong both to folklore and to the realms of unexplained phenomena. Certainly ghosts are a part of the folklore of this land, for they can be divided into certain types, and tales about them have common elements, just as in other areas of folklore. Accounts of ghosts are the most common type of folk tale now being generated, as I have found in my own researches. The vast majority of the tales people have told me relate to their own experiences of ghosts, and that is where ghostlore differs from other folklore. People often have direct experience of ghosts, and they believe firmly in them. They are not repeating tales heard from other people, but they have themselves heard, or seen, or felt, or smelled, something inexplicable.

Father returns after death

So what are ghosts? Not being particularly psychic myself, I put this question to someone who emphatically is psychic. Jean Morrison is a lifelong resident of Bratton, a fine folklorist and local historian, and she has had a great deal of experience of ghosts and their like. This is what she told me: -

I've no idea what they are, but they are in existence, I know, because three years after he died, I met my father in Salisbury. And a year before that, when my sister was worrying and wondering should she join her

husband out in India, because father was dead, but mother was still alive, and was living with my sister. And sister didn't know whether she could leave mother and send her down to me or what she ought to do, whether she ought to go out because it would mean the boys would have to stop in this country, and so on. And she was sitting in her bedroom, with the youngest one who was only a baby, and my father tapped at the door, with the little tap that he always gave before he entered a room, and she said, 'Oh, come in'. He came in, he said 'It'll be quite all right for you to go to India, she'll be able to cope. Just go: she'll be all right'. And then he walked out again. She suddenly began to shiver, she'd forgotten, you see, he was so real.

So I was given no answers, but I did get another fine ghost story. And this simply reinforces our difficulty in studying ghosts: there is plenty of 'evidence' for their existence, but nobody can precisely define what that existence actually is. Too many books on ghosts are simply catalogues of spooky tales (and very enjoyable they are too), which make little attempt to treat the material seriously. As this is a book on folklore, my main aim is to set before you a number of ghost tales old and new, and show how they illustrate some of the common features of ghostlore as folk narrative. But because, like many people, I believe that ghosts do exist – whatever that means - at the end of this chapter I will make some structured attempt to show what these things we call ghosts might be. In the meantime, enjoy the fine ghost tales that follow.

A simple traditional tale

You don't need much to make a good ghost story. Sometimes just a few dark hints are enough to get the right atmosphere. "The informant said that there were some houses [in Tisbury] she wouldn't spend a night in for all the gold in the Bank of England: and that's not surprising, considering what went on there long ago." This one sentence does the job perfectly. It hints at dark deeds long ago, it hints at dreadful disturbances now, and it specifies nothing, so you spend all your time wondering what happened then, what is happening now, and which are the houses affected.

Abbey ghosts

One very typical type of ghost is the phantom monk or nun. These are very widespread, perhaps because some ghost sightings report vague, misty or smoky figures, whose shape suggests flowing robes of neutral colours. Not

Haunted holy well at Monkton Farleigh.

surprisingly, ghostly monks and nuns tend to be seen around churches or monastic ruins. A black-robed monk is said to haunt around the holy well known as the Monks' Conduit, in Monkton Farleigh (ST804657). As its name suggests, Monkton Farleigh was the site of a Priory of Cluniac monks, and this spring was their main water supply. It stands on its own in a field, where the spring is covered by a steep-pitched, 14th century building, and if you push open the door you will find that where the floor should be, there is only water. There is also a lot of pumping equipment, and it is clear that the water from the holy well is still heavily used in the village.

The sound of plainchant is another form of monastic haunting, the most famous example being at Beaulieu in Hampshire, where the sound of the monks singing has been heard many times over the years. Here is one description of it: -

> When I opened the window I heard it quite distinctly: it was definitely chanting, and very beautiful chanting. It came in uneven waves, as if from a faulty wireless – sometimes quite loud and then fading away. It was just as if a Catholic mass was being played on the radio in the next flat, but I thought it was curious that someone should have the radio on at that time of night [the early hours of the morning]. Anyway, it was so beautiful that I tried to find it on my own wireless. I tell you, I went through every blessed programme there was – French, Italian, everything – and I couldn't find it. Later on I was told it was just a common or garden super-natural phenomenon.

At Malmesbury, a different kind of music has been heard in the ancient abbey. "On summer evenings, too, one can often see a group of people

standing at the back of the abbey listening for the ghostly playing of an organ which it is said can at such times be heard. Some of the even described to me the music – thin, reedy sounds faint on the evening air." In the churchyard a ghostly monk has been seen, at dawn, searching intently among the gravestones. He seems in the end to find whatever he is looking for, for he throws up his hands in apparent joy, and sinks into the ground.

The Drummer of Tidworth

A far more disruptive auditory haunting seems to have taken place in Tidworth in the 17th century. The story of the Drummer of Tidworth is a famous poltergeist tale, and the Mompessons, who lived in Tidworth House in April 1661 when the haunting began, were allegedly plagued by typical poltergeist phenomena. The drumbeats sounded in the house, the children were bruised and battered by an unseen force, furniture and floorboards moved of their own accord. It was all supposed at the time to have been caused in some way by William Drury, a vagrant musician whose drum had been confiscated by the magistrate John Mompesson, and there is a strong vein of hysteria running through the whole tale.

So it is refreshing to read John Aubrey's version of it, a near-contemporary one, which exhibits a refreshing lack of credulity. The account shows Aubrey's inquiring and scientific approach: he is sceptical and clearly suspects the maidservant of perpetrating a hoax. We note that there is no mention in his account of the more dramatic poltergeist activity alleged to have taken place.

> In the time of King Charles II, the drumming at the house of Mr. Monpesson (sic), of Tydworth, made a great talke over England, of which Mr. Joseph Glanvill, Rector of Bath, hath largely writt; to which I refer the reader. But as he was an ingenious person, so I suspect he was a little too credulous; for Sir Ralph Bankes and Mr. Anthony Ettrick lay there together one night out of curiosity, to be satisfied. They did heare sometimes knockings; and if they said 'Devill, knock so many knocks', so many knocks would be answered. But Mr. Ettrick sometimes whispered the words, and there was then no returne: but he should have spoke in Latin or French for the detection of this.
>
> Another time Sir Christopher Wren lay there. He could see no strange things, but sometimes he should heare a drumming, as one may drum with one's hand upon wainscot; but he observed that this drumming was only when a certain maid-servant was in the next room: the partitions of

the rooms are by borden-brasse, as wee call it. But all these remarked
that the Devill kept no very unseasonable houres: it seldome knock't after
12 at night, or before 6 in the morning.

Three 'chops'

Traditionally, one of the primary causes of a haunting is violent death, either
by suicide or murder. Olivier tells us of an auditory haunting of a most
gothic kind at Verneditch, near Broad Chalke.

> Legend tells that at a certain hour every night, three distinct 'chops'
> can be heard. A large house called 'Lodge' once stood on this site (cellars
> and walls of which still remain). The owner was found murdered, and
> the noise is supposed to be the sound of his head being chopped off.

This is a superbly ghoulish tale, and beautifully inventive. It also contains
some key elements of folk narrative: the haunting repeated at a certain time,
and the number three. It is thought that some ghost stories were put about
by smugglers to discourage people investigating strange sounds in lonely
places at night, and this may be one of those tales. One wonders what might
have been concealed in the cellars of the deserted house.

Murder will out

George Pearce, the shepherd who saw strange lights on Knook Down (see
Treasure on Knook Down in chapter 3), once undertook to investigate a
persistent auditory haunting.

> I met with a queer thing once in lodgings. There was a house at Knook
> belonging to a Mr. Flower, which no one stayed long at on account of a
> curious knocking heard at night. I took lodgings there, and in those days
> had little fear of aught, and offered to sleep in [the] room downstairs
> where the knocking was heard. I slept some time; then, sure enough, I
> heard a knocking. For a time I lay listening; then, slipping out of bed,
> crawled on hands and knees over the floor till I came to where the sound
> was. There being a piece of iron handy, I lifted the board with it, and to
> my horror saw the remains of a dead body.
> I went upstairs and called the landlord; waiting for daylight, he then
> fetched [the] police. It was the body of a well-grown girl. The murderer
> was never found.

This, whether a 'true' story or not (for how could the smell of a decomposing corpse have escaped notice in a boarding house?) demonstrates one of the typical characteristics of the ghost with something to communicate: if it has not the strength to manifest itself in human form, it knocks to attract attention, and continues knocking until it finds someone with the courage to investigate. It is a characteristic exploited in the classic *séance*: 'Knock once for yes, twice for no'.

Laid in the Red Sea

Manley tells a strange tale of how a troublesome Marquis of Bath was laid to rest, not in a barrel of cider as genial Squire Crowdy was, but in the more customary location of the Red Sea.

> The ghost of an ancestor of the present Marquis of Bath used to haunt the House and even appear in the Park both by day and night. He worried his widow so much with constant appearances that it was decided to rid him to the Red Sea. 'Twas said they invited twelve parsons to the House. A sheepskin was procured, into which the Marquise was wrapped, and in a cradle they laid her, and carried her to her room.
>
> The twelve parsons sat around a table and waited. At midnight the ghost appeared and stood among them. Each parson in turn asked the ghost what troubled him. It begged to be allowed to touch the hem of his wife's garment. They told him that was impossible, because she was wrapped in lamb's wool.
>
> Then they walked through the House reciting the Lord's Prayer backwards, which proved effective in ridding the place of the ghost.

I suspect the final sentence of this account to a modern accretion, but the rest of the tale has an authentic feel to it. We have the troublesome ghost, which requires the statutory twelve clergymen to exorcise it; the troubled wife is wrapped in wool from the most innocent creature, the lamb, to protect her from the ghost's advances; the ghost is formally challenged as to its motives; and it is laid to rest in the Red Sea, a far-distant location of Biblical significance.

The haunted oven

In the following tale from Cholderton, the entity trying to communicate with the inhabitants of a cottage uses classic poltergeist activity to make its presence felt, but its intentions seem entirely benevolent, and the activity ceases when its secret cache of treasure has been found.

Many years ago, a little cottage in this village had the reputation of being haunted, and no one [who] rented the cottage every stayed there long, if they could possibly get another to live in. Outsiders, who had never lived in it, used to scoff, and pooh-pooh the idea of ghostly happenings. But, people who did live in it said that every night the old oven where the bread had been baked for ages, used to fall out and roll all over the floor, and all the china seemed to tumble off the dresser and roll about.

The time came when the gude-wife decided to call in the local bricklayer and have the oven repaired. This he did, but while examining the inside of the oven he found an old wooden bowl, round, such as were then used as tills in old inns. This he took home as a curio, declaring it was empty. He had, however, a deaf and dumb daughter, and she told by signs to a friend that it had lots and lots of money in it. Anyway, the bricklayer was never short of cash afterwards, and the cottage ceased from having oven and china rolling about.

This is one of many folk-tales where the presence of hidden treasure is indicated by some kind of poltergeist activity. This tale also has a moral to it: do not ignore such warning sounds or you may lose the chance of great wealth. We note that it is not the inhabitants of the cottage, who had lived with the disturbances for so long, who got the cash, but the local bricklayer who did the actual investigating of the oven. How a wooden bowl with money in it escaped the notice of people regularly using the oven is unclear, but it may be that at this point the tale slips into the realms of myth. We read that the bricklayer was "never short of cash" afterwards, and it may be that the wooden bowl he had found had taken on the role of a horn of plenty, which could never be exhausted.

Powers of the skull

A human skull is not the most usual ornament for the mantelpiece, but one or two houses around the country do have such curios, because the consequences if they are discarded range from the simply uncomfortable to the disastrous. One of the best known of these skulls is the one at Bettiscombe Manor, between Broadwindsor and Lyme Regis, Dorset. This was said to have belonged to a black servant who came from the West Indies, and who died of consumption. For some unknown reason his skull was kept in the house, and whenever anyone tried to remove it, continuous and unendurable screaming filled the house, and disasters of all kinds ensued.

147

Christina Hole tells us that "the bones of the dead have always been regarded as centres of psychic power", and "in many pagan religions it was thought that the ghost clung to his tomb and took summary vengeance on those who violated it, and this ancient belief underlies many of our folklore superstitions." Certainly we can see something of this belief in action in tales of skulls treated with disrespect.

The Celts were probably not the first culture to regard the head as the seat of the soul, and this respect has continued to the present day. It is a very understandable attitude: one can lose other parts of the body without fatal effects, but remove the head and one is instantly dead. The head is the most characteristic part of us, for our individual faces make us instantly distinguishable one from the other. Aspects of this special regard for the head can be seen in all the arts, from the painting of miniature portraits (usually head and shoulders) to the carvings of heads which decorate churches everywhere, to poetry and song.

An indestructible skull

The first of Wiltshire's skulls of power is reputed to be kept at Pinkney Park, near Great Sherston, although whether the house in question is Pinkney Court, or another house within the park, is unclear from the author's text.

> About ten miles from Chippenham and a mile from Shurston Magna, is Pinkney Park, set in an ancient deer park. The name doubtless derives from Ralph de Pinckney, who once owned it. In 1407 a suit between the families of Esturmeys and Giffords occurred and it was earlier owned by the Estcourts and Cresswells (1303). From which family comes the skull, kept on a special niche under the window above the stairs and said to be indestructible, is not known; the skull is small and said to be of a female. One story tells that one sister killed the other and a ghost is said to be seen, which carries its head beneath its arm. On a door of Pinkney Park is the imprint of a woman's hand, and on the floor are bloodstains which cannot be removed. According to legend many attempts have been made to destroy this skull; it has been burnt, hammered to pieces, and so on, but always returns, whole, to its niche. The legend runs that when all the Pinkney race are dead, and strangers hold the land, the skull will crumble into dust.

This tale has many standard ghostly elements besides that of the powerful skull, which as well as having uncanny powers is linked to the well-being

of the inhabitants of Pinkney, for when they fail, so will it[1]. Along with this central motif we have the ghost-with-head-under-its-arm, the print of a hand, and another indelible bloodstain. These are often found alongside other tales, as here, and seem to me to have been added later to the essential tale for extra effectiveness. The headless ghost fits in very nicely indeed with a disembodied skull: how soon before someone starts the tale that the ghost is searching for the skull?

Molly of Pythouse

A collection of contemporary folklore published in 1973 includes a tradition from Pythouse near Semley (ST907285). Pythouse is a fine mansion dating from 1805, once the home of the Benett family, but now largely divided up into very desirable apartments.

> There is at Pythouse (once the home of Col. Benet Stanford) a skeleton which is known as 'Molly'.
>
> Molly is the remains of a female who was hanged at Oxford for the murder of her baby girl by scalding, the father of which is rumoured to have been a member of the Benet Stanford Family. The crime is supposed to have been committed in what is known as the 'Pink Room' at Pythouse, which Molly is supposed to haunt, as well as walking in the nearby corridors. There is also a curse which states that should Molly be taken away from Pythouse misfortune will fall upon the family.
>
> Three times Molly has been removed.
>
> The first time a wing of the house caught on fire.
>
> The second time the son and heir died.
>
> The third time the daughter died.

This relatively recent tale (it was collected as part of Palmer's survey carried out 1968-70) has all the hallmarks of the traditional tale of this kind. We are dealing in this case with an entire skeleton, but the tale and the effects, are the same as if it were just the skull. The skeleton has a history (not necessarily true), which links it to the family living in the house, and in this case it has a name as well. A ghost and haunted room in the house are woven neatly into the narrative. The bones are the 'luck' of the family, and if removed, disasters occur. The number three is significant once again: three attempts at removal, three corresponding disasters to the family. It is a well-crafted tale, which demonstrates that the art of storytelling is still thriving.

Bumps in the night

Another example of living folklore – a contemporary haunting but with traditional elements attached – appeared on the front page of a free paper, the *Trowbridge Star*, on 4th February 1994. It concerned the Factory Shop in Roundstone Street, Trowbridge, where some typical poltergeist activity had been taking place. The entity, known to staff as 'George', rattled china, moved shoes around, and tapped staff on the shoulder. The centre of activity appeared to be the attic, where the alarm would go off for no apparent reason, and from where staff had heard footsteps and the sound of crashing and banging.

This would be just another poltergeist haunting (and very uncomfortable for the people who had to work there, although they kept fairly calm about it) except that it shows signs of being transformed into a folk tale by the people reporting it. Poltergeist activity usually centres upon an adolescent child: one theory is that the hormonal energy pulsing through their developing bodies at that time sometimes overflows as irritating or destructive psychic activity. It has little to do with a given location, and if the person on whom it centres moves house, the disturbances often move with them. But in this account there are clear attempts being made to create a neat explanation for the activity. The shop manager begins the process by mentioning that the attic has a very chilly atmosphere, and a 'sinister looking stain' on the floor, and that "…we would really like to know the history of the building." The reporter next supplies the following information: -

> The shop is housed in Victoria Buildings, constructed in 1897. It was built by a draper, Mr. J. Kemp. It used to be a haberdashers and the attic was used as the living quarters for the family governess.

And here the report ends. Nowhere is any connection overtly made between any of these disparate elements, but they are so typical of the traditional ghost-tale that most readers must surely have been left with an impression very similar to this: -

> The shop's haunting goes back to the early 20th century. An unhappy governess lived in the attic, and some kind of murder was done there - perhaps she killed her illegitimate child - which left an indelible bloodstain on the floor. She cannot rest, and haunts the entire building, but especially the attic where her cold presence is most keenly felt.

We have a need to explain the unexplainable, to understand the incomprehensible, and so we look for explanations where perhaps no real explanations exist. We fit strange events into familiar patterns, and this is one way in which genuine ghost experiences are transformed into folk legends.

The lady on the stairs

In the 1940s, Mr. & Mrs Arthur Phillips lived in Pewsey High Street in the flat over what was then the newsagent's but is now the chemist's shop. When their daughter-in-law, Win Phillips, was visiting them once, she saw a ghost on the stairs. She later described the ghost to an acquaintance, Marjorie Jordan, as a lady in a crinoline, and told her how she not only saw the ghost, but also brushed past it. When Win mentioned the ghost to her mother-in-law, she already knew all about it.

Female ghosts, if not in nun's habits, are often described as wearing a 'crinoline'. This would be a convenient way of dating such ghosts to the Victorian period when the crinoline was a cage or hoop worn beneath wide skirts to hold them out and do away with the need for the many heavy petticoats that used to do the same job. Unfortunately, when used of ghosts, 'crinoline' tends to be code for 'very wide skirt', and signifies anything from the farthingale of the 16th century to the genuine crinoline of the 19th.

Old Mother Sharp

One function of ghosts and other folk bogeys seems to be to frighten children into good behaviour. 'Don't go down there at night or Black Annis will get you' is one fairly effective way of ensuring that your children don't stray too far from home. The ghost at Netherhampton House (SU111297) may have been used in this way.

> A lady dressed in white was said to appear and walk up and down at the back part of the house, and children were frightened by references to 'old Mother Sharp'.

In large houses the children's nursery and bedrooms were usually at the back – why waste the fine rooms on the children? – and stories of Old Mother Sharp at the back of the house may simply have served to make sure they stayed in bed once put there. And people have always enjoyed frightening those too young or innocent to rationalise away their own fears.

Used to live here

Not everyone who sees a ghost is frightened by it. Some people act with perfect composure, like this visitor to a house in Mere: -

> ... an old lady appeared to a visitor. Next morning, she told her host of the 'ghost' – 'a stately old lady in a voluminous silk dress', and other details. 'That,' said the host, 'is an old lady who used to live in this house.'

In many ghost tales we find this satisfying twist at the end, when someone who does not know anything of the house's history and former inhabitants sees a ghost, describes it, and finds they have accurately described one of the former inhabitants. Often they come across a portrait and recognise their ghost, or are shown a painting or photograph in which they see them. There are many variants, but the basic formula is the same. The story from Mere is quite a simple version, carrying little conviction. More complex versions would have told us the lady's name, her history, how she died, why she haunts, and have produced a picture of her; and each of these elements would have added to the spurious authority of the identification.

Always pleased to see him

Some inoffensive ghosts of long standing are simply accepted by the families whose homes they share. One member of the family it haunted positively welcomed a Bromham ghost.

> ...at least one ghost used to be seen in the elder part of Battle House. One of her aunts had told her that she was always pleased to see him because he was so like her eldest brother.

The clairvoyant Tom Corbett recommends exactly this sort of approach to ghosts, should you find yourself sharing a house with one. He has found that acceptance and tolerance creates the kind of warm link which helps the spirit realise the futility of its haunting, and encourages it to move on. This he believes to be what happened at Littlecote House when the Wills family lived there. Littlecote was badly haunted at one time by disturbances related to the cold-blooded murder of a new-born baby: the story of Wild Will Darell and the baby in the fire can be found in many other books. But when Corbett visited Littlecote in the 1960s he sensed nothing of this particular haunting. Diana Norman explains, "The Wills family made no attempt to exorcise it, they just went on living their contented lives, accepting the ghost as a fairly

normal phenomenon. The ghost has not been seen or felt for many years now..."

It was only the ghost

Another ghost takes the form of a carriage and pair, which drives up to Spye Park on Bowden Hill (ST951674), and even followed a member of the family when she was visiting another house.

> ... it could be heard driving up and coming to a halt on the pitching stones before the front door.
>
> Very many times...did my grandmother ring the bell and ask Philpott, the butler, why he had not come to tell her that her carriage was ready, and he replied that he also had heard it come round but that it was only the ghost.
>
> This ghost once went visiting Wans, (this also belonged to the family until quite recently, I think my great grandmother was a Wyndham).
>
> My mother had gone with her mother to lunch there and after they had ordered their carriage to drive home, everyone in the drawing-room heard it come round and draw up on the pitching stones which Wans also possessed; but when they went into the hall they found to their astonishment that the carriage was still in the stable yard.

What fascinated me most about this tale when I first read it was that I had heard it before. In 1994, a Bath resident had told me of his own ghostly experience. It relates to a car, not a carriage and pair, but apart from the type of vehicle, it is the very same tale.

Before they moved to Bath, he and his family lived at a house in Great Missenden in Buckinghamshire. One evening he and his wife were just about to go out to dinner when he heard a car drive up to the front door. Of course he was not terribly pleased about having visitors at such an inconvenient time, but he went to the door to see who had driven up. He was very puzzled to find that there was nobody there, no car and no people.

But his wife had had the same experience, and she writes, "I had heard the car several times during the time we were there from 1970 until 1988. Always at 6.30 in the evening, always the sound of gravel crunching and the slam of the car door closing. My husband did not believe this tale until he heard it for himself. The previous owners of the [house] were our hosts at Coleshill. They told us it was a chauffeur and maid or cook arriving from Scotland."

These two tales may start us wondering about the nature of reality and the power of stories. If these are both genuine ghostly encounters, how is it that they are so similar? How is it that we can see a folklore motif ('the vehicle that came too') emerging? Do ghosts conform so strictly to type that they behave in exactly the same way? Or is fantasy author and Folklore Society member Terry Pratchett right, and do stories (folk-tales, fairy tales, or ghost stories) exist independently of their players? "This is called the theory of narrative causality and it means that a story, once started, *takes a shape*. It picks up all the vibrations of all the other workings of that story that have ever been. This is why history keeps on repeating all the time." We know he is joking, but does he have a point?

I wonder whether these stories affect, not reality itself, but our memory of reality. Memory is notoriously unreliable and very persuasive. I read once of a man who parked his car outside a shop, and when he came out, found that a cyclist had ridden into his parked car and fallen off. And there were two witnesses prepared to swear that he had been driving the car and knocked down the cyclist. Perhaps we make sense of incidents according to certain well-established patterns – like the patterns in a ghost story – creating a pleasingly coherent tale out of random events.

You have to believe the evidence

Another type of ghost tale tells of the ghost using some feature of a house that no longer exists. Typically, when construction work is done later on the house, that feature is shown to have existed at some time in the past. This tale about Baynton House in Bratton illustrates this perfectly: -

In Baynton House there is a passage where somebody walks along, goes right, and goes through a door, only there isn't a door. When they were redecorating and replacing the plaster, there was an old bricked-up doorway.

There are many ghosts that only appear from the knees up, because they are still walking on the old floors; or which descend staircases that no longer exist. These ghosts seem to be oblivious to current conditions and seem in many ways to be no more than a psychic video of some much-repeated action undertaken during life.

All the clothes were stripped off him

This ghost tale from Stourton has several nice traditional features, which create a ghostly atmosphere without having much coherence.

> Brook House is said to be haunted. This is the Dower House of Stourhead Estate. One window is bricked up and the room. It is supposed the room is never used because of a ghost of a black dog which haunts it; and I have also heard from an old man (reputed to be from self-experience) that once he slept in this haunted room, and an old woman appeared at the foot of the bed. In the morning all the clothes were stripped off him - even the bolster removed from its case.

So here we are yet again: the bricked-up window, the closed room, the black dog, and the female ghost. Just as we begin to smile in disbelief, the final sentence sends a well-calculated chill down the spine: not only was the bed stripped, but even the bolster was removed from its case. This small domestic feature, evoking in our minds the horror of waking to find that some obsessive phantom housekeeper had unmade your bed *while you slept in it*, raises this tale from the pedestrian to the level of gothic horror.

Only his slippers remained

Our next tale is extremely detailed and coherent, with full historical detail and every element explained and accounted for.

> Cholderton house appeared to possess a ghost. It was reported to be an old man, who went tap-tapping down a narrow old staircase in his flowered dressing-gown, making what has been described as 'old man noises', who eventually drowned himself in a well in the garden. Certainly queer noises have been heard, probably attributable to rats, and a Frenchwoman, who knew nothing of the story, when standing by the well is said to have shivered and said, "Quelqu'un m'a frolé," [2] before she left hurriedly. The facts appear to be that a learned canon was drowned in the well in 1896 only, but whether it was accidentally or not will never be solved. As he is said to have left his slippers neatly arranged on top of the well, it is hard to presuppose an accident and maybe he regrets his action and returns as a warning to later dwellers in the house.

I particularly like the little French phrase in this tale. It seems designed to say, 'Look, French, this can't be a folk-tale'. But I think it probably is.

The original event of the drowning may well be true, but the accompanying details have the elegant coherence of a work of fiction.

Hanging from a beam

From Boscombe comes the story of yet another unhappy Wiltshire clergyman and his sad fate: -

> The Rectory at Boscombe is said to be haunted by the ghost of a man who hung himself in one of the attics, and less than 50 years ago the rope was still to be seen hanging from a beam, though the tragedy happened a very long time before that - possibly before the days of Hooker (afterwards Bishop of Exeter), who was Rector of Boscombe.
>
> Though the house was rebuilt about 30 years ago, and there is very little of the old part left, mysterious sounds have been heard and become so alarming that the tenants who were there at one time lived entirely downstairs, and left the ghosts to themselves up above.
>
> Fights have been heard going on, so possibly the victor was seized with remorse and hung himself, and was then doomed to 'walk' as a penance. Even in the day time people sitting or working in the room have felt invisible companions, and the door has opened; and at one time a child who was sleeping there had such disturbed nights that he had to be moved elsewhere.
>
> For the last three or four years nothing has been heard, so possibly electric light and modern ways have been too much for the ghost, or he is having a rest from his penance.

The rope still hanging from the beam after all that time is a fine touch in this otherwise ordinary tale made up of very standard ghostly features. There are no names, dates or vivid descriptive phrases to add conviction. But the element of credibility is provided by the phrase, "For the last three or four years nothing has been heard…" Suddenly we are in the very recent past, and the tale takes on a spurious authority – until we stop to think.

Never seen again

Jean Morrison told me this tale of a double haunting in Bratton, based on the widespread motifs of the 'man attacked for his money' and the 'suicide by hanging': -

> Pierce's House in Bratton is the one with a blocked window in the

middle. When this was an alehouse, a travelling peddler hired a room for the night. Unwisely he let it be known that he had done well on his travels and had quite a bit of money. He was never seen again. His ghost used to walk. In a later period a man committed suicide by hanging himself in the attic, and his ghost walked.

What did the cat see?

Suicide may lie behind the incident recounted to me by Ivan Taylor, a security officer at the University of Bath. When he was a boy, Ivan saved a small kitten from being drowned, and took it home to where his family lived in an old house on Trowbridge's Bradley Road.[3] The kitten became the family cat, and it used to sleep on Ivan's bed at night. He recalls how one night the cat suddenly woke up, its fur stood on end, and it shot off the bed and out of the room. Ivan sensed nothing at all, but it was about a month before the cat would sleep in the bedroom again.

Some time later, a family friend asked Ivan if the old wardrobe was still in his bedroom. This was a built-in cupboard-style wardrobe with two large hooks fixed into the wall. The friend went on to tell Ivan that at the turn of the century, a man had committed suicide in the bedroom by hanging himself from one of these hooks.

So did the cat see a ghost that night? Cats sometimes take fright at nothing and rush off, but usually recover their equanimity very quickly, and it is strange that it avoided the bedroom for so long. Ivan believes that there was some kind of presence in the house, for he recalls the time when he was sitting in the front room and heard footsteps coming along the hall. He assumed that it was his brother, but although the door-handle turned and the door opened, there was nobody there.

Who was at the door?

During the 1970s, my schoolfriend Julie Wood had an experience very similar to this. She and her family lived in a house near the railway line in Little Bedwyn, and over the years they had all got used to hearing strange noises and footsteps. Her mother told me once that she heard footsteps walk around the bed one night. They also heard footsteps coming downstairs, and once a tiny pattering noise like the sound of many mice coming from the cupboard under the stairs. But Julie's story is the most unnerving of all.

All the rest of the family were out, and she was up in her bedroom writing letters. The doorknobs in the house were of the old-fashioned kind with a certain amount of 'play' in them before the opening and shutting mechanism

engaged: you could move the door knob back and forth without opening the door. As she wrote, Julie suddenly became aware that the knob on the bedroom door was rattling to and fro. She assumed that there was someone in the house, on the other side of the door, and doing this deliberately to frighten her. She didn't know what to do, and so she waited, while the doorknob rattled until eventually she couldn't bear it any longer. She grabbed hold of the doorknob to open the door, and I remember her telling me how she felt it twist in her grasp – but when she opened the door there was nobody there. She went and locked herself in the bathroom until the rest of the family came home.

Flowers Farm

Two members of Bratton Historical Association have told me about the ghosts of Flowers Farm. Jean Morrison recorded its structure carefully before it was demolished, and the atmosphere clearly made a deep impression upon her: -

Flowers Farm (on L) in an Edwardian postcard.

Flowers Farm was a most haunted place, with horrible ghosts. It used to stand at the entrance to Stradbrook Lane, but was destroyed. It was the most haunted building I have ever been into. I wouldn't allow myself to be frightened out of it, but went on measuring and recording. Friends

who came to visit me there complained that they couldn't stand it. I don't know how old the ghost was. It was only in the oldest part of the house. Last century some very wicked people lived there, who tricked an old man out of the place. Still I don't know who the ghost was.

Various strange things happened while Jean was working in the old building. Once she heard a door open and someone come into the room, but when she turned round, there was nobody there. She often felt that someone was standing just behind her. And strangest of all, she and two other historians all took photographs of the interior of the building, but when they were developed, both films proved to be totally blank.

A lost child

Another Bratton resident tells a tale of Flowers Farm which incorporates some traditional details, and again we find the 'door that wasn't a door' motif – the second house in Bratton where this occurs.

> There used to be some [ghosts] down in the farm, because we had somebody living with us who used to live there, and they said they were in this one bedroom, and chains clanked round, and a door opened and shut where there wasn't a door to open and shut. And there was this cold feeling, you know, and we all sort of had a good laugh at it, you know. But when they pulled the place down, they found this bit of the room for some reason had been sealed off.

Clanking chains are a wonderful traditional attribute of ghosts, which go back many centuries. Pliny the Younger (c. 61-113 AD) writes in one of his letters of a house in Athens where "frequently a noise like clanking iron could be heard at the dead of night, which if you listened carefully seemed more like the rattling of shackles".

Jean Morrison has recently found out something of the historical background to this tale, which seems to point to the sad history of an exhausted woman and her unfortunate children. Jean believes the figure which moved around the bed and over to the blocked-up door to be one of five children which were born, one each year, to a woman who died giving birth to the last of the five. All the children were weakly and all died young. The child who haunted the room, she believes, was still trying to attract its mother's attention. The blocked-up doorway was discovered in the corner of the bedroom when Flowers Farm was demolished. Behind the door was

a short flight of stairs leading up to an attic bedroom, where perhaps a nurse would have lived and cared for the sickly children.

Someone sat on his legs

Kay Wells told me about a disturbing little occurrence from Totteridge Farm near Pewsey: -

> My husband [George Wells] who lived in the farmhouse, he said, as a boy he used to sometimes wake up and there was someone sitting on his legs. They always thought there was a ghost in the farmhouse.

Children, like animals, are quite sensitive to ghosts. This is probably because they have less sense of reality to get in the way of their perceptions. For example, when my nephew Richard was about 4 years old, he was not too keen on going for a walk down Hollybush Lane in Pewsey. 'Are there any dragons there?' he asked in great seriousness. I am sure that if there had been any dragons in Hollybush Lane, Richard would have seen them, whereas I, who don't believe in them, would have walked straight past, noticing nothing.

An unhappy ghost

Rex Sawyer relates verbatim Mrs. Thelma Barter's tale of the ghost in a Bowerchalke farmhouse. Mrs. Barter is described as "an intelligent and unemotional person who does not give the impression of being fanciful".

> While I lived in the farmhouse I saw the ghost of an old lady several times. She was short, rather stout, and had a grey shawl round her shoulders. It was always in my bedroom that she appeared.
> In a nearby cottage called 'Craigleath' lived a very old blind lady, with a companion. Her name was Miss Elliott and she had been born at Woodminton. I went to see her one evening and described my ghost to her. She at once said it was her mother. Her companion found a very old photograph of Mrs Elliott and sure enough, it was my ghost.
> When Timothy and Clare, as children, were ill, one night they both told me that someone had sat on the chair between the cots and held each child by the hand; they thought it was me, but I had not even been in their room during the night.
> Some years after, I had moved to my present house and my son Richard, who continued to live in the farmhouse, came in for coffee. In

the course of conversation, he asked me it I had seen an old lady upstairs in the farmhouse. He described my ghost as he had seen her. He said he had seen her several times. His poor wife, Susan, was terrified one morning as she vacuumed the bedrooms and someone spoke to her although no one was there! It was some time later before she finished the floor as she was too frightened to stay there. I had never spoken of the ghost to any of the children.

The 'baby sitter' for Richard also heard footsteps overhead, but found no one there except the children asleep in their beds. I spoke to old Mr Habgood about the strange happenings as he used to visit there as a child. He told me that Mrs Elliott was a very kind old lady and was very unhappy in the farmhouse.

This beautifully-told account unites various elements which we have met separately in previous tales: the ghost which when described is identified from a photograph; the children visited in their bedrooms by a ghost; the ghostly footsteps overhead; unprompted corroboration of the ghost's existence by other family members; and finally the explanation by a friend as to why the ghost should haunt. Keep all these elements in mind as you read the next tale.

Footsteps in the night

The people involved in this very convincing account are Jim and Sue Stevens, their son David, and their daughter Kate, with her Italian husband Gino and their young daughter Lucia [all pseudonyms]. In 1998, Sue told me of their strange experiences, which took place in their house in a village somewhere in the Pewsey Vale: -

Well, it was Friday October 21st, about 4 years ago, 4 or 3 - I can't remember - and my son was working in Reading at the time - he lived in Portsmouth and was working away at the time, so he lived with us during the week (the train was easier) and then going home to his own home at weekends. He always went home on a Friday.

Well one Friday - and I tell you the time now though I didn't know it then - it was half-past one in the morning, I heard him walking along the landing, because it creaks. And I though, 'That's strange, I thought David went back to Portsmouth this evening.' And I suddenly thought, 'Yes, he did, because we waved him off.' And I thought, 'We have intruders.' Well this - whatever-it-was - walked very firmly along the landing - I

could hear the creak. (And [my husband] Jim said [later] well it might have been the pipes, but you can hear an upward creak, and this was a downward creak.) It came along, and we have an opening out on the landing, say 6' by 8', with a standard lamp, and an old typewriter and a bookshelf and a telephone, and this whatever-it-was was literally walking very firmly all over this area. And I was terrified, because I thought it was an intruder, and I thought he's only got to come up these couple of steps into our bedroom. And my husband was asleep and I thought, I won't wake him, because he'll say, 'What's the matter with you?' then they'll come in and we'll be shot or something. So I stand there and find that my heart's beating up in my throat - brrrrrrp! - up here, and I thought, I'm going to die, 'cause I couldn't breathe with the sheer fright, I was absolutely frightened to death. And it was literally walking, and I couldn't see anything, it was so dark out there. It was walking, and I thought, 'It's going to walk into the standard lamp - how is it it's missing all this stuff?' I couldn't see the area where it was because it was so dark, but I knew it should be walking into things by now. And then all of a sudden, it stopped. And I suppose it went on - now I know time is difficult to judge, but I would say it went on a good 10 minutes. It seemed like about three hours!

When it stopped, my husband got out [of bed] and walked round to switch the alarm off. Now, I said to him - being very brave now, 'cause he's up! - I said 'What's the time?' He said, 'It's half-past one.' And I said, 'Put the light on.' He said, 'Why?' and I said, 'Just put it on.' So he did, and I said, 'We've got intruders.' Not being very brave I sent him off and he went all the way through the house and looked everywhere. He said, 'We haven't,' then came back up, looked under the beds, looked in every cupboard, and said, 'There is nobody here at all.'

Well I was still very, very frightened, and I said, 'Didn't you hear anything?' - because at one stage he seemed to hold his breath, as if he was listening, but then he went on breathing normally. I said, 'Didn't you hear that?' and he said, 'No'. Now, he must have done, in an unconscious manner, because the system was, when my son got up on Monday mornings to catch the train to go in to work, he would get up at 6 o'clock, come along, go to the loo, and my husband would then hear him, and get out and switch off the alarm. So I deduced afterwards he must have heard it, without even realising. If [my husband] was just going off to the loo he would not have to go there and switch the alarm off. So we deduced that he did hear this, and then got out, switched the

alarm off, then realised it was Friday, he's not here, and all the rest of it.

And I was so scared, I went in to see his brothers in Marlborough. Well, I was going to tell them all about it, but they had visitors and I didn't want to make myself look a fool so I couldn't say anything. So I had a stiff gin-and-tonic, and I felt a bit better. I had to get out of the house. I just really did. And I've waited since and I've waited to hear this, and never have.

But, when my grand-daughter was about nine months old, my daughter brought her down to stay. She was sleeping in my son's room, and Lucia was in the cot, and my daughter was here [also in the room]. When my daughter came down to me next morning she said, 'Have we got a ghost?' And I said, 'Don't be silly, of course we haven't.' And she said, 'Well, something walked along the landing, came into the room, walked through the wardrobe, and stood and looked at Lucia.' And she said, 'I followed this and heard it.' It woke her up, she said, but there was nobody nor anything there. So I said, 'Don't be silly, of course we don't have a ghost,' all the while having my experience in mind.

So when David came home to see her at the weekend, I said, 'What d'you think, David? Kate says we've got a ghost.' He said, 'Oh we have.' I said, 'What do you mean?' and he said, 'Well I often hear it walking on the landing.' But he'd never said. So that all tied up.

And then about two years later I heard a child running along the landing. Lucia was about two or three, and she had an Italian father. I didn't want her climbing down the stairs, and I thought, 'These Italians, why don't they look after their children? They never do anything.' So I shot along to the spiral staircase this end, and my daughter was in the kitchen, she heard this, she shot along to the stairs the other end, to see, to catch the child when she fell downstairs. But there was nobody there. I walked through, and it was silent. I went into the rooms calling her, but she wasn't there. You know how nothing has moved, I mean, you know nobody has been there. So I went downstairs, and there she was, sitting up in the armchair watching television. I said to her father, 'How long has she been here?' He said, 'All the time.' All the time I had been calling her she had been there. So we assume - and Gino also heard it, he was sitting there and he heard it - I was in the kitchen and I heard it there, and Kate also heard it, this running - the only one who didn't hear it that time was my husband - so there's something about, but for a little while now we haven't heard anything. It just comes and goes.

I was telling a doctor friend of mine, who's very interested in this

kind of thing. I said, 'Well, I'm frightened to go home, you know, we've got this ghost.' He said, 'Don't ever label it.' He said, 'Don't say, we've got a ghost, you just say you have an energy in your house. It will not harm you.' I said, 'It jolly well has, 'cause I was frightened to death!' I could have been harmed from sheer fright. He said, 'Now look, you'll always know again it won't attack you, that it's not an intruder, but this energy.' But I will always think [it's intruders] because it is so firm, so real. Does that make sense to you?

It is pretty clear from the style and force of her narrative, that Sue had been more than shaken by her experiences, and that what she recounted her had truly happened to her. I have no doubt of that, having listened to her tale: her voice, her tone, everything was frank and genuine. This is not the tale of someone spinning a yarn – the urgency in her voice and in the tumbling narrative speaks of someone whose tale has to be told in spite of her own amazement and her unwillingness to "make myself look a fool". I believe this tale, of all those recounted in these pages, to be the most likely example of a 'true ghost'.

Yet we can still identify some of the key features of the typical ghost tale: the ghostly footsteps; the ghost which visits a child in her room; the members of the family who have also heard, or seen, or sensed the ghost and who confirm that they know of it after the event and with little or no prompting. This is surely how many ghost legends start, with a core of genuine experience, and as the tales are told and retold by various people they acquire those other extra touches – the convenient history, the ghostly sightings, perhaps in time even the black dog, headless figure and the clanking chains – which signal to us that we are in the realms of folk legend.

Sue tells me of another curious incident that happened about 18 months after the events above. She and Jim had been shopping, and were at opposite ends of the kitchen putting everything away. Outside it was dark. Suddenly they both heard a voice say three separate but indistinct words. Sue says that they came as if through a mist or a veil, muffled and impossible to make out exactly, but there were definitely three separate words spoken by some other voice. After establishing that they had both heard the words, they each pointed to where they believed the voice to have been, and found they were pointing to exactly the same place. Since that time, there have been no more ghostly incidents at their house.

Can't keep a cat

Now we have a series of three linked tales about a small house in Bratton where some very strange things have happened over the years. The three accounts were told me by two different people but on the same occasion, and although it all happened quite naturally and easily, in retrospect it was so perfectly-paced a piece of storytelling that it could almost have been scripted (but I'm sure it wasn't). So you must imagine the three of us standing in Bratton village hall in July 1997, the two women talking in turn, while I clutched my dictaphone, listening and hoping that later on I should be able to sort out their stories from the jumble of voices around us.

> There's another little cottage ... and they've been there now about eighteen months, and they can't keep a cat. They cannot keep a cat. They took three cats there when they went there to live, and they all vanished. Now since then she's tried to get another one to stay - he'll come in, walk round, and go straight out again. He won't stay there - he will not stay there. And she had some relations come down ... to stay - it was her grand-daughter I believe - came down to stay with her, and she said, 'I'm not staying here for another night, I'm going up to the Duke to stay for the rest of my holiday,' and she went up to the Duke.

So first of all, the scene is set. We have a cottage which is so plagued by unspecified events that cats and grand-daughters sense the atmosphere and refuse to stay there. This is bad enough. But things get worse.

> Mrs. P[...]'s dogs wouldn't stay in there, would they? It's very strange. Because they had this bakery, whatever it was, outside, and they had to make that in for the dogs because the dogs wouldn't go inside.

So the tension was now quite high. I still didn't know what the problem with the place was, but it was now so uncomfortable that dogs wouldn't go in there, so it really had to be pretty bad. And then the third part (even storytelling goes in threes) of the tale was told, and it was better than I could possibly have imagined or hoped.

> When Mrs. - oh, what was the funny old lady who lived there before? ... Well, she told me that she had somebody came and slept with her every night, and she didn't seem to mind. She swore that somebody came and slept with her every night. And she knew about the cats because

165

they now live over in the opposite place, and she said she couldn't keep any milk, she used to have powdered milk because the milk turned. All the time the milk turned.

To live with a ghost about the house is difficult, but it is achievable. To live with one which gets into bed with you every night would be beyond the acceptable for most people. The old lady must have been either extremely tolerant or very remarkable – or both. The atmosphere in the house was clearly very powerful (or the house rather warm) for the milk turned all the time – a sure sign of occult activity. One of the crimes of which witches were accused, was that they caused the milk to turn. So why did she live with it? Stubbornness, perhaps, or having nowhere else to go; or perhaps in spite of the problem with milk and cats, this was rather a companionable ghost.

HE told I to

And now one of the finest ghost tales I have ever read, related by a Justice of the Peace, B.H. Cunnington, and dealing with events which he claims were genuine in so far as he was able to verify them.

'HE told I to' - a ghost story(?) that is true. Some years ago there stood - and may be there now - a pretty thatched cottage just off the road leading to [Bishops] C[annings]. A garden full of flowers lay in front with a shallow well at the side. Behind the cottage were some fields that each spring were preserved for haymaking. A farm labourer and his wife and family lived in the cottage, and all of them helped at haymaking time as well as when harvest was on.

One summer's day, when haymaking was in full swing, the labourer, who was on the top of the rick, suddenly, in view of all his fellow-workers, jumped to the ground and in doing so broke his legs. He was taken to the hospital, and later on, when he had recovered, he was asked, 'What ever made you jump from the top of that rick?' He replied, 'HE told I to', but refused to say anything more about it.

Soon afterwards, when he had quite recovered from his accident, he and his family left the cottage and went to live in another village in Wiltshire. The cottage remained empty for some months but was later occupied by a man and his wife, who, I understand, had retired from work but had just sufficient means to live quietly. One afternoon the wife was horrified to find that her husband had jumped out of the

bedroom window and was lying unconscious on the ground. He was taken to hospital, and, when sufficiently recovered, was asked what had made him do such a foolish thing as to jump out of the window. To which he replied, 'HE told me to'. When able to leave the hospital he gave up the cottage and went to live some miles away. Again the cottage was vacant for some months until it was taken by a woman with a daughter about twenty years old. Here I come into this strange story.

One afternoon I was asked, being a Justice of the Peace, to go to the cottage to certify the daughter as a case that should be sent to the Mental Hospital. On arrival I found the young woman sitting in a chair by the fire, but for a long time could not get her to speak. Her mother said that her daughter had drunk a pint of paraffin and then jumped into the well, which, as stated before, was a shallow one. I went and had a look at this well and found it only about ten feet deep with not more than about two feet of water at the bottom. The mother saw her daughter jump into the well and raised an alarm. Neighbours came to her assistance, and the girl was safely brought to the surface, though of course she was wet through. Medical aid was obtained, and in a few days the doctor recommended that she should be sent to the Asylum. This was how I got mixed up in the matter and learned the details of this remarkable story. After I had talked to the girl for a little while, doing my best to get her to speak, I asked her, 'Why did you do such a foolish thing as to jump into the well?' and at last she said, 'HE told me to'. The mother then told me that she had previously heard about how a man had been told by someone to jump out of the bedroom window some years ago. This led me to make enquiries, and when I had finished I had gathered indisputable evidence that in the two cases mentioned above 'HE' had told the victims to do the silly and dangerous acts as recorded, and as for the third case, I had heard it from the girl herself.

I should add that, though every effort was made to see if the three occupants of the cottage had any connection with one another or even knew each other, not a single thing came to light to support this possibility, as they were perfect strangers to one another. Neither did I ever find out who HE was.

I would like very much to know the nature of the "indisputable evidence" collected by Cunnington. It seems to me that he could certainly vouch for the actions of the girl who jumped down the well, but we do not know whether he was able to speak to the other two people who heard the voice.

All three incidents happened within months of each other, and all three victims survived, so interviewing each one personally would have been quite possible. Yet he specifically says, "as for the third case, I had heard it from the girl myself", which implies that he did not hear directly from the other two. If Cunnington had done so, then we would have had to consider the possibility that some kind of malign entity temporarily possessed all three victims and induced them to act self-destructively. If his information gathered came from neighbours and witnesses, then it must be suspect. When dealing with ghosts, the memories of witnesses, as we have seen before, tend to adapt to fit ghostlore motifs, and the 'genuine' ghost account becomes a folk tale – as this one, with its three victims, seems to be. I believe that the core event – which sounds like the action of a very depressed teenager[4] who in retrospect wanted to deny responsibility for her actions – along with the accidents to previous inhabitants of the cottage (the linking factor), prompted the creation of memories which bound up all three events into a coherent tale.

Alternatively, a malign entity did induce them all to jump. How can we know for certain?

On the nature of ghosts

It will have become fairly obvious that, like many people, I am uncertain about ghosts. They defy explanation, and just as you think you have one classified neatly as 'folk tale' or 'genuine sighting', some witness or folk-tale element will come to light that overturns all your previous ideas. Those who have seen ghosts are in no doubt of their existence; while those who have not seen ghosts often fiercely refuse to entertain any possibility of their existence. But belief in ghosts is fairly widespread[5], and encounters with ghosts by all kinds of people are surprisingly common. In spite of the failure of ghost-hunters to produce any convincing evidence of the existence of ghosts, I believe we must take them seriously and at least try to understand what they might be.

One of our problems is that we often use the word 'ghost' very loosely to indicate some kind of inexplicable event or phenomenon that we cannot classify according to our understanding of normality. As a folklorist, I do this myself, for I accept the terminology used by the people recounting their experiences: if they believe they saw a ghost, then (for this is their 'lore') it was a ghost within the context of their narrative. This leads us into the next problem: when is a ghost narrative a report of a genuine encounter, and when is it 'just' a folk tale? The one seems to slide over into the other almost

immediately, as we have seen, and when retold, especially by others, a genuine account acquires the features of a traditional ghost tale surprisingly quickly.

I believe that 'ghosts' exist on different levels and in different realities, ranging from existence in folk narrative alone through to well-attested objective reality. Some exist in one or more of these realities at once: for example, a coach and horses exists in the reality of the tradition which says that it haunts a particular stretch of road, but when someone actually sees that coach and horses, it is very much real in the everyday sense for them. Once they start to tell people about it, everyday reality weaves itself back into folk narrative, and the threads become ever more entangled.

So what are ghosts? In spite of their elusiveness, it is possible to begin to identify types of ghost, and then to work out a helpful definition of 'ghost'. Ian Wilson has done some particularly useful work in this area, which I found tied in and helped to clarify the conclusions that I had independently been reaching. Here are some of the main types of phenomenon usually called 'ghost': -

● *Poltergeists*. The 'noisy ghosts'. These are usually short-lived phenomena, which seem to arise from the unhappy, frustrated or rebellious energies of an adolescent. They seem to be a form of expression of destructive teenage angst rather than a ghost as such. Example: *The drummer of Tidworth*.

Ordinary noises around the house – water hammer in pipes, beams expanding and contracting, vibration from passing planes and lorries – can also cause very convincing poltergeist-type sounds.

● *The 'passing caller'*. Wilson's evocative term for the ghost of a person recently dead who returns to reassure their family or friends that all is well. They may easily be visionary experiences generated by the mourning process. They do not haunt, but usually appear only once to each person involved. Example: *Father returns after death*.

● *The 'ghostly video recording'*. These are visual phenomena, which are seen repeatedly, and seem frozen in time and place, unaware of the present day, walking on old floor levels etc. They may be accompanied by, or be solely, animals or vehicles. They seem to have been generated initially by some powerful outpouring of emotion – anger, distress, grief, and jealousy

– as in the case of suicides or road traffic accidents. Example: *Death over Salisbury Plain* at the end of chapter 3.

● **The 'traditional ghost'.** One that exists only within the context of a folk tale – a huge number of ghosts belong here or move into this category. It has particular characteristics, e.g. clanks chains, or carries its head under its arm. It may have developed once from a genuine ghost, which has since faded, leaving behind the folk memory in the form of a traditional tale. It may have developed in response to a community's need persuade people to avoid certain places, for their own safety, or to ensure privacy for illicit acts. See, out of many examples, *Laid in the Red Sea*, *Molly of Pythouse* and *Three 'chops'*.

.

● **The 'manufactured ghost'.** One that has been seen or heard as a result of suggestion or hypnosis. It is very real to the witness, but has been deliberately created by another human being. Example: *A witch's ghost* in chapter 4.

● **The outright fraud.** Someone simply and blatantly lies, for purposes of their own, e.g. as a joke, to add interest to their commercial property, to induce the Council to rehouse them, to attract attention to themselves, or perhaps to please and satisfy a persistent folklorist. Possible example: *Murder will out*.

● **The photographic ghost.** A ghost-like figure appearing spontaneously on a photograph. Usually the photographer has noticed nothing while taking the picture. The most famous example must be the hooded figure on the Tulip Staircase in the Queen's House, National Maritime Museum, Greenwich. This has been pretty conclusively explained as a repeated image of someone in a white lab coat ascending the stairs during a single long exposure. Example: *A pair of ghostly boots* in chapter 2.

● **The hallucination.** Also known as 'psychological projections', these are 'images... from the unconscious mind which are projected by a person under stress or in a state of denial'. Canon Dominic Walker, one of those in the Church of England who responds to reports of incidents of a ghostly nature, believes that the vast majority of reported ghosts can be explained as psychological projections. They can affect groups of people as well as individuals. Examples: *A witch's ghost* in chapter 4.

● *The true ghost.* I believe that very few reported 'ghosts' fall into this category, yet this is the essential ghost, the conscious spirit that remains after death. This is the ghost on which all other ghosts are based. Based on his careful researches into several hauntings of this type, Wilson tells us, "...ghosts are people, people who have died yet who still live on, tied to their old earthly existence in an unsatisfactory manner. They need to be treated with all the sympathy and help we would accord to a living person who was in trouble." This means that we should not in our fear take refuge in the traditional (but brutal) defence of exorcism. Ghosts of this kind respond remarkably well to prayers for their well-being and release. If you ever encounter such a ghost, remember that they need requiems, not exorcism. Possible example: *Ghostly footsteps in the night.*

References
Father returns after death: Jean Morrison, *pers. comm.*, Bratton, 1994
A simple traditional tale: Ashworth (1954), p.1592
Monk at Monks' Conduit: Terry Veale, *pers. comm.*, University of Bath, 1990s.
Plainchant at Beaulieu: Norman (1977), p.174-5
Malmesbury Abbey ghosts: Ashworth (1956), p.203
Drummer of Tidworth: Reader's Digest (1977), p.186; Aubrey (1969), p.121.
Three 'chops': Olivier (1932), p.73.
Murder will out: Olivier (1932), p.40.
Laid in the Red Sea: Manley (1924), p.14.
The haunted oven: Olivier (1932), p.78.
Screaming skull of Bettiscombe Manor: Hole (1950), p.45.
The power of bones and skulls: Hole (1950), p.42.
Indestructible skull: Wiltshire (1973), pp.89-90.
Molly of Pythouse: Palmer (1973), pp.101-2.
Bumps in the night: Hendry (1994), p.1.
The lady on the stairs: Marjorie Jordan, *pers. comm.*, Pewsey, 1994.
Old Mother Sharp: Olivier (1932), p.46.
Used to live here: Olivier (1932), p.80.
Always pleased to see him: Davis (1965), p.226.
Littlecote haunting: Norman (1977), p.191.
It was only the ghost: Davis (1965), p.226.
Ghost car: Bath resident 1, *pers. comm.*, University of Bath, 1994; Bath resident 2, *pers. comm.*, Bath, 2000.
Theory of narrative causality: Pratchett (1992), p.8.
Haunted Baynton House: Jean Morrison, *pers. comm.*, Bratton, 1994.
Haunted Brook House: Olivier (1932), p.83.
Only his slippers remained: Olivier (1932), pp.74-5.
Hanging from a beam: Olivier (1932), pp.71-2.
Never seen again: Jean Morrison, *pers. comm.*, Bratton, 1994.
What did the cat see: Ivan Taylor, *pers. comm.*, University of Bath, 1998
Who was at the door: Julie Wood and her mother, *pers. comm.*, Little Bedwyn, c.1975
Flowers Farm ghosts: Jean Morrison, *pers. comm.*, Bratton, 1994, 2000; MM, *pers. comm.*, Bratton, 1997
History of Flowers Farm ghosts: Jean Morrison, *pers. comm.*, Bratton, 2000.

Someone sat on his legs: Kay Wells, *pers. comm.*, Wiltshire Farming Club, Oare, 1998.
Unhappy ghost: Sawyer (1989), pp.137-8.
Footsteps in the night: Sue Stevens [pseudonym], *pers. comm.*, Wiltshire Farming Club, Oare, 1998, and [location withheld], 2000.
Can't keep a cat: Kathleen White (part 1), MM (parts 2 & 3), *pers. comms.*, Bratton, 1997.
HE told I to: Moonrake (1942-4b), p.415-6.
Ian Wilson's work on ghosts: Wilson (1995), specifically 'passing caller', p.57; Tulip staircase photograph, p.29; 'psychological projections', p.23; true ghosts, p.246. Wilson's book is the most fair-minded and rational that I have yet read on the subject of ghosts.

Notes

[1] A similar tale, but in reverse, is told of the Jew's Wall near Kingston Deverill church, for if the wall ever falls, the Marquisate of Bath will fail, or some other disaster occur to the Thynne family.
[2] "Someone brushed against me."
[3] The house has been demolished - it stood where the ALDI supermarket is now.
[4] Or was she a victim of abuse? If so, 'he told me to' takes on a much more sinister significance.
[5] I called for a quick show of hands at a lecture once. Out of about 120 people, around one-third had seen a ghost (or some inexplicable phenomenon), another third believed in them, and the remaining third either disbelieved, didn't know, or weren't saying.

Chapter 6

Black dogs, big cats
& other beasts

Animals in folklore

In the countryside not so very long ago, animals were central to all areas of life. They provided meat for the table, wool and leather for clothing, they drew the plough, cart and carriage, they cropped the grass, provided manure for the fields, herded sheep, kept down vermin and were quarry, assistant and transport for the hunter. Although machines have taken over some of these tasks, animals still fulfil many of these roles today. Moreover the English are renowned (in spite of our curious obsession with killing animals for sport) for being animal-lovers. There can be few people who do not share their lives with animals in some way, either by keeping a pet, by working with animals, or simply by watching birds or animals in their natural habitat. Not surprisingly therefore, there is a huge amount of folklore relating to the animals which share our lives and live in and around our homes and workplaces. Animal-related folklore includes folk-tales, both serious and humorous, signs and omens, traditional nicknames, holy wells and of course ghosts. We may perhaps also include crypto-zoological beasts, like alien big cats (ABCs), dragons and other curiosities of that kind. This final chapter takes the form of a Wiltshire Bestiary, setting out just a few of the many animal traditions to be found in books and in contemporary belief.

The Thing

To set the scene, let us consider this chilling little tale, recorded by Kingsley Palmer in Donhead St. Andrew:-

When first married I lived in a cottage up Fetch Common way. The bedroom had wall cupboards in opposite corners of the room, and

something used to pass from one cupboard across to the other. The 'thing' was large, dark and animal-like.

This short account neatly encapsulates many of the themes that run through animal folklore. The animal is uncanny, perhaps ghostly; it crosses a threshold or boundary; it follows a well-defined path; it is acting in an uncharacteristic way; it is out of its usual environment; it leaves us with a sense of foreboding or unease. We shall meet these attributes many times in the course of this chapter, and nowhere more so than in folklore relating to Black Dogs.

Black Dogs

Black Dogs are apparently ghosts, but they do not fall easily into any of the categories identified at the end of the last chapter. They come in three basic varieties: the demon dog; the black dog; and the very rare dogs that appear in a specific place at a specific time of year. The demon dogs appear all over the country and are known in different regions by a variety of names, such as Padfoot, Barguest, Shriker, Hooter, Shuck or Trash. These are generally ominous, often belligerent, and change their shape at will, appearing also as donkeys, calves and other less gentle beasts. These dogs go out of their way to show anyone meeting them that they are monsters from another world – and the reader may be pleased to know that I have no examples of these from Wiltshire.

But we have very many accounts of the ordinary black dog in the county. A great number of these have been identified and recorded already by Kathleen Wiltshire in the course of her three books of Wiltshire ghosts and folklore. These black dogs always appear simply as dogs, usually around the size of a retriever, or 'as big as a calf' – or mastiff, or donkey. They are usually associated with a particular stretch of road, or a stream, or places of transition like gateways or parish boundaries. They are essentially non-aggressive, kindly and protective beasts, whose role seems to be either to patrol or guard the boundary or road that is their 'beat', or to protect and guide travellers home. One characteristic which Kathleen Wiltshire tells us is particularly associated with Wiltshire black dogs is that many drag a chain, and the sound of this chain rattling is usually (but not invariably) the only sound they make.

The Inglesham Ghost

Black dogs appear very often in folk tradition, often just as a simple passing comment or in place-names. Alfred Williams records one such example from Inglesham in the very north of Wiltshire:-

'Well, good-bye to 'e, if 'e must go. Look out for the owl' black dog o' Engleshum,' said Gramp… As I passed beneath the dark trees a black dog came running by, and I thought of Gramp's parting words at the cottage, in which he referred to the Inglesham Ghost, though that was probably one let loose from the neighbouring farmyard.

Black dog of Wilbury

A typical example of a black dog encounter is related by Olivier, and concerns that same rather uncanny stretch of road, near the Double Shutte, which we have met before.

I was sitting, some years ago, in the little White Lodge on the Salisbury Road, waiting for my husband to come to tea. It was mid-winter and quite dark at 5 p.m., and I was somewhat nervous, after being alone all day. Suddenly I heard his step, and he opened the door and walked in.

I looked up and exclaimed at his extreme pallor. 'Why, whatever is the matter?' I cried. 'How white you are'.

'Yes, and so would you be white if you'd been with me to-night,' he said.

'Why, what's happened?'

'Give me a cup of tea, and I'll tell you.'

He then said: 'It was pitch dark when I left the Avenue and turned into Wilbury, and I had just entered the Grove, when I found something trotting beside me. It seemed to be a big black retriever dog. I spoke, but it did not bark, and continued trotting by my side, and panted as if it had been running hard. It left me at the Double Shutte and although I whistled and called he did not return. It was only then that I realised it was not a real dog, but a ghostly one.'

Again, this is fairly typical of black dog encounters. The person who meets the black dog does not at first realise that it is in any way uncanny, and the encounter might easily be explained as a meeting with a genuine dog – as no doubt some are. But here we find the woman's husband in no doubt that what he met was not a normal dog, and so convinced of it is he

that he is still pale from shock when he returns home. The dog accompanies him quite harmlessly along a specific stretch of road, and when they reach a boundary point – the Double Shutte – the dog's task is done and it leaves.

Black Dog Hill

A group of place-names on the A36 Bath to Warminster road have given rise to a very well-developed folk narrative. Black Dog Farm stands on Black Dog Hill at ST 831488, and it is easily recognised by its signpost of a large Labrador-like black dog with tongue extended. Black Dog Woods lie to the west and north of the farm, and at the top of the hill, many motorists must be surprised to find the interchange junction clearly labelled Dead Maids, after another farm nearby. Manley tells us that the hill is haunted by a black dog with large fiery eyes. Eyes 'like burning coals' or 'as big as tea-saucers' are one typical attribute of the less-realistic version of the black dog, for the traditional black dogs do seem sometimes to acquire a touch of the demon dog. But I have never met anyone who has seen a black dog of this kind – they always see a more realistic beast.

Kathleen Wiltshire tells the most generally accepted version of the tale that binds all these names together into a coherent whole: -

… a farmer's daughter… had two suitors, each unknown to the other. One suitor owned a black dog. When they did hear about each other, the two men battled to the death, the owner of the dog being killed. Whereupon the dog killed the other man and the farmer's daughter committed suicide, her body being buried at Dead Maid's Cross, at the top of Black Dog Hill. The dog thereafter haunted the district.

It is always difficult with a tale of this kind to be able to say whether the tale existed first, and inspired

Black Dog Farm's evocative signpost.

the place-names (as the tale would have us believe); or whether the tale has been created to explain the names. My belief is that usually this type of tale has come second, in an attempt to rationalise place-names whose original significance has been forgotten. In this case, we know that an inn called the Black Dog stood in the area, and it is very likely that the woods and farm were named after it. The name Black Dog Woods goes back at least to 1809, and Dead Maids Cross appears on Greenwood's map of 1820, but not on the 1773 Andrews & Dury map of Wiltshire. It is probably, but not certain, that the names go back to around 1800 and the tale arose later.

That being so, what are we to make to the sighting not too far from here of a large black beast? My colleague Christine Bright recounted to me how her husband and son were travelling back to Bath late one night in the mid-1990s. They were driving around the Warminster by-pass when they were very startled to see a great black beast that loped across the road in front of them. Was this the phantom black dog, or one of the alien big cats that are seen from time to time?

Black Dog Hill (ST980709), and the now disused Black Dog station between Calne and Chippenham, also are associated with black dog sightings.

Terror in Collingbourne Woods

Another stretch of woodland associated with a black dog is Collingbourne Woods east of Collingbourne Ducis. Alan Cogdell told me: -

> Well, the story goes about it – it's in the magazines – there's a murderer who was escaping from the police once, and he went into the woods, and he had dark hair when he went in, and when he came out he was white… The police caught him, he said that he had seen a black dog with blazing eyes…

Kathleen Wiltshire records the black dog's haunt as being White Lane, which is around SU275546. This gives us the typical black dog that is associated with a specific stretch of road; the tale of the murderer escaping from the police (a relatively modern touch) must have come later and may be very new indeed.

Black Dog Corner

Tony Church told me that a black dog used to be tethered at Black Dog Corner near Black Dog Farm south of Potterne. Black Dog Corner is the

crossroads at ST995558. As at Black Dog Hill, we find that around 1840 Black Dog Farm was the Black Dog public house. It seems most likely that the black dog legend has grown up from the pub name, but at the house of Mrs Hunt-Grubbe is kept a brass collar which Tony has seen, and which he tells me is the one the dog used to wear. In a later letter he continues, "a further story suggests there were three large black dogs which savaged a customer and killed him, the dogs were destroyed and dropped into a field well. In a recent dry summer the well was emptied but now bones were ever retrieved." It is unlikely that any would be. The story is surely a development of the black dog legend, as the mystic number three features significantly, along with a version of the 'dropped down the well' motif that I encounter quite often in my research into wells.

The black dog of Burton Hill
As he was showing a friend and me around the many wells of Malmesbury, John Bowen happened to mention that a black dog haunted the main road at Burton Hill, between the milestone and the old coaching pool.

> There is a black dog at Malmesbury, at the coaching pool that is off the Chippenham road. It is about 250 yards due north of the milestone coming into the town. As you go past the school which is known as Burton Hill school, and while you are still in the grounds of that, the wall suddenly breaks off at one point and goes in - there are sometimes two cars in there. That's where the old coaching pool was. That's where the coaches used to stop and clean their wheels when they got really muddy before coming into town. But that is where the black dog is. I haven't seen it but my grandfather always used to complain about the black dog.

The black dog of Quaker's Walk
Quaker's Walk at Devizes is a footpath that runs from the canal at Park Bridge north-east to Roundway. The ghosts of Quakers have been seen on this path, but I heard about the black dog for the first time in 1995: -

> An old friend of ours at Devizes, he saw the black dog down Quaker's Walk in Devizes. He said he was walking down the track and this dog was there, and then it was through on the other side of the hedge, and then it was gone. He said it was a black dog.

This encounter seems extremely low-key and unthreatening, and it is

Imposing entrance to Quaker's Walk.

interesting that anyone should bother to recount it in the first place: 'a dog ran across the track in front of me' – amazing! It may be that the dog was different enough from the norm to inspire the belief that it was otherworldly; but if the track had the reputation of being haunted by a black dog, as seems to be implied here, then probably any black dog seen there would be taken for the ghost.

Guardian of the boundary

However, my colleague Terry Veale and his wife Marie once saw a black dog near South Wraxall in a place where they knew of no such tradition, and it was only after he heard me talking about black dogs and their characteristic behaviour that Terry realised what it was that they had seen.

One afternoon in May 1993, at around 3 o'clock in the afternoon, Terry and Marie were walking from Monkton Farleigh Manor along the green avenue leading to South Wraxall. Both suddenly saw a huge black dog like a mastiff about a quarter of a mile away, standing between them and the village. They didn't see it walk out onto the avenue, nor did they see it appear: simply one moment there was nothing, the next, it was there. It remained there absolutely silent for several minutes, watching them as they walked cautiously towards it. When they were about 200 yards away it moved suddenly towards the hedge on the right and they lost sight of it. When they got to the spot and looked for it, there was no sign of it anywhere. The countryside around about is fairly open, and they both felt that they should have been able to see where it had gone. At the time Terry knew of nobody locally who kept such a large black dog, and he described it to me as "a very spooky experience".

At long last I had a black dog sighting which I could investigate in a little more detail. I got out the Ordnance Survey map of the area and asked Terry to show me whereabouts he judged the dog to have been standing

while they walked towards it. He picked out the area around ST818654, and this is quite close to where the parish boundary crosses the avenue. I also noted that on either side there were trees that could have screened any dog from view quite quickly, or this is where the dog may have gone. But Terry's tale contains a fair number of typical black dog features - its large size, its silence, the uncanny atmosphere, its position on an old way and near the parish boundary – and I believe we may consider it a good candidate for a genuine black dog sighting.

Dog on the track

Frances Price and her friend Lois Holland once had an encounter with a dog on an old drove road near Totteridge Farm in the Pewsey Vale. Once again, it was the dog's silence which impressed and surprised them: -

> I live on a farm and there's quite an old track. It's on a highish ridge, and about 4-5 years ago [i.e. around 1990] my friend and I were up there one evening. It was about half-past nine, it had gone dusk, and we were looking around and saying, 'Well, those must be the lights of Hungerford over there, and those are the lights of Marlborough'. We were just talking together. We were about that [arm's length] far apart, and suddenly I heard a tinkle, like the disk of a dog, and there was a dog coming, a sort of lurcher type, and it went straight between us. It didn't look at us, it didn't do anything, it just went straight through. And we said, 'Well, if we hadn't heard that tinkle, we wouldn't have known about it!' ... No sound, only this little tinkle - we just couldn't believe it, we were just so close. 'Do you hear a tinkle?' though, we both thought... It was not a very broad dog, a sort of slimmish dog really. I can't get over it, it was just there, it went straight between us. I mean my friend will tell you the same. We didn't go up there looking for dogs - we were looking at the scenery.

Normal dogs do not run silently. They pant, and their paws and claws make a noise as they hit the ground. They also have a tendency to stop and investigate the people they meet along the way. Yet this animal was completely silent except for a slight jingling sound: one is reminded that some of our Wiltshire dogs drag a chain. The track is a wide one, and they were standing to one side of it, so there was plenty of room for the dog to go past them, but it ran between them as if they were not in its way. Frances tells me, "If we had been looking away we might not even have been aware

that it had gone past us." At the time, neither Frances nor her friend knew anything of ghost dogs, but they were much struck by the demeanour of what they describe as a grey, rough-coated, lurcher-like dog. Once again, this is a low-key encounter that might easily be explained away; yet the impression made at the time, and in retrospect, was clearly very strong indeed. Lois says, evocatively, "It was like a dog in a dream."

So we find that the existence of black dogs (and grey lurchers) is as difficult to judge as that of any other ghost. They might be real dogs, but the people who see them are shaken by the experience beyond what seems appropriate for a chance meeting with a dog. Some are obviously legendary, but sometimes people still see them. I have never seen anything of the kind, so I cannot really understand what such a sighting is like, but after almost every lecture I give where I mention the black dogs, someone comes to me and tells me of their own experience of meeting one. They are one of the most widespread of ghosts, yet one of the more difficult to explain.

The dog as omen

"To have a black dog on one's back is a local idiom for a bad temper," writes Manley in 1924, and we can appreciate this metaphor which combines the image of bared teeth and uncertain temper with the darker suggestion of a black demon literally dogging the angry person. Rather surprisingly, given that it is such a genial, friendly beast, the dog is often an omen of death; but we find too that dogs have "almost always and everywhere been credited with the power of seeing ghosts and spirits, gods and fairies, and the Angel of Death in all his various forms." This belief was current in Wiltshire at the end of the 19th century, as is evident from this account: -

When my mother died, we had a very favourite dog, a fox terrier, who was greatly attached to her. All our persuasions would not induce him to enter her bedroom; his abject terror was so great that we gave up all attempts to coax him into the room. On the morning of her death, the dog was asleep before the kitchen fire; suddenly he jumped up with a cry and, with his tail between his legs, retreated under a chair, nor could we, by any persuasion or tempting, get him to come out; there he lay all day, shivering with terror. After all was over, our servant, a raw specimen from the wilds of Wilts, who was the wonder and astonishment of all the London tradespeople, told me 'she knew that missus would die directly the dog behaved so strange-like, as he saw the Angel of Death come into the house, and that fritted (frightened) him. Animals could see those

things' she said; and added a list of similar cases she had 'see'd with her own eyes'.

Elsewhere in the collection of folklore that contains the account above, we read that the howling of a dog is a sign of impending death. Donald Gough, a native of Chippenham, holds the same belief. His son Steve sent me in 1996 a collection of his father's tales and beliefs that included the line "if a dog howls throughout the night, someone is dying."

The traitor dog

South of Upton Lovell where Water Street crosses the river Wylye stands Suffers Bridge (ST942401). The village name is derived from William Lovell, who held the manor in 1428. The village and bridge names are linked in a tale that once again seems carefully constructed to explain them: -

> The story is that Lord Lovel, being besieged in his Castle, escaped into Boyton Woods, and from thence into the river, where he hid himself under a bridge. His pursuers sought him everywhere in vain; at last they let loose his favourite dog, who went straight to the spot and stood there whining, and so betrayed his retreat; he was dragged out and carried away prisoner, and that is why the place is called Sufferers' Bridge.

Horse chestnuts shroud Suffers Bridge.

Just keeping an eye on you

From Potterne in the Pewsey Vale comes the tale of a witch who could transform herself into a greyhound. The narrative shows strong parallels with the witch-into-hare tales we considered in chapter 4, but here the witch is not shot or beaten to death. It was recorded by B.H. Cunnington, and seems to date from the 1920s or 1930s, suggesting that a strong belief in the witch as shape-shifter lasted into the early years of the 20th century.

> Some years ago I employed a man who was engaged to a young woman living at Potterne, and he made it a habit to walk there and see her most evenings when his work was done, and they used to go for a stroll together. He told me that whenever they went out her mother changed herself into a greyhound and followed them. As a proof of this, he said that on one occasion, when the rain was falling and he and his girl were walking homewards, the greyhound dashed in front of them and leaping the garden gate vanished out of sight. After saying 'good-bye', he walked with his girl up to the house and on looking through the window saw the mother standing in a shallow bath washing mud from her legs. He also assured me that the woman never had to get up at tea-time to fetch anything from the dresser or shelf, but merely beckoned to them, and they flew into her hands. She had a book full of sorcery and witchcraft, which she kept in a tin box buried in her garden, but he had never been able to get hold of it.

The ultimate insult

The power of 19th century country squires to influence their tenants is demonstrated beautifully in a tale about election practices in Hindon.

> ...it is said when a member returned thanks for the honour of election he was told not to trouble himself, 'for if the squire had zent his great dog we should have chosen him all one as if it were you, zur.'

Alien Big Cats

ABCs have been part of the popular crypto-zoological profile of the United Kingdom since the famous sightings of the Surrey Puma in the early 1960s. Since then ABCs have been fairly consistently reported all across the country, but sightings can be traced back to the 18th century. The cats are dubbed 'alien' because they are not likely to be native to this country. Witnesses report seeing large cats of two main types: moderately large cats around

the size of a lynx or retriever dog; and truly big predators of puma or panther size. Controversy rages as to whether these are sightings of genuine big cats, or hoaxes, or cases of misidentification: in this, ABCs are similar to ghosts.

A number of different groups of people are studying ABCs fairly consistently, for there is, as web-author Brian Goodwin writes, "simply too much evidence for alien big cats to be disproved." Goodwin summarises one plausible current theory, which suggests that many of the sightings are of Asian Jungle Cats, *Felis Chaus*, or of hybrids of jungle cats and feral domestic cats. Asian jungle cats were often found in Indian villages, and some of these large cats may have taken on board the old sailing ships to help keep down the ships' rat population, and later released or escaped when the ships docked. *Felis Chaus* is genetically compatible with *Felis Domesticus*, so that they can interbreed. Moreover, the crossbreeds are fertile, so that a hybrid strain of very large feral cat may well have established itself in this country. Sightings of the larger puma-sized cats might perhaps be explained by escapes from wildlife parks and zoos, or by the irresponsible release of exotic pets into the wild. Goodwin estimates that perhaps as many as 70% of ABC reports are of jungle cats or jungle cat hybrids, while the other 30% are most likely of a larger species, such as pumas.

The unfortunate Hannah Twynnoy

There is no doubt that ABCs have been reliably reported in Wiltshire in the past. Probably the most famous one is the tiger that attacked 33-year-old Hannah Twynnoy on October 23rd, 1703. Hannah was a servant at the White Lion inn near Malmesbury Abbey churchyard. A travelling menagerie was stopping at the inn, and Hannah began teasing the tiger through the bars of its cage. The poor beast, which was doubtless already half-mad from its confinement, broke out of its cage and killed its tormentor. Hannah's famous gravestone can be seen beside one of the churchyard paths. It reads:

> In bloom of Life
> She's snatched from hence,
> She had not room
> To make defence:
> For Tyger fierce
> Took Life away
> And here she lies
> In a bed of clay
> Until the Resurrection Day.

Tease not the Tyger...

Poor Pomegranate

Just over a century later, in 1816, there was a similar incident in not far from Salisbury. The scene was the Pheasant Hotel (SU232348), which was then called the Winterslow Hut, and stands beside the main A30 road north of Winterslow. This time the ABC was an escaped menagerie lioness[1] that pounced on one of the horses pulling the Exeter mail-coach. Mayhem ensued: the passengers took refuge in the inn and barred the door, the mail-coach guard tried to shoot the lioness with his blunderbuss, and a Newfoundland dog grabbed the lioness by the leg but soon let go, badly mauled. The lioness took refuge under a nearby granary, and here the menagerie proprietor and his assistants "placed a sack on the ground near her and made her lie down upon it; they then tied her four legs, and passed a cord around her mouth, which they secured; in this state they drew her out from under the granary, upon the sack, and then she was lifted and carried by six men into her den in the caravan."

The menagerie owner acquired the poor horse, Pomegranate, and exhibited her with all her wounds at Salisbury Fair the next day. One of the terrified passengers had failed to make it into the inn before the door was shut, and as he stood desperately beating on the barred door, the lioness had brushed against him. The terror of this encounter was too much for the unfortunate man, who was admitted to Laverstock asylum a few days later. He remained there until his death, 27 years later.

The black beast of Stradbrook

A large black animal, variously described as a black dog or a big cat, haunts Stradbrook Lane in Bratton. It seems most likely that this beast is a black dog, or was one originally, for Stradbrook Lane follows the line of the parish boundary, prime black dog territory. However, most local people say that the beast is a black cat, a belief that may be linked to the name of a nearby holy well. St Catherine's well – Cat's Well for short – may have been what tipped the balance in suggesting to locals that the beast of Stradbrook is a cat, not a dog.

A distinctive thump

The Stradbrook beast is comfortingly ghostly – in the case of big cats, ghostly is to be preferred to real – but no such claims can be made for the next three ABCs. Back in the early 1990s, a County Council surveyor was out in the south of Wiltshire, surveying a site for a rubbish dump. He heard a strange noise, and caught sight of a very large cat that was up in a tree about 50 yards away from him. He told my informant, then his colleague, that the cat dropped out of the tree with a distinctive thump, which confirmed his visual assessment that it was an animal of considerable size and weight.

The big cat of Southwick

In 1995, *Fortean Times* reported two sightings of a large black cat at the village of Southwick, near Trowbridge: -

> In spring 1994... a man walking his dog ... saw a large black cat-like animal running very fast across a field close to the main road. It had an over all length of about four feet and its tail was almost as long as its body. It had small pointed ears and a smallish head.
>
> On 3 July 1994, two men driving along the main road encountered the same (or similar) creature sitting in the road. They had to slow down as it didn't move away until they were very near; then it leapt up and bounded down a short track into the same field where it had been seen previously. The witnesses described its eyes as white and glowing in the car's headlight beam.

An Upavon ABC

Another sighting, this time in March 1996 (which I remember hearing about on the TV news at the time) was also reported in some detail in *Fortean Times*: -

Jonathan and Matthew Sloggett, 12-year-old twin sons of Rev. Don Sloggett of Upavon, were playing in fields about 80 yards (73m) from the vicarage garden. As dusk fell, they rolled up their play telephone (yoghurt cartons joined with twine) and prepared to return home.

Noticing a strong smell, they turned round to be confronted about 4 yards (3.7m) away, by a large dark grey cat the size of an Alsatian with a thick tail that reached the ground. It leapt from the shadows and grabbed the twine, pulling it tight around Matthew's arm, snarling all the time. Jonathan ran up and gave the animal a hefty kick in the side. It released the string and sank its teeth into the zipper of his coat. He hit it on the nose with the palm of his hand, the zip broke in its teeth and the boys made a run for it. The animal chased them back to the vicarage, twice grabbing the trailing string in its mouth. The family boxer dog, Jemma, fled and cowered in a corner.

When Rev. Sloggett arrived home from evensong, he found his panic-stricken sons in the driveway. It took them an hour to calm down sufficiently to relate what had happened. The vicar took plaster casts of some 4in (10cm)-wide pawprints to Bristol Zoo, but they were too indistinct to identify. According to a keeper at the zoo, the sound the brothers described the cat as making indicated that it was either a puma or caracal, a relative of the lynx. The vicar had scoffed at earlier sightings of the animal in the area, including some by his own daughter Rachel, 15, when she was out riding. However, the boys' account was 'particularly convincing'. Jonathan had been left with a bruise on his arm he said had been made by the animal's tail.

The bacon ate the cat

Let us leave the ABCs for some rather less intimidating cats. Pewsey, where I lived for a while, was known in the mid-19th century as the village where "the bacon ate the cat". The story is supposed to have arisen because a child rushed out into the street crying "Oh mother, mother, the bacon has ate the cat!"

This is, I think, one of those one-upmanship tales told by the members of one community at the expense of another. Very many tales of this kind are told about Bishops Cannings, which is the most famous noodle village in Wiltshire. But such tales are not exclusive to Cannings, and Pewsey, Downton and Aldbourne folk, among others, all feature as less than bright in the accounts of their exploits.

Cat magic

Cats are traditionally magic creatures. The black cat is the archetypal witch's familiar, but it is nevertheless considered in Wiltshire to be a lucky animal. One piece of Wiltshire cat magic says that you can strengthen your eyes by rubbing them when you wake up with a cat's tail. This is a widespread cure for a stye on the eye, but on balance, a visit to the nearest healing well would seem a preferable form of treatment.

In 1996, Carole Stone told me about the 'magic cat', a tradition that I have never met anywhere else: -

> A cat that has six toes on its front paws is called a magic cat. If you look after it for seven years, it will grant you a wish.

At the time she told me about this, Carole had a six-toed cat that was fourteen years old. She was pregnant when the cat was seven, and wished for a healthy baby, which she got. She did not tell me what her second wish was to be.

Cats sense the ghost

Jean Morrison happily shares her home, Priory Cottage in Bratton, with a long-standing ghost. Parts of the house are nearly 400 years old, and it has many interesting features like its original ingle-nook fireplace. The previous tenants had great problems with the ghost of an old woman, who used to go and peer at their terrified ten-year-old son as he lay in bed at night. When she moved into Priory Cottage, Jean was very aware of the presence there, and the cat that she brought with her was terrified of it. Jean got the sense that the ghost was unhappy about the state of her old home, which had been superficially much altered by previous tenants.

> I thought, 'Well, I'm not going to be driven out by any presence. I'm going to make friends with it.' Every time I felt it I thought at it, saying, 'What a lovely old house you have – it's lovely to be here', and so on. I began restoring the house to the way it used to be. From the moment I opened up the ingle-nook fireplace, there was no feeling of haunting at all.

Although she never notices the ghost now, it does seem to linger on the stairs. "When the cat comes in, if it tries to go upstairs, it stops and looks – who's that?"

A witch's cat

A witch of my acquaintance told me that she once had a small white cat that seemed to dislike a neighbour of theirs, a woman who had small yappy dogs. It seemed to sense, as cats invariably do, that the woman was also terrified of cats, and it used to go down and sit on the gateposts and peer into the room at her. It had no fear of dogs, and would see them off by dropping onto their backs, digging in its claws, and riding them home!

My own black cat, Comfort (please note that I am not a witch), is quite a timid creature, but twice now I have seen her chase large dogs, which were so surprised that they ran away in obvious embarrassment.

A courageous cat

Marlborough's history is punctuated by the fires that periodically swept through the town. The famous wide high street was originally two streets, and owes its existence to the loss in a fire of the whole row of houses which separated them. St Mary's church at the top of the High Street did not escape, and in both 1460 and 1653 it was badly damaged by fire.

The tale is told of a cat that had its kittens in the church tower and, while the building was on fire, went in and out fetching them to safety. Almost all were saved, but when she went back for the last one, she never came out again. A small, weathered carving on the string course along the south side of the church is supposed to show the brave cat carrying one of her kittens.

Local author Hughes has suggested that, since the carving dates from the 15th century, the events in this tale must have taken place during the 1460 fire. I love this poignant little story, but suspect that it developed after the carving of the string course, to explain why the small cat is carved there, in the same way that so many tales have grown up around standing stones to explain how they came to be there. In this case, surely, as in life, the tale must have followed the cat.

Hilltop Fairs

The rural economy depended largely on farm animals, from the livestock kept by the landed farmer through to the family's pig in the sty at the bottom of the garden, which would provide so much of their meat for the coming winter. As well as at regular markets, trading in livestock took place at the great hilltop fairs, like the one that was held on Tan Hill (SU082647) on August 6th, St Ann's day. This was a horse and sheep fair, and a general holiday, but the traditional rowdiness and enthusiastic partying which went on there gradually became unacceptable to the arbiters of morality in

Victorian times, and the fair, like so many others, died out. Ella Noyes describes a similar horse and sheep fair which was held each year at Yarnbury Castle, within the bounds of the hillfort (SU035404) that is clearly visible from the A303 trunk road.

Once a year Yarnbury becomes reanimate, on the day of the Horse and Sheep Fair, October 4th, held in this lonely trysting place by immemorial tradition. Here, within the rampart, the flocks which in the twilight of the autumn morning poured with a loud multitudinous clamour across the downs, weary and perplexed, stand close packed in pens; bunches of young ponies are tied up in one corner, their wild manes streaming in the wind of the high downs, and near by are the sober cart-horses, their plaited manes and tails aprick with ornaments of straw. The vendor of sheep-bells spreads his metal wares upon the ground and a group of shepherds gathers round him, discussing the subject and giving good advice to a would-be buyer, who tests the tones of the bells with great care - for the purchase of sheep-bells is a serious matter, good ones costing as much as five shillings - and the shepherds have to 'find' them themselves. A huckster of the big cotton umbrellas that the shepherds carry slung across their dinner baskets, wanders about with his goods. In the old days, up to within the memory of people still living, the fair was followed by horse races next day, and sports of all kinds. But now the pleasure part of the meeting has been abandoned; the folk disperse quietly soon after noon, when business is done, leaving Yarnbury to the silent occupation of its prehistoric ghosts for another year.

Wool fit for Lords

Bettey tells us "In the chalklands of Wiltshire, Dorset and Hampshire, sheep and corn have dominated the farming scene right up to the twentieth century." Their production was inextricably linked, for the thin downland soils were kept fertile enough for the production of corn only by having large flocks of sheep folded on them overnight, so that the sheep droppings enriched the soil. Huge flocks of sheep were pastured all over the downland, and the wool they produced formed the basis of wool and woollen industries in cottage and town. My own town, Trowbridge, proclaims itself "an historic woollen town", that is, one where the wool was woven into cloth. Wiltshire wool was apparently the very best to be had, for "tradition holds that the first Woolsack for the House of Lords was filled with wool from Wiltshire."

The haunted sheepskin

It is not surprising, then, that some tales tell of the strange experiences of shepherds upon the downs, and we have already met George Pearce who had some uncanny encounters in the course of his working life. Manley recounts one of the most unnerving of these tales: -

About midway between Warminster Downs and the White Horse are the deserted ruins of a farmhouse. The last occupant was a farmer who lived there alone. One night he heard a commotion downstairs, and on going to investigate saw the forms of three men removing the carcase of a sheep he had killed. He threw his stick at them, which passed through a form without injury, whereupon they turned on him with such horrible grins that he fled to his room. The rotten floor broke beneath him, and he fell through, to land in the midst of the ghosts - for so they must have been. The sheep's skin was there and in terror he huddled himself on it. Away it slid with him up and down stairs and all over the house. He screamed, but the ghosts only screamed louder, 'Scream as loud as you like for there is no one on the downs to hear you,' adding 'Some day you will be one of us.'

Daylight came, to his relief. The sheepskin was pegged down, the house was set ablaze, and away he tramped in search of lodging in Westbury.

Healing wells for cattle

Healing wells could be used for animals as well as for curing people's ailments. Hancock's well at Luckington was used to cure sick dogs as well as human sprains and similar muscular complains. In Wiltshire were two wells that are specifically associated with cattle. Net Well (SU091453) on Net Down is a Cattle Well, for 'net' is most probably derived from Old English *neat*, meaning a cow, as in 'neat's foot oil'.

The Salt Spring at Wootton Bassett was used in the curing of cattle. John Aubrey writes of a medicinal spring here, "at some little distance from the town", and at the end of the 19th century this was clearly a very famous healing well for the people in the area:

In the summer months large quantities of the water are taken away by visitors from the towns and villages within a radius of ten miles or more. On Sunday mornings, especially, in May and June, there may sometimes be seen as many as thirty persons at one time drinking the

water or filling their various vessels. On one occasion (in May 1879) the present tenant of the farm (Mr. Hathway) had the number who came during the day counted, and they amounted to near upon four hundred. The public have full and free permission to visit the place and take the water at all times. The well is enclosed with brick, and the water comes up slowly through an iron pipe, the length of which is not known. The field in which the spring is situated is usually reserved for the pasturage of young cattle, as it has been long known that they enjoy there an immunity from the disease known as 'quarter evil', or inflammatory fever, to which young stock are frequently subject.

The first series Ordnance Survey maps show the salt spring at SU048834, in a field between the railway and the Thunder Brook. Local author Gingell tells us that use of the saline spring, except for cattle, declined after the Second World War. "It was an intermittent spring, welling up and then disappearing. In the late 60s despite the roadway engineers' assurance that they had piped an outlet to it the spring disappeared for ever." The roadway engineers were engaged in building the M4 motorway.

This is one of the many examples of wells which were once crucially important to the local community, but which have been lost in the latter half of the twentieth century, largely because of the general availability of water from the tap, and medical assistance from the National Health Service. The old reliable water-sources were quickly forgotten, and it is only over the last twenty years or so that interest in holy and healing wells has been growing again among those of us with an interest in the local landscape. For many of the old wells, this interest has come too late. Of the 19 specifically healing wells that I have identified in Wiltshire, ten are untraceable or have been lost within the last 30 years.

Of pigs and pig-killing

The family pig was very important in the domestic economy of those villagers who could afford one. In the twentieth century up until the Second World War, pig clubs ensured that everyone could own a pig, for if they could not afford the few pence needed, the club would pay. If anyone's pig died, the club would replace it. This was a truly practical version of a kind of Friendly Society.

Fed on scraps, the pig would grow fat in its sty until the time came for slaughtering. Noyes tells us "There was a sort of solemnity and mystery... about the proceedings which accompanied the sacrifice of the peg [sic]... It

had to be done during the waxing of the moon; otherwise the bacon would waste in the frying." The waxing moon is the time used in magical practice for any spellwork that requires growth or increase. Here it is used for the very prosaic reason that people did not want their bacon to shrink in the pan. All parts of the pig were used up: as well as joints of pork, ham and bacon there were brawn, faggots and sausages to be made, and the trotters to cook. It was said that "only the pig's squeak escaped the pot!"

One wonders what the villagers really thought if their pig was taken by the rector as part of his tithe. Manley records the custom of 'taking seisin' as practised at Norton Bavant around the turn of the twentieth century: -

> They had a custom at Norton Bavant then when one Sunday, after morning service, Jim in his best smock conducted the rector to a pigstye, the congregation bringing up the rear. The path was strewn with clean straw. The rector selected a pig by marking a chalk cross on his back. There and then the pig was put in a sack, the clean straw gathered up, and the two things carried away to the rectory.

One gets the feeling that the rector would have picked the best pig of the lot. Did pig clubs give replacements for pigs that had been appropriated by the clergy?

Pig cures and pig wells

Coleman tells us of two less-than-appetising pig-based cures for common ailments. "Swine's blood is also supposed to be good for warts if used for washing purposes. It should be drunk for ague." There are many different cures for warts, some less appealing than others. A farmer once cured my brother's warts with the stuff they put on sheep's feet to prevent foot rot. Heaven knows what it does to the sheep, because it cleared away his warts very quickly. He also had beautifully multi-coloured hands for a number of weeks, from the indelible dye in the spray. A famous family cure for warts is the one discovered by my father, whose hands were covered with warts on his wedding day. When he got back from the honeymoon, they had all disappeared, and he always recommended marriage as a most agreeable cure for warts.

Hog's Well[2], at Bugley near Warminster, was used to strengthen weak piglets. Shuttlewood tells us that "farmers with a weak pig in a litter would let the piglet stand in the spring for fifteen minutes." This is interesting in itself, as pigs are not usually associated with healing wells, but Hog's Well

is the focus of a tale concerning the kindly barrow-wight which haunted a round barrow on Cley Hill: -

> Inside the barrow there once lived the guardian spirit of the Bugley folk. One day he heard the trickle of water beneath him, and, entering into the spring, he directed its course underground until he reached a convenient spot which is now called Hog's Well. He told the folk not to drink the water, but to use it only for curing weak eyes, with which complaint the people were much afflicted. One day a woman who was gathering sticks near by ignored his warning, and drank of the water. She was found dead in bed next morning. Another time a cow polluted the water by standing in it. The spirit was angered and caused the animal to sink in the mire. When the cowherd saw this he dug a ditch to drain the water away, but it was of no use: the cow sank until it was drowned... Until recently sixpence a bottle was paid for the water if a boy also brought some flowers called Ground Ivy to be brewed in it, with which concoction the eyes were bathed.

This tale contains many authentic elements of folk belief, both about wells and about barrows. First we have the concept of a guardian spirit that inhabits a round barrow, and this has been and still is part of beliefs about ancient burial mounds in this country and elsewhere. Tales of ghosts at barrows may be a residual memory of the original barrow-wight. One such ghost traditionally haunts the West Kennett long barrow, in the form of a priest who enters the barrow at sunrise on the longest day. Jenny Blain, who visited the long barrow on the eve of the last full moon before summer solstice 2000, told me that there is indeed a guardian spirit at the barrow. She saw its white form first within the barrow itself, and again when she looked back from the white path leading away from the burial mound.

Hog's Well also conforms to various beliefs about healing wells. Setting aside its use in strengthening piglets, its water is used to cure weak eyes. This is the primary ailment cured by well water: there are more eye-wells across the country than any other kind. It seems most likely that the complaint we are dealing with here is *xerophthalmia,* the 'sore eyes' caused by a lack of vitamin A, which is found in yellow and green vegetables. A soothing eyewash made from ground ivy flowers and fresh spring water (let's try not to think about what the pigs might have done there) would have relieved the symptoms, if it could not cure them. Use of the well is surrounded by various taboos: do not drink the water; do not let animals

drink there and pollute it. This kind of taboo is found in many folk-tales dealing with magical or mythical sources of plenty. One similar example is the tale of the fairy cow (found at Mitchell's Fold, Chirbury, Shropshire, among various other places), which gave endless supplies of milk as long as nobody took more than one pailful. But a greedy old witch milked her into a sieve, which of course she could not fill, and so milked her dry. After this treatment she was never seen again. Some wells around the country are reputed to have dried up or lost their healing qualities when they were misused.

Fairy pigs and fairy dogs

Calcutt, just east of Cricklade, has some remarkable ghosts, if ghosts they be. Olivier tells us that on Christmas Eve, little pigs run across the road, and Kathleen Wiltshire adds the important detail that these are white pigs with red ears. White animals with red ears are usually fairy beasts. We have another fairy animal in Wiltshire, for when the white priest enters the West Kennett long barrow at dawn on the longest day, he is followed by a great white hound with red ears. If the 'priest' is a memory of the barrow-wight, then the fairy dog that accompanies him is entirely appropriate, for 'fairy' is a generic term for the many different types of nature spirit said to inhabit mounds, stones, trees and wells.

Pig humour

Liddington villagers used to be given the nickname 'pig-diggers', because one of them one claimed to be 'digging for pigs'. He meant that he was digging out flints to make enough money to buy a pig, but members of rival villages doubtless forgot this when they used the nickname.

When I was very small I was told that if you pick a guinea pig up by its tail, its eyes will drop out. I very soon discovered that guinea pigs don't have tails.

My first wedding

There are many different superstitions relating to birds of different kinds, perhaps going back in spirit to the days of ancient Rome when omens were read in the flight of birds. Donald Gough recalls a strange ritual phrase that he and his friends used to use in Chippenham. When a flock of birds passed overhead, they would look up at the sky and say "my first wedding". He has no idea why. He used to think that the number of birds in the flock indicated the number of children who were going to be ghosts.

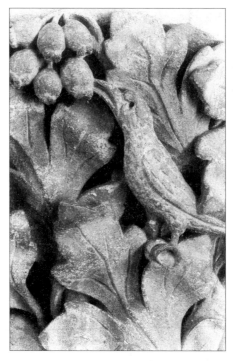

Birds have inspired many superstitions (detail of Green Man, Sutton Benger church).

Omens of death

Certainly there are many examples of birds being regarded as omens of death or ill luck: owls and ravens are two of the most common. Like all night-dwelling creatures, and especially those with eerie cries, the owl attracts superstition. We know that the owl has been associated with death and disaster since the days of ancient Rome, and in Wiltshire it was no exception.

Clark recalls "...owls hooting near a dwelling was considered a sure sign of death. I have often been told, 'How the owls hooted the night your father died!' "

Ravens, now no longer to be found in Wiltshire, were once also viewed as birds of ill omen: -

> David Watts, clerk at Baverstock, 1920, said, referring to a tombstone in the churchyard, that he and the man whose tombstone it was, were working together and one of the ravens that then (many years before) inhabited Grovely Wood and nested at Compton Chamberlayne, flew over croaking. The man said 'Dave, did you hear old Jack Raven? There'll be a grave to be dug soon'. That man was buried soon afterwards. They used to say a raven's croak was a sign of death.

The raven is sacred to the Norse god Woden or Odin, god of the dead, who led his wild hunt of lost souls across the sky. Moreover, it is a carrion-eater, and with its black plumage and harsh voice it is little wonder that people came to regard it as a harbinger of death.

A flock of misfortunes: magpies, robins and peacock's feathers

The magpie can bring either good fortune or bad, as the well-known magpie rhyme 'one for sorrow, two for joy' makes clear. This reputation is probably linked to its bi-coloured plumage of striking black and white. Legend says that it would not go into full mourning with the rest of the birds at the time of the Crucifixion, and it is supposed to have refused to go into the ark with Noah, preferring to stay outside and chatter maliciously over the world as it drowned.

Donald Gough recalls a magpie tradition that was current in Chippenham when he lived and later worked there. If you see a magpie on your outward journey, you can't return home until you have seen another. He knew a delivery man who, if he saw one magpie, would never return to base until he had seen another. Even now Donald always looks around for a second magpie if he has seen one – but it doesn't stop him from going home.

The robin is an aggressive, feisty little bird, but it is well loved and the legends about it testify to its supposedly noble nature. It got its red breast when it tried to pull the thorns out of the Crown of Thorns, and was stained by Christ's blood. Another legend says that its breast is red because the fires of Purgatory scorched its feathers as it carried water to the souls suffering there. Perhaps because of this, it is reckoned to be extremely unlucky to harm and kill a robin.

In Wiltshire it was considered cruel and unlucky to keep a robin in confinement. Clark tells us, "I remember hearing of the death of a caged robin, which was the forerunner of endless troubles to the people who had confined it…" Steve Gough confirms the dangers of killing the bird: "…it is very bad luck to kill a robin – my Dad [Donald] has a tale of a motorist in Sheffield who ran one over recently and came to all sorts of grief."

Donald Gough's family shared the common superstition that peacock's tail feathers are unlucky and should never be brought into the house. The peacock was sacred to Juno, queen of the Roman pantheon, and the ever-open eyes on its tail are the myriad eyes of the giant Argus, her faithful servant. When the god Mercury cut off Argus's head, Juno gathered up his many eyes and scattered them over the tail of her favourite bird, the peacock. It seems likely that the superstition against peacock's feathers stems from

some association of the 'eyes' with the Evil Eye that brings the worst kind of ill-luck.

A lark's got 'im

The skylark is like the robin in that it is dangerous to molest, but is not usually believed to be actively malicious. But Goddard noted an odd Tidworth superstition, which is apparently peculiar to Wiltshire:

> An old shepherd c.1880s maintained that the lark was an uncanny bird, and that the spur on its foot was poisonous. It would spur sheep in the head, and this is what would make them giddy. "One day master come to me when I was minding my sheep and one of 'em was down just then, and he says – 'Bredmore, what be up with that 'ere sheep?' 'Oh', I says, 'he be taken giddy, and I'll be bound a lark's got 'im', and up we goes to the place and sure enough there was a lark there."

Birds bring good luck to a house

Swallows and martens are birds of blessing all over Britain and Europe, and their nests under the eaves are a sign of good fortune. They arrive with the warmer days of summer, and in some legends it is the swallow that brought fire to humankind, getting its red markings and its smoky blue feathers in the process.

Clark notes a Wiltshire version of the good luck belief: "Martins and swallows building their nests under the eaves of a dwelling house was favourably looked upon, as it was believed that riches would follow."

This seems a much more pleasant way of ensuring good luck than "the burying of a live pigeon beneath a flagstone", noted by Manley on Warminster Common, which seems early in the twentieth century to have been a place of poverty, unrest and dark superstitions. This was apparently a kind of household sacrifice, akin to the mummified cats and other beasts that have been found walled up in old houses, apparently placed there during the building process.

Cuckoo rhymes

The cuckoo is a lucky bird because, like swallows and martens, it is a herald of spring. It may once even have been thought of as actually bringing the spring and the warmer days, rather than just announcing their arrival. So the cuckoo was awaited with pleasurable anticipation, and there are many local variants of the standard rhyme that helps people remember when to

listen out for its distinctive call. The version I grew up with goes: -

> The cuckoo comes in April
> He sings his song in May
> In the middle of June he changes his tune[3]
> And then he flies away.

At the end of the 19th century there several different cuckoo rhymes current in Wiltshire. The first is a simple verse very like mine: -

> The cuckoo comes in April,
> Stays the month of May,
> Sings a song at Midsummer,
> And then goes away.

This version is pleasingly non-gender specific (for why should the cuckoo be a 'he'?), and we also see the cuckoo linked closely to the coming and going of summer. After singing to greet the longest day, the bird leaves, taking the summer with it, in the sense that the days start to get shorter and we are reminded that summer must give way to autumn.

There was also a version in the form of a question and answer: -

> Q: Cuckoo, Cuckoo!
> What do you do?
> A: In April, I open my bill;
> In May, I sing night and day;
> In June, I change my tune;
> In July, away I fly;
> In August, go I must.

And another variant says much the same but in more flowery language:-

> In April, come he will;
> In flowery May he doth sing all day;
> In leafy June he doth change his tune;
> In bright July, he doth begin to fly;
> In August, go he must.

The last cuckoo rhyme is an odd little couplet, which seems to make

very little sense, for who eats a cuckoo's egg, and what has a cherry tree to
do with it?

> Cuckoo, cherry tree,
> Lay an egg for baby and me.

I believe this to be a version of the cuckoo-and-cherry-tree charm, which
seems to be linked to key life events like marriage and (more rarely) death.
Radford notes that "on the first day or later in the cuckoo-season, [a girl]
can go to a cherry-tree, shake it, and say 'Cuckoo, cuckoo, cherry tree, how
many years before I marry?' The bird will duly reply, sometimes at greater
length than she desires." I guess the charm came into being partially because
cuckoos sing a simple repeated song, ideal for divination by counting; and
equally its association with the summer-time of pairing, mating and fertility
makes it an obvious bird to consult on the subject of matrimony. In our
Wiltshire rhyme, the emphasis seems to be on the fruits of matrimony:
perhaps the young woman speaking the charm is asking for an 'egg' in the
form of conception of a baby.

Cuckoo pens and drowning ducks

Of course, if we could just capture the cuckoo and prevent it from leaving,
then spring and summer would continue indefinitely. The problem is, the
bird can fly, and easily escapes from any pens that hapless noodles may
build around it. The renowned and extremely *un*-Wise Men of Gotham
(Nottinghamshire) "stood hand in hand around a bush with a cuckoo in it,
hoping to pen the bird and so capture Spring." Versions of this tale are
found all over the country, wherever one lot of villagers want to have a joke
at the expense of their neighbours down the road.

Wiltshire's version of the cuckoo pen myth does not come from Bishops
Cannings, like so many other noodle tales, but from Downton. It explains
how they got their traditional nickname, and has a particularly nice local
variant which links to the date of their annual fair, April 23rd.

> Downton folk are called 'Silly Downtons' because they hedged in the
> cuckoo to keep him there all the year and cut a hole in the hedge 'to let'm
> come out at the Fair'.

Not much brighter was the Lavington man (Market or West?) who, all
dressed up in his Sunday best, plunged into the village pond to save a duck

from drowning.

These 'noodle' tales – and we have met a fair few in the course of this book – come in two types: the 'straight' tale in which the noodles really are noodles; and the tale with a twist in which the noodles are shown to be not quite as stupid as they first appear. The obvious example of this second kind of noodle tale is the Moonraker legend, told of various villages but especially of Bishops Cannings (maybe to make up for all the other less flattering tales about the Cannings folk!). The villagers are apparently raking the village pond for the 'gurt cheese' that has fallen into it (the full moon's reflection), and put on such a fine act of bucolic stupidity that the excisemen leave them to it, and so they carry on raking out the barrels of brandy hidden in the pond.

Aldbourne dabchicks

The Aldbourne dabchick legend is one of the first type of noodle tales – where they really are noodles – but nevertheless the nickname became an honoured title for a true native of the village. Ida Gandy relates the full story: -

> One day a strange bird appeared on the village pond. Nobody could recognise it, until the oldest inhabitant was brought out in a wheelbarrow. 'Wheel oi round' he commanded, and 'Wheel oi round again', and after three circuits of the pond he announced that the bird was a dabchick. Ramsbury folk were much amused by this tale, as they see dabchicks daily on the river Kennet, and so the teasing custom arose of tying a dead dabchick to the back of the Aldbourne carrier's cart, and of taunting Aldbourne folk by calling them dabchicks. But Aldbourne people became proud of their dabchick associations: nobody but a true native can claim the title, unless they have been ducked in the village pond. Aldbourne bell-founders, the Cor family, used the dabchick as their symbol. They ceased production in 1757, so the tradition is long-standing.

We note that the village elder was ritually wheeled three times around the pond before he made his pronouncement: yet again the number three plays a key part in a folk tale. There is also a suggestion of ritual baptism, where incomers can 'become' dabchicks if they are ducked in the pond. I have found this kind of ritual ducking also at Market Lavington, where Peggy Gye told me, "When I was a girl they said that you weren't a native of Market Lavington until you'd fallen in Broad Well." Broadwell is the big

spring at the heart of Market Lavington, and was the main village water supply right up to the 1930s.

Shoeing the geese

Finally a noodle tale which is apparently of the first kind, but which, when explained, shows the Broughton Gifford villagers as enterprising, inventive and resourceful.

This legend, which apparently it is undesirable to mention in Broughton itself, is given in the North Wilts Herald of February 9th, 1934. Broughton still possesses a large open common on which a number of geese are to be seen. As the story goes, however, in former days these geese were much more numerous and large flocks of them used to be driven along the road to Trowbridge and Melksham markets. The roads were rough and the geese having to walk all the way, often got footsore and unable to go further. It occurred then to an inventive Broughton man, that they might be shod as horses are, and he called in the aid of the blacksmith to make the necessary shoes, which he proceeded, so the legend runs, to do, trotting out the geese on a trial run to see how the iron shoes fitted. An old inhabitant finished the telling of the story to the writer of the article thus: 'I dwoant spose as twer ever done, but we did used to shoe 'em in another way, and that wur te get a mixture o' tar and sand and let 'em tread on that for a few days. Then 'tood clot on their veet and walkin' to market didn' hurt 'em'.

Telling the bees

There are many traditions and superstitions regarding bees, which may have grown up from their sacred status in antiquity, where they were seen as diving messengers and foretellers of the future. In the Christian tradition they were revered as servants of God, and they came originally from paradise. So it was that their wax was used for altar lights, and they hummed praises to God all day. It is thought very unlucky to kill a bee, and if you keep bees there are many courtesies to be observed, for they must be kept informed of all the important household events, lest they swarm and fly away.

Donald Gough recalls his aunt Phyllis's husband, Leonard, who kept bees in Devizes.

One day (in the 1930s) [I] encountered him passing from hive to hive.

As he reached each hive he stopped and talked to it for a while. [I] asked him what he was doing and received the reply that if he did not talk to his bees they would be sure to swarm and abandon the hive. ...Leonard offered to prove the point by missing out one of the hives. Next day the hive was empty.

Lucky insects

The bumblebee is generally regarded as a lucky insect. In Wiltshire, one flying in at the window indicated that a friendly visitor was on their way. A neighbour in Oare when I was a child always insisted that "bumble-bees don't sting". My brother Alan believed this so completely that one day he went out happily collecting bumblebees in a jam-jar. Our neighbour was wrong: they do sting.

Francis Kilvert records a small but cruel rite of spring from Chippenham: "At Chippenham a boy was heard finding fault with a companion because he had not killed the first butterfly which he saw in spring, on the ground that to kill it was a sure way of bringing good luck to the killer." This is, or was, a common custom in many parts of Britain, and often it was believed that if you did not kill the first butterfly of spring, misfortune would follow. The belief seems to be linked in rather convoluted form with the association of the butterfly with the soul: at death the soul leaves the body in the form of a butterfly, and can be seen sometimes hovering above it. An extension of this belief is that butterflies are souls lingering on Earth before entering Purgatory. It is easy to understand how the butterfly might come to be seen as an unnervingly supernatural visitant, and reminder of mortality and judgement, and how, finally, people began to kill them for luck.

Worse than the disease?

Traditional cures for ailments vary from the moderately pleasant (healing wells, herbal remedies) to the stomach-churningly bizarre. I guess my brothers do not know what a narrow escape they had as children, for when they had whooping cough they had modern medical treatment from the family doctor. Had they lived a century earlier they might have been given a medicine that included a large spider in its ingredients.

It was even worse if you had consumption (tuberculosis), for then the cure was snail broth. Clark gives us the Wiltshire recipe: -

The broth was made by boiling the snails, shells and all, in milk, straining it, and giving it to the sick person fasting, generally before

breakfast. It was very slimy and jellied when cold.[4]

He adds that if you didn't want to go to all the trouble of making the broth, you could just eat the big black slugs that come out in the dew at dusk. These apparently worked just as well.

The belief in snail-slime as a remedy for consumption goes back at least to the 17th century, and snails are used in various other semi-magical remedies, such as the well-known wart cure where you take a snail, rub the wart with it and then impale the snail on a thorn. It all seems unnecessarily cruel when, as we know, a little matrimonial activity will get rid of warts extremely well.

A family ghost story

My family on both sides comes from the Vale of Pewsey, from Huish, the Altons, Oare and Pewsey. So when I went to give a lecture to Pewsey Local History Society in 1995, I knew I was really going home, and in the audience were a number of familiar and friendly faces. I had been talking about the folklore of archaeological sites, which includes black dogs, and as usual afterwards a number of people told me about their own ghostly experiences. But I was completely stunned when I heard Joan Gradidge's tale, because it was about members of my own family, and I had never heard anything about it before. It seems a fitting way to end this chapter of animal tales.

> Do you know about the black dog at Sharcott? Now I'll take you through a bit of family history. Your great-grandmother's cousin was George Edward Goddard. His wife, your great-aunt, when she was a child, on her way to Sunday School with her sister, saw this black dog. And as you've said they couldn't get near it. They moved forward, it moved forward. As they got to the main road it ran across towards the hill, and they could hear a chain rattling.
>
> Now years later when she was married, one of her sons - she had several: one was my Uncle Tom - he was riding home one dark night on his bike and he noticed this dog following him. So being a family of dog lovers he stopped. The dog stopped. He called to it. It wouldn't come. So he got on his bike and rode, and it was still following him. And suddenly he remembered his mother's story about the dog she had seen as a child - he dropped his bike and ran the rest of the way home!

References
The Thing: Palmer (1973), p.130
Black dogs: See Brown (1958) and Brown (1978) for an overview of black dog characteristics. For many examples of Wiltshire black dogs, see Wiltshire (1973), pp.1-16, and Wiltshire (1984), pp.9-22.
Inglesham ghost: Williams (1922), p.312.
Black dog of Wilbury: Olivier (1932), p.76.
Black Dog Hill: Manley (1924), p.10; Wiltshire (1973), p.6.
Black beast on the Warminster by-pass: Christine Bright, *pers. comm.*, University of Bath, 1990s.
Black Dog Hill and Station: Anonymous informant, *pers. comm.*, University of Bath, 1994.
Terror in Collingbourne Woods: Alan Cogdell, *pers comm.*, Pewsey Local History Society, 1995, and Collingbourne Ducis, 2000; Wiltshire (1973), p.10
Black Dog Corner: Tony Church, *pers. comm.*, Wiltshire Farming Club, Oare, 1997, and Potterne, 2000.
Black dog of Burton Hill: John Bowen, *pers. comm.*, Malmesbury, 1997 and 2000.
Black dog of Quaker's Walk: Name withheld, *pers. comm.*, Pewsey Local History Society, 1995.
Guardian of the boundary: Terry Veale, *pers. comm.*, University of Bath, mid-1990s.
Dog on the track: Frances Price, *pers. comm.*, Pewsey Local History Society, 1995; Frances Price and Lois Holland, *pers. comms.*, Milton Lilbourne, 2000.
Dog as omen: Manley 1924, p.10; Clark (1893-5), p.58, 9; Donald Gough, *pers. comm.*, Sheffield, 1996.
The traitor dog: Gover (1939), p.171; Noyes (1913), p.202.
Just keeping an eye on you: Moonrake (1942-4), p.414.
The ultimate insult: Hutton (1919), p.186.
Alien Big Cats: an excellent website giving a well-balanced view of ABCs, and more information on the Asian Jungle Cat hybrid theory, is Brian Goodwin's *British Alien Big Cats* site at http://vzone.virgin.net/brian.goodwin/bigcats.htm and any web search engine will find dozens more. Those readers concerned about possible encounters with ABCs may like to check out http://www.bigcats.org.uk/pantherweb2.html that contains a useful section on 'What to do if you encounter a big cat!'
Unfortunate Hannah Twynnoy: Ashworth (1956), p.203; Lees (1996), p.81
Poor Pomegranate: Whitlock (1976), pp.154-5
Black beast of Stradbrook: Jean Morrison, *pers. comm.*, Bratton, 1993 and 1994.
A distinctive thump: Simon Best, *pers. comm.*, Trowbridge, 1994.
Big cat of Southwick: Barton (1995), p.55.
Upavon ABC: listed on the *Fortean Times* website at http://www.forteantimes.com/artic/101/abcs.html
Bacon ate the cat: Moonrake (1944a), p.283.
Cat magic: Coleman (1952), p.7; Radford (1974), p.87; Carole Stone, *pers. comm.*, University of Bath, 1996
Cats sense the ghost: Jean Morrison, *pers. comm.*, Bratton, 1994 and 1997.
Witch's cat: Name and location withheld, *pers. comm.*, 1994
Courageous cat: Hughes (1953), p.20.
Hilltop fairs: Noyes (1913), pp.250-1.
Wool fit for Lords: Bettey (1987), p.10-11; Coleman (1952), p.1.
Haunted sheepskin: Manley (1924), p.15.
Cattle wells: Parsons (1894-6), pp.252-3; Gingell (1985), p.133.
Of pigs and pig-killing: Wiltshire Federation of Women's Institutes (1993), p.73; Noyes (1913), p.305; Manley (1924), pp.30-1.
Pig cures and pig wells: Coleman (1952), p.7; Shuttlewood (1971), p.128; Manley (1924), pp.4-5; Westwood (1986), pp.257-8.
Pig diggers: Bigger (1977), p.23.
Guinea pig's tail: Fred Jordan & Ned Coggins, *pers. comms.*, Oare, early 1960s.
My first wedding: Donald Gough, *pers. comm.*, Sheffield, 1996.
Omens of death: Clark (1893-5), p.58; Goddard (1942-4), p.41.

A flock of ill-luck: Radford (1974), pp.256-7, 281-2,225-7, 282-4, 260; Donald Gough, *pers. comm.*, Sheffield, 1996; Clark (1893-5), p.102; Guerber (1911), pp.112-4.
A lark's got 'im: Goddard (1942-4), p.25.
Martens and swallows are lucky: Radford (1974), pp.330-332; Clark (1893-5), p.155.
Pigeon sacrifice: Manley (1924), p.35.
Cuckoo lore: Radford (1974), pp.120-3.
Cuckoo rhymes: L.D. (1893-5), pp.36-7.
Wise men of Gotham: Westwood (1986), p.190.
Silly Downtons: Bigger (1977), p.23.
Aldbourne dabchicks: Gandy (1975), pp.16-17.
Falling in Broadwell: Peggy Gye, *pers. comm.*, Market Lavington, 1995.
Shoeing the geese: Goddard (1942-4), p.33.
Bee lore: Radford (1974), pp.38-40.
Telling the bees: Donald Gough, *pers. comm.*, Sheffield, 1996.
Bumblebee foretells friendly visitor: Clark (1893-5), p.60.
Killing the first butterfly: Goddard (1942-4), pp.37-8.
Butterfly lore: Radford (1974), p.77-9.
Cure for whooping cough: Coleman (1952), p.7.
Snail broth: Clark (1893-5), p.315.
Snail lore: Radford (1974), pp.312-4.
Black dog of Sharcott: Joan Gradidge, *pers. comm.*, Pewsey Local History Society, 1995.

Notes
[1] My father always used to say that the equator was a menagerie lion running round the centre of the earth – obviously another ABC!
[2] If anyone reading this can tell me exactly where Hog's Well is, please let me know. My contact details are listed in the *Conclusion*.
[3] This refers to the variant call one sometimes hears 'cuck-cuck-oo' – which does seem to come later in the summer.
[4] If any reader is inspired to try this recipe, please let me know what you think of it. But don't bother to save any for me.

Conclusion

'These stories were everyone's when I was young... it is right to keep them alive still.'

Joan Gradidge, pers. comm, Pewsey, 2000

When I began collecting folklore seriously in the early 1990s, I was not in the least prepared for the number and quality of tales that were to come my way. I have really done little active seeking out of folklore. The contemporary accounts you have read in these pages were collected on very few occasions indeed: half-a-dozen lectures, and perhaps two dozen individual encounters. I can only think that there must be a huge amount of folklore of this kind out there, each tale known to just a few people, from a single family or community. And it is being forgotten. In my own family, as we have seen, there was a history of a black dog sighting, a true Wiltshire black dog which drags a chain, and I had known nothing about it! The tale had not been passed on in my side of the family, and I am immensely grateful to Joan Gradidge for relating it to me and giving me back a part of my family history. How many tales of this kind are hidden in the memories of older folk, just waiting for an opportunity to be told? How many new tales are being told by younger generations? Does it really matter that we are forgetting them?

On one level, perhaps, it does not matter. As the old customs and traditions die, new ones spring up to take their place. Society creates its own mythology: the alien big cats, the ghostly motor vehicles, the urban legends which, as true lore of the folk, are believed to be true and genuine. (And maybe they are.) Folklore reinvents itself as society changes, in a natural process of evolution.

But I believe it does matter if we forget the tales and traditions of our own time. They tell us about ourselves, about our daily concerns and about the magic and mystery which we need to enliven our ordinary lives. If we can record our own tales, our descendants will have more than dry facts to judge us by: they will be able to appreciate something of the true flavour of what it meant to live at the turn of the second millennium.

So think for a moment about yourself, your family and friends. Do you have family traditions? What do you consider to be lucky, or unlucky? Have you seen a ghost, or something you can't explain? Do you know any tales about the places around your home? Do you know of any special stones or springs or trees? Did any of the tales in this book make you think of something similar from your own family's history?

If you have any tales or traditions of this kind, and would like to share them, I would be very pleased to hear from you. You can contact me by phone, or mail, or email (details below). Then perhaps in a few years, *The Haunted Landscape II* will be published, but this time made up entirely of contemporary folklore: a snapshot of Wiltshire tales, customs and beliefs at the start of the third millennium. Now that would be something to celebrate.

So in anticipation of the publication of that future volume of Wiltshire folklore, I leave you with a traditional toast used in my own family.

> *Yer's a health to you two,*
> *And yer's a health to we two,*
> *And if you two loves we two*
> *Like we two loves you two,*
> *Yer's a health to all vawr[1] on us!*

<div align="right">

Katy Jordan
July 2000

</div>

Contact details:-

<div align="center">

Katy Jordan,
Library & Learning Centre,
University of Bath,
BATH
BA2 7AY
Tel: 01225-826826 Ext. 5612
Email: K.M.Jordan@bath.ac.uk
Home page: http://www.bath.ac.uk/~liskmj/home.htm

</div>

[1] four

BIBLIOGRAPHY

WAM = Wiltshire Archaeological & Natural History Society Magazine

Allen, G.W.G (1935-7). **Earthen circles near Highworth** / by G.W.G. Allen & A.D. Passmore. *WAM*, 47, pp.114-22.

Andersen, Jorgen (1977). *The witch on the wall : medieval erotic sculpture in the British Isles.* London: Allen & Unwin.

Anderson, William (1990). *The green man: the archetype of our oneness with the earth.* London: HarperCollins.

Andrews, John (1773). *Andrews' & Dury's map of Wiltshire 1773: a reduced facsimile.* Devizes: Wiltshire Record Society. (Wiltshire Record Society; 8)

Annable, F.K. (1956). **Burials at Bratton & Longbridge Deverill.** *WAM*, v.56, pp.190-1.

Ashworth, Katharine (1954). **Tisbury's ancient secrets.** *Country life*, Nov., pp.1590-2.

Ashworth, Katharine (1956). **The mysteries of Malmesbury.** *Country life*, Feb., pp.202-3.

Aubrey, John (1969). *Aubrey's natural history of Wiltshire : a reprint of "The natural history of Wiltshire" by John Aubrey* / edited by John Britton. New ed. New York: Kelley.

Aubrey, John (1972). *Three prose works: Miscellanies; Remaines of Gentilisme & Judaisme; Observations* / ed. with intro. & notes by John Buchanan-Brown. Fontwell: Centaur Press.

Barber, Paul (1988). *Vampires, burial & death: folklore & reality.* London: Yale University Press.

Barton, Richard (1995). **Odd events in Wiltshire.** *Fortean Times*, 81, p.55

Basford, Kathleen (1998). *The green man.* London: Brewer. [orig. pub. 1978]

Bergamar, Kate (1997). *Discovering hill figures.* 4th ed. Princes Risborough: Shire.

Bett, Henry (1952). *English myths and traditions.* London: Batsford.

Bettey, J.H. (1987). *Rural life in Wessex, 1500-1900.* Gloucester: Alan Sutton.

Bigger, Stephen F. (1977). **Those 'idiot villages' again.** *Wiltshire folklife*, 1(3), pp.21-4.

Bord, Janet (1974). *Mysterious Britain* / by Janet & Colin Bord. London: Paladin.

Briggs, Katharine (1977a). *British folk tales & legends: a sampler.* London: Paladin Granada.

Briggs, Katharine (1977b). *A dictionary of fairies, hobgoblins, brownies, bogies & other supernatural creatures.* Harmondsworth: Penguin.

Brown, Theo (1958). **The black dog.** *Folklore*, 69, pp.175-192.

Brown, Theo (1966). **The triple gateway.** *Folklore*, 77, pp.123-31.

Brown, Theo (1978). *The black dog in English folklore.* **In:** Porter, J.R. (1978). *Animals in folklore* / ed. by J.R.Porter & W.M.S.Russell. Cambridge: Brewer, pp.45-58.

Brown, Theo (1985). **The mystery voice.** *Wiltshire folklife*, 13, pp.28-31.

Burl, Aubrey (1979). *Prehistoric Avebury.* London: Yale UP.

Burl, Aubrey (1999). *Great stone circles: fables, fictions, facts.* London: Yale.

Chandler, J.E. (1977). *A history of Marlborough : the gateway to ancient Britain.* Marlborough: White Horse Bookshop.

Chandler, John (1993). *John Leland's itinerary: travels in Tudor England.* Gloucester: Alan Sutton.

Chetan, Anand (1994). *The sacred yew* / by Anand Chetan & Diana Brueton. Harmondsworth: Penguin.

Clark, A.L. (1893-5). **Good Friday**. *Wiltshire Notes & Queries*, 1, pp.35-6

Coleman, S. Jackson (1952). *Folklore of Wiltshire* / collected, collated & edited by S. Jackson Coleman. Douglas, Isle of Man: Folklore Academy. (Treasury of folklore; 23)

Cory, Harold (1988). **Farley lore**. *Wiltshire folklife*, 17, p.29.

Cunnington, M.E. (1927-9). **Sarsen stones at Kingston Deverill**, *WAM*, 44, pp.261-2.

Davis, Hilda E. (1965). *A history of Bromham*. [Unpublished typescript in Trowbridge Reference Library]

Devereux, Paul (1979). *The ley hunter's companion : aligned ancient sites : a new study with field guide & maps*. London: Thames & Hudson.

Devereux, Paul (1999). *Earth mysteries*. London: Piatkus.

Ettlinger, Ellen (1970). **Seven children at one birth**. *Folklore*, 81(4), pp.268-275.

F.B. (1899-1901). **The Gibbet, Maddington**. *Wiltshire notes & queries*, 3, pp.333-4.

Farquharson, A. (1882). *A history of Longleat*. Frome: Penny.

Farmer, David Hugh (1992). *The Oxford Dictionary of Saints*. 3rd ed. Oxford: OUP.

Fletcher, J.M.J. (1933). *The story of Salisbury Cathedral*. London: Raphael Tuck.

Gandy, Ida (1975). *The heart of a village : an intimate history of Aldbourne*. Bradford-on-Avon: Moonraker Press.

Geoffrey of Monmouth (1966). *The history of the Kings of Britain* / trans. with an introduction by Lewis Thorpe. Harmondsworth: Penguin.

Gingell, P.J. (1985). *The history of Wootton Bassett : a very ancient mayor towne*. Wootton Bassett: Historical Society.

Goddard, C.V. (n.d.). *Wiltshire & general folklore & tales: notes of beacons, gibbets, holy wells.* [Manuscript notebook in the library of WANHS, Devizes.]

Goddard, C.V. (1942-4). **Wiltshire folk lore jottings** / by the late Rev. C.V. Goddard & others ; edited by Canon E.H. Goddard. *WAM*, 50, pp.24-42.

Gomme, George Laurence (1901). *Topographical history of Warwickshire, Westmoreland & Wiltshire*. London: Elliot Stock. (Gentleman's Magazine Library)

Gover, J.E.B. (1939). *The place-names of Wiltshire* / by J.E.B. Gover, Allen Mawer & F.M. Stenton. Nottingham: English Place-name Society. (EPNS; v.16)

Green, Miranda J. (1994). *The gods of Roman Britain*. Princes Risborough: Shire. (Shire Archaeology; 34)

Greenwood, Christopher (1820). *Map of the county of Wilts, from actual survey, made in the years 1819 & 1820*. **In:** Chandler, John (1998). *Printed maps of Wiltshire 1787-1844: a selection of topographical, road & canal maps in facsimile* / edited by John Chandler. Trowbridge: Wiltshire Record Society. (Wiltshire Record Society; 52), pp.97-145.

GWR=Great Western Railway (1908). *Wonderful Wessex: Wilts Dorset & Somerset from Salisbury Plain & the Severn Sea to the English Channel*. London: GWR.

Guerber, H.A. (1911). *The myths of Greece & Rome: their stories, signification & origin*. London: Harrap.

Harte, Jeremy (1996). **How old is that old yew?** *At the edge*, 4, pp.1-9.

Harte, Jeremy (2000). **Holy wells & other holy places**. *Living spring journal: THE international electronic forum for research into holy wells & waterlore*, 1. [WWW] *http://www.bath.ac.uk/lispring/journal/issue1/research/jharhpl1.htm* (accessed 21.7.2000)

Hendry, Sally (1994). **Bumps in the night**. *Trowbridge Star*, 4.2.94, p.1.

Hole, Christina (1950). *Haunted England: a survey of English ghost-lore*. 2nd. ed. London: Batsford.

Hole, Christina (1965). *Saints in folklore*. London: Bell.

Hole, Christina (1978). *A dictionary of British folk customs*. London: Paladin.

Hudson, W.H. (1924). *A foot in England.* London: Dent.

Hughes, Christopher (1953). *Marlborough : the story of a small & ancient borough.* Marlborough: Hughes.

Hutton, Edward (1919). *Highways & byways in Wiltshire.* London: Macmillan.

Hutton, Ronald (1993). *The pagan religions of the ancient British Isles: their nature & legacy.* Oxford: Blackwell.

Hutton, Ronald (1997). *The stations of the sun: a history of the ritual year in Britain.* Oxford: OUP.

Hutton, Ronald (1999). *The triumph of the moon: a history of modern pagan witchcraft.* Oxford: OUP.

Jackson, J.E. (1867). **Ancient chapels, &c. in Co. Wilts.** *WAM,* 10, pp.253-322.

Jacob, E.F. (1961). *The fifteenth century, 1399-1485.* Oxford: Clarendon Press. (Oxford history of England; v.6)

Johansen, Thomas (1991). **'Now we've got it': Danish treasure-hunting legends seen from a structural point of view.** *Folklore,* 102(2), pp.220-34.

Jones, Roger (1990). *Where Wiltshire meets Somerset.* 2nd ed. Bradford-on-Avon: Ex Libris. (West Country rambles)

Jones, W.H.R. (1907). *Bradford-on-Avon: a history & description.* Bradford-on-Avon: Dotesio.

Jones, W.H.R. (1922). *A stroll through Bradford-on-Avon.* [n.p.]: Library Press.

Jones, Malcolm (1987). *Dialect in Wiltshire & its historical, topographical & natural science contexts /* by Malcolm Jones & Patrick Dillon. Trowbridge: WCC Library & Museum Service.

Jones, Prudence (1995). *A history of pagan Europe /* by Prudence Jones & Nigel Pennick. London: Routledge.

Jordan, Katharine M. (1990). *Folklore of ancient Wiltshire.* Trowbridge: WCC Library & Museum Service.

L.D. (1893-5). **Cuckoo rhymes.** *Wiltshire Notes & Queries,* 1, pp.36-7.

Ladywell House Appeal (n.d.). *The story of Ladywell House.* Guides Association SW England.

Lees, Hilary (1996). *Hallowed ground: the churchyards of Wiltshire.* Chippenham: Picton.

Leete, J.A. (1979). *Wiltshire miscellany.* Melksham: Colin Venton.

Loring, Ben (1983). *The history of Keevil.* Keevil: D. Loring.

Manley, V.S. (1924). *Folk-lore of the Warminster district : a supplement to the History of Warminster & the Official Guide /* collected by V.S. Manley. Warminster: Coates & Parker.

Marples, Morris (1981). *White horses & other hill figures.* Gloucester: Alan Sutton. [Orig. pub. 1949]

Mee, Arthur (194?). *Wiltshire: cradle of our civilisation /* ed. by Arthur Mee. London: Caxton. (The King's England)

Mellor, A. Shaw (1935-7). **Box Parish records : sidelights on life in a Wiltshire village in the past.** *WAM,* 47, pp.345-57.

Miller, Hamish (1990). *The sun & the serpent /* by Hamish Miller & Paul Broadhurst. Launceston: Pendragon Press.

Millson, Celia (1982). *Tales of old Wiltshire.* Newbury: Countryside Books.

Moonrake (1942-4a). **Moonrake medley.** *WAM,* 50, pp.278-86. [Collection of articles by E.R. Pole, H.C. Brentnall, J.S. Fowler, R.S.Newall]

Moonrake (1942-4b). **Moonrake medley.** Second series. *WAM,* 50, pp.411-6. [Collection of articles by A.D. Passmore, B.H. Cunnington, H.L. Guillebaud]

Morris, Richard (1989). *Churches in the landscape.* London: Dent.

Morrison, Jean (1992). **White horses.** *Wiltshire folklife,* 24, pp.3-11

Myatt, Frederick (1982). *The Deverill valley: the story of an upland valley in south-west Wiltshire /* ed.

by F. Myatt. Longbridge Deverill: Deverill Valley History Group.

Norman, Diana (1977). *The stately ghosts of England*. 2nd ed. Stevenage: Robin Clark.

Noyes, Ella (1913). *Salisbury Plain : its stones, cathedral, city, villages & folk*. London: Dent.

Olivier, Edith (1932). *Moonrakings : a little book of Wiltshire stories* / told by members of Women's Institutes & arranged by Edith Olivier & Margaret K.S. Edwards. Warminster: Journal Office. [Reprinted 1979]

Opie, Iona (1992). *A dictionary of superstitions* / ed. by Iona Opie & Moira Tatem. Oxford: OUP.

Pafford, J.H.P. (1953-4). **The spas & mineral springs of Wiltshire**. *WAM*, 55, pp.1-29.

Palmer, Kingsley (1973). *Oral folk-tales of Wessex*. Newton Abbot: David & Charles.

Parker, Derek (1993). *Wiltshire churches: an illustrated history* / by Derek Parker & John Chandler. Gloucester: Alan Sutton

Parsons, W.F. (1894-6). **The chalybeate spas or saline springs at Whitehill farm, Wootton Bassett, and at Christian Malford**. *WAM*, 28, pp.252-4.

Passmore, A.D. (1922-4). **Notes on field-work in N. Wilts, 1921-22**. *WAM*, 42, pp.49-51.

Peddie, John (1992). *Alfred the good soldier: his life & campaigns*. Bath: Millstream.

Pevsner, Nikolaus (1975). *Wiltshire*. 2nd ed. /rev. by Bridget Cherry. Harmondsworth: Penguin. (The buildings of England)

Powell, J.U. (1901). **Folklore notes from south-west Wilts**. *Folklore*, 12, pp.71-83.

Pratchett, Terry (1992). *Witches abroad*. London: Corgi.

Radford, E. (1974). *Encyclopaedia of superstitions* / by E. & M.A. Radford, edited & revised by Christina Hole. London: Book Club Associates.

Ramway, A.J. (1984). **Erchfont memories**. *Wiltshire folklife*, 12, pp.52-5.

Rattue, James (1995). *The living stream: holy wells in historical context*. Woodbridge: Boydell.

RCHME=Royal Commission for the Historical Monuments of England (1993). *Salisbury : the houses of the Close*. London: HMSO.

Reader's Digest (1977). *Folklore, myths & legends of Britain*. 2nd ed. London: Reader's Digest Association.

Ross, Anne (1992). *Pagan Celtic Britain: studies in iconography & tradition*. Rev. ed. London: Constable.

Ruddle, C.S. (1900-1). **Notes on Durrington**. *WAM*, 31, pp.331-42.

Saumarez Smith, W.H. (1984). *A history of Baverstock*. Lymington: Spartan Press.

Savage, Anne ed. (1995). *The Anglo-Saxon chronicles* / translated & collated by Anne Savage. London: Tiger.

Sawyer, Rex L. (1989). *The Bowerchalke parish papers: Collett's village newspaper 1878-1924*. Gloucester: Alan Sutton with WCC Library & Museum Service.

Sheridan, Ronald (1975). *Grotesques & gargoyles: paganism in the medieval church* / by Ronald Sheridan & Anne Ross. Newton Abbot: David & Charles.

Shortt, Hugh (1972). *The giant & Hob-Nob*. Salisbury: Salisbury & South Wiltshire Museum.

Shuttlewood, Arthur (1971). *UFOs: key to the new age*. London: Regency.

Shuttlewood, Arthur (1979). *More UFOs over Warminster*. London: Arthur Barker.

Simpson, Jacqueline (1973). *The folklore of Sussex*. London: Batsford. (The folklore of the British Isles)

Simpson, Jacqueline (1976). *The folklore of the Welsh Border*. London: Batsford. (The folklore of the British Isles)

Smith, Alan (1968). **The image of Cromwell in folklore & tradition**. *Folklore*, 79(1), pp.17-39.

Sullivan, Danny (1999). *Ley lines: a comprehensive guide to alignments*. London: Piatkus.

Time Team (1994). *The Time Team reports.* London: Channel 4 Television.

Valiente, Doreen (1973). *An ABC of witchcraft past & present.* London: Hale.

Walters, R.C. Skyring (1928). *The ancient wells, springs & holy wells of Gloucestershire: their legends, history & topography.* Bristol: St. Stephen's Press.

Warner, Marina (1976). *Alone of all her sex: the myth & the cult of the Virgin Mary.* London: Weidenfeld & Nicolson.

Watkins, Alfred (1974). *The old straight track: its mounds, beacons, moats, sites & mark stones.* London: Abacus. [Orig. pub. 1925]

Weir, Anthony (1993). *Images of lust: sexual carvings on medieval churches* / by Anthony Weir & James Jerman. London: Batsford.

Westwood, Jennifer (1986). *Albion: a guide to legendary Britain.* London: Book Club Associates.

Whitlock, Ralph (1976). *The folklore of Wiltshire.* London: Batsford. (The folklore of the British Isles)

Whitlock, Ralph (1979). *In search of lost gods: a guide to British folklore.* Oxford: Phaidon.

Williams, Alfred (1922). *Round about the upper Thames.* London: Duckworth.

Williams, Alfred (1981). *In a Wiltshire village: scenes from rural Victorian life* / selected from the writings of Alfred Williams by Michael Justin Davis. Gloucester: Alan Sutton.

Wilkinson, J. (c.1860). *Wilkinson's Parish Questionnaire: collections for the Parochial Histories of Wilts.* [Manuscript returns in the Library of WANHS, Devizes]

Wilson, Ian (1995). *In search of ghosts.* London: Headline.

Wilson, Margaret (1994). *The Limpley Stoke valley.* Bradford on Avon: Ex Libris. (West Country landscapes)

Wiltoniensis (1896-8). **Swanborough Ashes.** Wiltshire notes & queries, 2, pp.243-5.

Wiltshire Federation of Women's Institutes (1993). *Wiltshire within living memory.* Newbury: Countryside Books & Devizes: WFWI.

Wiltshire, Kathleen (1973). *Ghosts & legends of the Wiltshire countryside.* Salisbury: Compton Russell.

Wiltshire, Kathleen (1975). *Wiltshire folklore.* Salisbury: Compton Russell.

Wiltshire, Kathleen (1984). *More ghosts & legends of the Wiltshire countryside.* Melksham: Colin Venton.

Wiltshire Historic Churches Trust (1969). *A tour of Wiltshire churches.* Dochester: Friary Press.

Wood, Michael (1981). *In search of the Dark Ages.* London: BBC.

WRO 130.8. *Plan of Dairy House Farm in the parishes of Steeple Ashton, Tinhead & Edington in the County of Wilts.* [dated 1799]

Yonge, James (1963). *The journal of James Yonge (1647-1721): Plymouth surgeon* / ed. by F.N.L. Poynter. London: Longman.

INDEX

Of people, places, & folklore

Index

More books of Wiltshire interest from Ex Libris Press:

256 pages; illustrated
ISBN 0 948578 95 5
Price £9.95

128 pages; Illustrated
throughout with maps and
photographs
ISBN 0 948578 93 9
Price £5.95

112 pages; full colour maps
and photographs throughout;
ISBN 0948578 74 2
Price £14.95

80 pages; Illustrated;
ISBN 0 948578 80 7
Price £3.95

176 pages; Illustrated
ISBN 0 948578 92 0
Price £7.95

160 pages; Illustrated
ISBN 0 948578 58 0
Price £7.95

160 pages; Illustrated
ISBN 1 903341 07 8
Price £7.95

224 pages; Illustrated
ISBN 1 903341 05 1
Price £9.95

*Ex Libris Press books are available through local bookshops or may
be obtained direct from the publisher, on receipt of net price, at
1 The Shambles, Bradford on Avon, Wiltshire, BA15 1JS
Tel/fax 01225 863595 e-mail rogjones37@hotmail.com
www.ex-librisbooks.co.uk*